nderful person,
eople full of delight.

r her patience in
stages!

For my family; Elisabet
and both Tom and Byrony, gr

Particular thanks to Bryo
assisting the edi

Flirting with Space
Journeys and Creativity

DAVID CROUCH
University of Derby, UK

ASHGATE

Published by
Ashgate Publishing Limited
Wey Court East
Union Road
Farnham
Surrey, GU9 7PT
England

Ashgate Publishing Company
Suite 420
101 Cherry Street
Burlington
VT 05401-4405
USA

www.ashgate.com

British Library Cataloguing in Publication Data
Crouch, David, 1948-
 Flirting with space : journeys and creativity.
 1. Space. 2. Human geography. 3. Space (Art)
 I. Title
 304.2'3-dc22

Library of Congress Cataloging-in-Publication Data
Crouch, David, 1948-
 Flirting with space : journeys and creativity / by David Crouch.
 p. cm.
 Includes bibliographical references and index.
 ISBN 978-0-7546-7378-1 (hardcover) -- ISBN 978-0-7546-9103-7
(ebook) 1. Space. 2. Space--Social aspects. 3. Life. I. Title.
 BD621.C76 2010
 910.01--dc22

 2010023101

ISBN 9780754673781 (hbk)
ISBN 9780754691037 (ebk)

Mixed Sources
Product group from well-managed
forests and other controlled sources
www.fsc.org Cert no. SA-COC-1565
© 1996 Forest Stewardship Council
FSC

Printed and bound in Great Britain by
MPG Books Group, UK

Contents

List of Figures

Acknowledgements

Many of the academics and artists; the gardeners and recreational caravanners; numerous individuals who have talked with me at diverse meetings above pubs and in local halls, as well as universities in many countries; and all sorts of friends who are mentioned in this text have contributed in their each distinctive ways – for which I am very grateful, of company and talk – to whatever value I have made of this book. Further thanks, please, go to good colleagues and friends with whom I have co-authored and co-edited, and have produced or worked on television documentaries.

I thank each and all of them deeply. Of course, my reading and artistic engagement with many others included here adds greatly to the list of further influences. To identify particulars seems to be inappropriate: they are all much valued. Sharing my sincere acknowledgements are Val Rose at Ashgate and all the responsive and very professional members of the team.

A further special thanks to Mark Toogood, for agreeing that I may [re]-present the paper from *Ecumene* (now *Cultural Geographies*), that we wrote together in the late 1990s, as the core of Chapter 2.

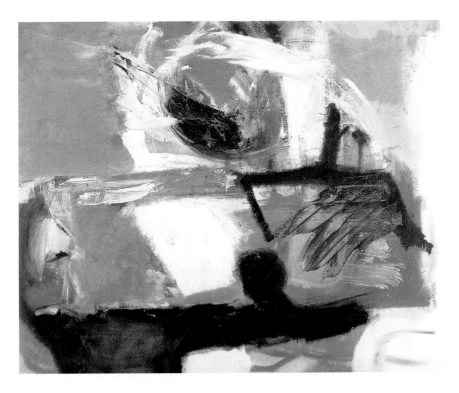

Figure 1 'Offshore', oil on canvas, Peter Lanyon
Source: Peter Lanyon 1959 © Sheila Lanyon. All Rights Reserved, DACS 2010.

Figure 2 'Chatham Vines', site-specific sculpture, John Newling
Source: John Newling 2007.

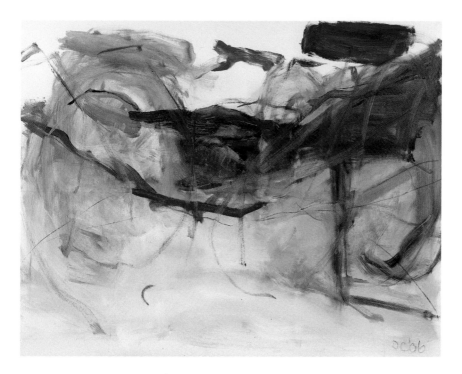

Figure 3 'Land Waves', oil on canvas, David Crouch
Source: David Crouch, the author 2006.

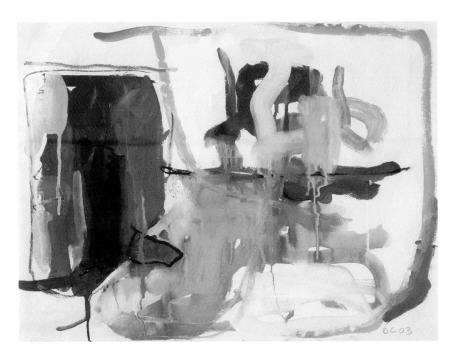

Figure 4 'Monastery I', watercolour on paper, David Crouch
Source: David Crouch, the author 2003.

Prologue

In his marvellous story *The Unbearable Lightness of Being*, Milan Kundera asks what flirtation is:

> One might say that it is behaviour leading to another to believe that sexual intimacy is possible, while preventing that possibility becoming a certainty. In other words, flirting is a promise of sexual intercourse without a guarantee. (Kundera 1984: 174)

Such pregnancy of possibility, and possibility of becoming; the implicit if possibly agonizing playfulness; the very combination of contingent enjoyment, uncertainty, frustration, anxiety and hope would seem to thread across living. Along with these, living holds a felt possibility of connection, meaning, change. To fix may be assurance, certainty or entrapment, closure or a mix of these.

The more explorative, uncertain and tentative ways in which our being part of a world of things, movements, materials and life; openings and closures, part openings mixed with part closures; engaged in living suggests a character of flirting; spaces of possibility. It can be exemplified in the way in which we can come across very familiar sites finding new juxtapositions of materials, materialities and feelings, as it were, 'unawares'. The unexpected opens out. Ordinary, repetitive, extraordinary, we find that we can 'look ... for the first time'; feel the world anew. (Bachelard 1994: 156, x). Our emotions become alive in the tactility of our thought; we discover our life and its spaces anew. Time and emotion can deliver the change. However modest these feelings of vitality may be this quiet dynamic can unsettle familiar and expected cultural resonances and the work of politics. What was felt ordinary, mundane and everyday changes; changes in texture and in a feeling of what matters. Encounters like this can happen in diverse, nuanced, complex ways amongst moments of doing things, across different spaces and journeys of our lives and different intensities of encounter. Familiar and habitual rhythmic engagement, meaning and relationships with things can change in register. In these ways flirting is a creative act. My particular concern in this book surrounds cultural and geographical knowledge of fluidities, contingencies and complexities: a practical, embodied ontology of living and the feeling of its doing and becoming (Crouch 2001, Harre 1993, Shotter 1993).

Flirting is not something in passing, superficial or an alternative to the flaneur. Flirting offers a means through which to explore the character of living spacetime through a number of threads that connect everyday living and our feeling and thinking. It serves as a means to articulate life in its negotiation, adjustment,

disorientation and becoming. Whilst it may be caught in more widely dispersed influences and affects of the contemporary, flirting is not offered as a twenty-first century emergence. Flirting with space is a vehicle to explore the dynamics of what is happening and how that flirting can affect things. Yet what is 'space' in this context; do we flirt 'with' it or is space of the flirting itself, only engaged, not detached or semi-detached from us?

Space may be at once considered a loose entity or mixing of features, movements, energies; ideas, myths, memories, actions; an active ingredient in processes of feeling. Amidst these energies is a rearrangement of energies and the spaces we feel can arise, that we felt we knew but that emerge in new ways different in assemblages of power and meaning. Resembling my approach to everyday knowledge, so too the matter of meaning; incomplete, contingent and temporal. Space can be a vehicle through which the world can emerge and offer stimulation. Space is complex, multiple; existing and constituted in energy, living, doing, thinking and feeling. It is in the commingling of energies; in the feeling and thinking that individuals do that space is affected and affects, affects us, through which richness of life and space emerge. In trying to get closer to the character of flirting with space it seems necessary to engage a compilation of conceptual approaches in order to attend to the multi-faceted character of living and feeling; an active world in which we participate in multiple ways, certain and uncertain, relating memory, relationships, the dynamics between things, actions and ourselves. In the inter-subjective and co-operative acts of individuals a multiplicity of different kinds of life and space occur, offering numerous points of alternative stories, subjectivities and politics. Flirting happens in journeys whether intimate or grand. Its creativities are modest and profound.

My approach is not poised in a particular labelled area of big theory, significantly because I have never found such resembled in living in any of the investigations I have made nor in my own life, whether this is the modernisms in their various sorts or the eventual meta-theory of postmodernism, or the over-interpretation of Deleuze and Guattari's work. Going beyond category-driven thinking that retains itself across disciplines through a need to make categories rather than articulate flows, processes, complexities, action, I am sensitive to theory but not coerced by it.

Similarly I seek to cut through the vice of reductive politics to try and get closer to the politics of lives and things; nuance and feeling, both in the sense of feeling and being in the world sensuously and in momentary or prolonged mental reflection, feelings' thought and our complexities (Bauman 2009, Virillio 2009). I examine these contestations of 'hard politics' later in this book. Such a series of efforts or claims brings the discussion to doing; an awareness of my own body in things that I do, feel and reflect. With all the limitations of our investigative methods to be sensitive and responsive to what individuals say, feel, and in a multitude of ways express. To do so is not to privilege the human or to remove the individual from the multiplicity of flows of available social or other contexts in which we live that I note with a light touch. It is to acknowledge the affects open

to us and our affects too. It is to engage the affects of this multitude, not to be driven by them. I avoid the notion of post-human, too, since this seems curiously inappropriate to the present world (Castree and Nash 2004).

Considerable scholarship has pursued the construction of space in terms of institutional power and its contemporary dominance in so-called 'capitalist space', in a priority of the detached and global, in the reductive 'time-space compression', or as exemplified in the detached depiction of lives and spaces in some of the reporting of the Iraq war (Smith et al. 2009: 3). However there remains significant complementary progress to be made in terms of more dispersed, nuanced happenings in the gentle space and politics of everyday life. The social anthropologist Michael Taussig remarks upon the importance of acknowledging everyday feelings and sensations as continually productive of the social, of styles of life and of human subjectivity in ways that avoids the more tightly enframed prioritization of context over life, that rely on a restricted form of social constructivism (Taussig 1992). Yet alongside other readings, social constructivism does contribute an interpretation of individuals' life actions and relationally with a multiplicity of influences and inter-subjective grounds for significance and meaning. Contexts like these have affects, but in a wider if also intimate world of flows. Social constructivist explanation has been enlarged to an engagement with the body in mobilizing ways in which lives are made sense, in the notion of process in a practical way of getting by, even of making some temporary gathered feel of the world, a practical ontology (Shotter 1993, Burkitt 1999). Our practical ontologies become enfolded as ongoing contexts.

Through the philosophical work of Deleuze and Guattari a generative frame of thinking emerges that is open in the character of deploying a flexible notion of subjectivity that does not see the world as human-centred but participative. Such an 'open' subjectivism enables engagement of the non-human in the multiple energies, actions and mutual affects that commingle with human lives that take us beyond the bounds of human subjectivity but do not completely lose touch with it. Some recent contributions within this more open thinking have verged on the perplexing, surely a reductive reality of individual lives, to be thought as bits and pieces, mere germs and molecules, as it were bits only flying in the wind, or being blown by it (Thrift 1996). Subjectivity, however contingent and complex, and sensation can be felt and effort is made in living, to draw together and relate however incompletely these fragments. Drawing out how things become meaningful in our lives requires attention to such workings of 'ordinary' (sic) life. Subjective meaning may be incomplete but can still be felt to be important in figuring the self in the world; the world in the self. It is strange how a denial or refusal of the self and subjectivity has emerged in literature, given the importance of self-definition and self-projection and otherwise making the self in the academic world.

In order to make critical reflection on the workings of flows and energies of feeling, subjectivity and human relations amongst the world, an attention to everyday sensuality remains germane. Our attention to the sensuous encounters we make takes us beyond mental processes and the abstraction of everyday life to engage

our sensual being, and becoming. Of course, the body is not merely a receptacle or container, even less a cultural object, but dynamic, active in our engagement in the world, and our engagement in ourselves. The reworking of Merleau-Ponty's work since the end decade of the last century, if often underplayed in the onflow of Deleuze and Guattari, brought out the inter-subjectivity, expressivity, and poetics of the body's way of touching the world in the widest sense (Crouch 2001, Crossley 1995, Radley 1995). As Brian Massumi expressed: 'When I think of my body and ask what it does to deserve its name, two things stand out. It moves. It feels, and it feels itself moving … intrinsic connection between movement and sensation whereby each immediately summons the other'; 'the way we live it is always embodied' (Massumi 2002: 1). Massumi brings the body alive in a way that articulating the body in Deleuze always seems to be elsewhere and elusive.

In the dynamics of everyday life emerges a gentle politics, operating alongside explicitly resistant modes of living (Thrift 1997). Gentle politics works across this book, intentionally in a progressive way regarding social and environmental justice. I find great difficulty in understanding everyday life's politics as 'framed' by virtualized global and political economies (Crouch 2006, Massumi op cit. Miller 2000). This language speaks too linearly, too dominating and missing the complexities of things and life embroiled in a multiple way. Orienting the discussion in this book around 'flirting' re-orients and re-positions human living. It emerges not as micro, subordinate, secondary, but as an important dynamic of energies that work relationally in multiple and commingling ways. Everyday living is frequently misunderstood, usually from an 'outside view' to be boring, dull, repetitive, closed, fixed; simply uninteresting and without energy outside an assemblage of closed acts (Highmore 2002). However, as Holloway asserts, the extraordinary can emerge in what is apparently ordinary and uneventful (Holloway 2003). Harrison argues that 'in the everyday enactment of the world there is always immanent possibility for new possibilities of life' (2000: 498). Jane Bennett's discussion of wonder in ordinary things takes this notion further in her elaboration of enchantment, that I re-engage in Chapter 7 (2001).

I cannot help but feel the importance of generosity, hopefully amidst critical thinking as I write these essays, by which I mean to try to share the expression and feeling that individuals share with me in a way that articulates their experience of things and acknowledges their emotion; and to give something back to their lives in the process, without condescension or arrogance. This quest is probably always fairly elusive. I am also trying to affect their lives progressively and constructively, through some of my interventions in formal and semi-formal politics as conduit with those voices, and in contributing a little to a progressive understanding of the world. All of this means an approach that brings individuals' lives more closely into our consideration and tries to play deftly between these and an effort of theory. It also means recognizing that individuals lives matter, that may sound banal or too obvious but, in the way that everyday life affects things, is easily missed in much recent debate.

I came to writing these chapters through a convoluted journey of interest, anger, curiosity and a feeling of care for individuals' lives, probably linked with my being a Quaker and a democratic slightly anarchic socialist of sorts. My work on community gardens [allotments] grew from a dual attachment to growing things and a feeling for people's lives often with few resources, and the possibility of fragments of freedom they discover in what they do, which freedom seemed to relate to the 'makeshift' spaces and 'makeshift', or everyday creativity; kind of human, kind of 'not-institutional', hardly prefigured. Spending time with individuals I discovered both their mutual animosities but also their mutual regard and care, in a way that moves my thinking beyond a world dominated by capitalism and global influences. Their lives and their doing a small plot of rented ground might be an escape, an avoidance of life but I don't think only this. What they are doing and the space they are engaged in making is significant in their lives in a way that reductive focus upon things like a global timespace compression simply seems to misunderstand (Harvey 1989); the notion of spacetime complexity would seem more able to embrace human livings' complexity of everyday life and feeling too.

That work over two decades led me to be involved helping many groups of people across the UK and beyond to hold onto their ground, advising, supporting and frequently helping them win their fights with landowners; embroiled in divergent politics. In the guise of an expert witness in a UK public enquiry, I helped to change government policy to increase protection of these vulnerable sites and important lives. Through a BBC television film, I promoted a popular emotional understanding through everyday extraordinary expressions individuals made themselves onscreen. Many academics get involved like this, for example in the realm of 'public geographies', that seems to mean something similar. There is a soft crossover of politics of different kinds that can also have sharp edges.

An approach of generosity and a progressive attitude to social justice seeks neither to privilege human life or anything else in the rich mix of what is and what happens; in what can be and how we can become. There is a linked critical respect for care, love and mutual regard in human life and its relationality in the world that I think chimes with recent work on mutual regard (Lee 2004). Deleuze and Guattari identified 'minor practices' with being political and of collective affect; the potential of merging and becoming a collective rather than individual subject (Cocker 2009). It seems to be important to attend generosity to the critical consideration of everyday life. Rather than refer it to arguably overarching power such as 'capitalism', or demure to its apparent dullness, conservatism and lack of creativity or simple working of kindness, its power is in the gentle politics of negotiating life. The habitual economies of the everyday are not simply the matter upon which power works. They are the powers themselves (McCormack 2003: 490). 'The habitual cannot be written out of a politics of propinquity yet tend to be undervalued in accounts of the everyday taken as the geographically proximate' (Amin 2004: 33). Foucault argued that the everyday of life exemplifies subjectification without a loud assertion of power (Foucault 1980).

The importance of emotions in the way we act and feel has recently been integrated in for example geography's attention to human practices. We feel: we have emotions as well as senses (Bondi et al. 2007, Smith et al. 2009). Things, happenings and the emotion of relations affect life. Massumi identifies emotion as entirely personal, and that heightened senses of belonging in intensified affect (Massumi 2002b). Yet the personal affects, and is affected by, other than its self. Body-gestures in performance have the power to *move* us and others in two broad, commingling ways: our hand moves; our feeling of the world and our interactions in it are changed in register.

> ... the notion that gesture is a form of personal experience as well as a conveyor
> of abstract and predetermined meaning has been rigorously explored by theorists
> of acting, performance and ritual ... the somatic experience of motility. (Noland
> 2008: xi-xii)

Movement is being alive; energies. Having emotions, thinking and feeling, implies a subject; not a coherent subject, but a subject capable of relating feelings, thoughts, living relationally with things, objects and events. We can say 'I know this' in a feeling of knowing. The body, feeling, thinking and being aware of subjectivity are mutually embedded: 'the body the ... very 'stuff' of subjectivity' (Grosz 1994: ix).

I examine how a 'flirtive' character of our complex relationality with space inflects significance in our lives through our journeys and creativity. The generation of space as something with which individuals 'flirt' may imply a detachment of life from an objectified character of 'space': we flirt with, or in relation with, 'it': assemblages of materiality, metaphor, memory and numerous contexts, along with our own myths and contingent meanings in mixture. Space is at once considered a loose entity or assemblage of multiply signified features, movements, relations, energies, and amidst these a rearrangement of energies in new or different ways. Whilst spacing is always occurent and does not exist as materiality, bundles and moments of the feeling of space occur to individuals who can try and hold down a notion of its material and metaphorical character to reflect our grasp of life, things, spaces and identity; feeling belonging. Thus I suggest that it is possible to speak of flirting *with* space, whilst also offering the 'with' in parenthesis. Whilst there may not be a 'real' space 'out there' space comes to be imagined and granted as such in relation to particular features, experience. At the same time space is in and amongst the energies themselves and so our participation in relation to and in space can be thought of as flirtive in character.

We live in journeys. Journeys are endemic in living; journeys of experience, emotion, of different spaces, of different times. Each moment of our lives is a journey-fragment in flows, a movement, a gesture working uncertainly with other fragments and with time and in time. Events happen and change the way we grasp the world; feel and engage it; make sense and give meaning to aspects of our lives and things. Their passage can be large: in migration, travel and equally in

intimate and slow engagement with one or numerous spaces across the shortest trajectory of and in life. Spaces encountered and interacted metaphorically and materially, combine with a raft of other components of life and its materiality or 'thingness'. Our interaction with and participation in active space can frustrate and affirm what space means to us in our lives, and can work with us in making life, in opening possibilities and, perhaps, realizing them. Space can be an interactive tool of creativity and its foreclosure or frustration. Central to the argument that founds this book are these notions of possibility and activation; opening and becoming; the 'making' of space and the kinds of knowledge of the world in everyday life. I examine ways, processes in and through which lives and spaces interact through time duration dynamics through which individuals' lives may be changed or influenced by this encountering. I consider how journeys can be constructive and unsettling; progressive and retrenching.

Perhaps surprisingly artwork features in a book trying to unravel the complexities and nuances of everyday dynamics. Art and what artists do is not only a mirror to everyday life; indeed it is frequently its challenge and provocation. Yet artists work in the flows of their everyday life as well as deploying peculiar conscious awareness and particular skill. To some degree artists work with visual perception and enframing to particular learnt character of space, yet for over a century their thinking and feeling has been evidently more than this. Their way of working is flirtive and embodied. It becomes important to examine the ways in which doing art may draw upon the artists' own everyday practice and performance and perhaps exaggerate from it by heightening the articulation of its emotion, experience and encounter. Artwork offers provocations to examine in terms of an unnoticed dynamic and creativity of everyday living. Art and everyday life act in a dynamic conversation. Although I happen to focus this discussion through the visual arts, I anticipate every reason to engage the debate similarly across the making of artwork more broadly.

I argue that representations are performative and expressive. In the writing of art theory for a long time artworks have been regarded as representations. This approach, for different philosophical entry points, has been the emphasis upon art, media and cultural studies, and geography's tendencies towards representations. It is the expressive character in artwork, to risk a generalization, that seems unavoidably present but until recently habitually avoided across disciplines, the advancing edge of performance studies being exceptional.

Through more recent reasoning the mutual resonance of artwork and everyday life became obvious, and their mutual contribution to understanding flirting with space persuasive. I do not mean to say that 'life' and 'art' *blur* (Kaprow 1993). Rather that the making of art the complex process of flirting with space it can involve, has similarities with flirting with space in everyday life. The two are relational and mutually informing. The gestural expressive emergence of artwork and the similar process of experiencing the gestural and expressive space of artwork can be engaged similarly.

The particular positioning and character of the chapters as they develop through the trajectory of this book are as follows. Chapter 1 develops the position of the book as a whole with regard to flirting with space, its journeys and creativity. The two chapters that follow attend to the finer grain of flirting with space and inflect elements of the journeys that happen to individuals in doing so and in terms of creativity. Each is developed through empirical work. In very different ways they unravel, close-up and working from inside to outside, dimensions of how flirting with space, journeys and creativity merge in the constitution of feeling and the world, and in relation to cultural and geographical 'lay', or everyday, knowledge (Crouch 2001). Their theoretical development in each chapter is of course different but complementary.

The first of this pair of chapters advances the more phenomenological character of flirting with space through an exploration of the life and practice of one artist of the International Modern Movement during the middle decades of the twentieth century. This phenomenology marks the earlier phase of so-called 'non-representational' attention across the disciplines. Rather than focus upon the artwork in isolation the analysis concerns the everyday practice of abstraction deeply embedded in a felt and emotional awareness of flirting with space, relationally with a particular politics and memory, and its expression in the making of artwork. I stepped hesitantly into researching artwork as I wanted neither to compromise my thinking or doing my own art.

I examine ways in which one artist worked and expressed his practice through both his art and his writing and broadcasts. In the paper that Mark Toogood and I wrote in the late 1990s we were particularly concerned with the heritage of art geographies and their seeming inability to grapple with over a century of art. This concern extended to art history and much art theory that tended to dwell upon particular mechanisms of relating space or landscape, and nature to the act of representation. We sought to engage fresh understanding of the practice of art, as a cultural, social and phenomenological process. Not least this presented itself as a means to move beyond the entrapment of particular ideologies and interpretations. Moreover the approach reflects both Berger's work on ways of seeing in a more bodily and phenomenological way that engages feeling and thinking in artists' wider practices, contexts and an openness of becoming. Nature and landscape or space become reconceptualized in this complexity. The chapter concludes with an afterword of reflection on performativity in relation to the ways in which this evaluation of practice was progressed, opening forward to the chapter that follows.

The theoretical position developed through Chapter 2 is taken further and more problematically in Chapter 3. The relation between practice and performativity provides a key focus. Stepping from attention to the everyday character of flirting (with) space as felt and expressed by one artist this chapter examines these close-up through two slices of everyday life. One of these is the apparently habitual task of gardening exemplified in community gardening or allotment holding. The other is spending time in different sites and often amongst different individuals

from those with whom individuals habitually spend time, or to be alone, in travel vehicles, caravanning or mobile home touring. Combining these particulars enables a comparative interpretation to develop whilst avoiding familiar traps that make dualities out of apparent difference, there relational character thereby emerging. Whilst the conceptual emphasis is in the unpacking of performativity informed by Grosz, Deleuze and Guattari discussion also develops with phenomenology and social constructivism. In depth interviews, mixed with participant observations, provide the main wellspring of insight for this chapter. The way in which empirical evidence is unpicked and folds together, if awkwardly; kinds of continuity and disruption, feeling, identity and performativities are considered. This chapter concludes with critical reflections on the character of flirting with space, journeys and creativity that begin to emerge through this work.

Chapter 4 takes the discussion so far to advance four flows of living that themselves mingle and agitate flirting with space, as well as articulate the relational character of our spacetimes, feelings and things. It addresses these themes across everyday living. The first section opens with a discussion of W.G. Sebald's sensitive alertness to spacetime journeys in his novel Austerlitz, in an exploration of the relationalities of spactime, its awkwardness, desire and feeling of return (Sebald 2002). These reflections develop into a second section, belonging, disorientation and becoming. Different versions of identity and belonging, and their apparent tensions of disorientation and becoming are reconfigured relationally. The third ongoing section concerns the much discussed matter of intensities in the character of occurrence of becoming, working with the non-dualistic but tensional character of holding on and going further, that open out in negotiation of life. Intensities are worked through a consideration of play. The work of contexts, different sensualities and the nuanced semiotics-in-process often tied with vision are brought into critical encounter with the expressive character of living and space. The limits and possibilities of identity, feeling, emotion, belonging and the affects of nature are worked in relation to both the emergent insights from Chapter 3 in particular, and a number of other empirically-driven interpretations to unravel how these components affect and are affected in spacing. The challenge of contingent geographical and cultural knowledge emerges in the creativity of *process* of constituting lay culture and geography.

The next chapter re-engages the discussion of artwork from Chapter 2, through the developments of three and four in a close interrogation of the ideas surrounding the treatment of journeys and creativity. These are brought into play with recent interventions in art theory that address the performative vitalism of making artwork and its entanglement in different affects. The chapter works by taking art thinking outside the confines of traditional art theory and engaging in particular with social anthropology and cultural geographies, as well as aspects of performance theory. The discussion works beyond the object-character of artwork in relation to its contingent role in flirting with space; artwork and everyday living. The nuances of everyday unsettling in their flirting

engagements and their complexities and multiple demands emerge as personal, inter-subjective and open. Flirting is performative so are representations. Familiar distinctions between representation and 'non-representation' are progressed through a consideration of expressivity. What interests me here is the possibility of understanding of contemporary life-space relations through attention to creative work in narrative, photography, dance, performance and in other artistic expression. How these iterate in and through life; how can we understand artwork relationally with other feelings and expressions, rather than only representations, of cultural and geographical knowledge and the emergence of space? How do different expressions of things speak to each other; mutually inform or provoke? What does spacing in the making of artwork tell us regarding flirting with space, journeys, creativity; identity, emotion and belonging?

For over a decade landscape has been exemplary of the critical debates between representational and so-called non-representational theories. At the same time discussions concerning mobility contest the familiar emphasis upon the habitual and situated character of landscape and its role in the work of representations. Chapter 6 presents a contribution to the growing awareness of a need to try and engage these debates surrounding landscape across geographical, anthropological, cultural and art theory amongst others. It begins by considering different debates on landscape through the notion of spacing particularly in terms of how we understand artwork and representation, insistently in comparison with wider kinds of practice. Landscape is considered as the expressive-poetics of spacing in a way that makes possible a dynamic relationality between representations and practices both situated and mobile.

The book completes with a mixture of reflections across the journey of the chapters. These include critical reflection on some dominating critical debates; consideration of the notion of gentle politics and enchantment. The chapter knits together across themes of all the chapters and opens into further agendas of thinking and investigation.

Chapter 1
Flirting with Space

Space; Flirting

In a way, much academic debate has been flirting with space for some time. A post-contextual debate has opened up in cultural studies particularly through Grossberg's interventions that draws space into a relational role in the perpetual figuring and refiguring of culture, identity, power and politics that re-grounds cultural studies out of what he reasons to be a trap of dualities such as state and agency, lives and representations (Grossberg 2000, Wiley 2005). Numerous energies are rendered articulations in a one-dimensional ontology, without hierarchy or deference to particular kinds of context. All energies become multiply engaged in a popular culture and working of social practices of everyday life and their affects. Space, or place, is loosened from a heavy contextualization in pre-figured culture and put into a more complex dynamic as 'an articulation of bodies, materials, discourses and affects; a process that can occur in a wide range of scales and scopes' (Wiley 2005: 66). This generative character of space is set in relation with 'the ongoing spatial production of the *real*' (Grossberg 2000). Agency is the chaos or multiplicity in things and this offers a realignment of subjectivity and power, change and resistance.

Space is similarly a participatory and dynamic energy in Massey's geography: 'the coming together of the previously unrelated, a constellation of processes rather than a thing. This is place as open and internally multiple ... not intrinsically coherent' (Massey 2005: 141). Space is more that the contextual co-ordinates of the social, economic and political; more than the materials and their physical and metaphorical assemblage, of building material, vegetation, rock and so on. *Space* is increasingly recognized to be always contingently related in flows, energies and the liveliness of things; therefore always 'in construction', rather than fixed and certain, let alone static (Massey 2005). What space 'is' and how it occurs is crucially rendered unstable and shifting; matter and relations in process. It may be *felt* to be constant, consistent and uninterrupted, but that feeling is subjective and contingent.

The energy and vitality of space is articulated in the work of Deleuze and Guattari that has helped unravel and unwind familiar philosophies of the vitality of things; the multiplicities of influences and the way they work; and in a world of much more than the result of human construction. They offer a means to rethink the dynamics of space. Subjectivity is not erased but displaced, unsettled. Subjectivity works amongst the intensive capacity to affect and to be affected (Deleuze and Guattari 2004). Their term *spacing* introduces a fresh way of conceptualizing the

process-dynamics of the unstable relationality of space/life. Spacing occurs in the gaps of energies amongst and between things; in their commingling. Their interest thus emerges 'in the middle', the in-between (ibid.).

Space becomes highly contingent, emergent in the cracks of everyday life, affected by and affecting energies both human and beyond human limits. Any privileging of human subjectivity in relation to anything else is disrupted. Spacing has the potential, or in their language *potentiality*, to be constantly open to change; becoming, rather than settled (Deleuze and Guattari 2004, Doel 1999, Buchanan 2005). In these respects there is resonance with Massey's conceptualization of space as always in construction and relational. New encounters, however seemingly familiar, have the potential to open up new relations.

Deleuze and Guattari sought to make a distinction of emergent space in terms of an apparent duality of the energies of power in their constitution. Thus striated (institutional, capitalist) and smooth space that is a kind of freespace (Deleuze and Guattari 2004). These kinds of space suggest one way of thinking through the process of space in a way that operates in relation to what humans do, as different collectivities as well as individuals. Often their distinction appears as duality, yet: 'The two spaces in fact exist only in mixture: smooth space is constantly being translated, traversed into striated space; striated space is constantly being reversed, returned to smooth space' (Deleuze and Guattari op cit.). Neither space is sealed from the other; capitalist space is not a holistic drive. In this way enacting the relational character of space, affect and power, this commingling of the energies of spacing connects the case for better acknowledging the work of gentle politics that in a way works in the smooth space but unavoidably in relation to more institutionalized space. In a world that is multiple and relationally affective rather than hierarchical all kinds of life and things affect and are affected by space and commingle in their affects. Their multiple energies work in multiple ways with multiple affects, extending Casey's writing of the co-constitutive character of life and space (Casey 1993).

Space and place become problematic relational categories or processes between these writings. Is Deleuze's smooth space place, striated space place? The distinctions familiarly offered between space and place as ideas can get in the way of relating the multiple affects, energies and continual adjustments and relationalities of space in the wider grasp that Deleuze and others have articulated. The American geographer Tuan positions 'place' as

> the centre of meaning constructed by experience, not only through the eyes and mind but also through the more passive and direct modes of experience, which resist objectification … At one end of the spectrum, places are points in a spatial system, at the other end of the spectrum places form a nexus of strong visceral feelings … which presuppose rootedness in the locality and emotional commitment to it that are increasingly rare. (Tuan 1975: 152)

In contrast, Grossberg and Massey bring 'place' into relation with space as the human experience and feel of space but also as a contingent grasp of the flows surrounding its dynamic relationality (2000, 2005). Yet de Certeau inverts these terms and their constituent processes: '... space is a practised place ... the street geometrically defined by urban planning is transformed into a space by walkers ... i.e. place constituted by a system of signs' (de Certeau 1984: 118).

Whilst acknowledging the complexity of place Tuan presents the idea of place as profoundly 'situated' in his appeal to 'roots' and continuity, resisting its contingency in the flows of energy, affects and flows. This general fixity of place comes to mirror a notion of steady continuity of identity and feeling. In contrast Deleuze and Guattari exemplify the fluidity of things through the metaphor of rhizome rather than roots. Rhizomes grow along or just below the ground surface; ever branching and going beyond, going further, than a situated position exemplified in what a root does (Deleuze and Guattari 2004: 12 et seq).

These work as fleshy lines of energy and anastomosing ramifications that offer the loose meshing of directions and connectivity. Yet botanically rhizomes tend also to have roots situated at many different points in their lateral multi-dimensional growth. The significance of this everyday botany is that there can be multiplicity, multidirectionality in life as exemplified by a rhizome's growth, and also of some relational and partial anchoring in particular points in the 'ground': A desire to open a little to the dynamic character of living, there is another desire to feel life held together; feelings in ways that defy duality, and mix. Especially in Chapter 3 I examine the significance of this complexity in terms of Grosz's articulation of 'holding on' and 'going further' in living (Grosz 1999). In Chapter 4 the significance of the relational character of mobility, i.e. energies in multiplicity (not mobility as trains and planes), and of the variation of multi-local identities is taken up.

Reading Deleuze and Guattaari helps lift away from a human-centric grasp of the world that tended to occur in phenomenlogy, forcing our thinking towards much life that is not-human, wider materiality (things we can touch, see, feel) and other diverse energies and affects that flow in the making of space. The usefulness of this more open acknowledgement is exemplified in Deleuze's interest in the very English author Virginia Woolf. In her book *The Waves*, Woolf evokes space of a train:

> we are only bodies jogging along side by side. I exist only in the soles of my feet and in the tired muscles of my thighs ... I am like a dog slipping smoothly over some waterfall. I am not a judge. I am not called upon to give opinion. Houses and trees are all the same in the grey light. Is that a post? Is that a woman walking? Here is the station, and if the train were to cut me in two, I should come together on the further side, being one, being indivisible. (Woolf 1931, 1998: 196)

Woolf is writing in space and of space; writing space. She opens multiple vibrations in connectedness beyond her own body and unravels her self, mind/body, whole in parts, the world resonating in awkward ways, uncertainly in flows, a notion perfectly and elegantly captured and activated in her book's title *The Waves*. She narrates, in a stream of written consciousness-thought-feeling-unfeeling, the possibility of unthinking about self. In her uncertain resonance she exists relationally with and as space, life/space (hers, others'). She is jogged along as she sits in the train. It is as though she does not exist in this moment as an entity and is aware of everything in a detached manner, open only to the energies around her, beyond control and even of any reflexive sorting of the occurrence, a kind of disorientation. For Deleuze and Guattari *The Waves* exemplifies writing becoming (Deleuze and Guattari 2004: 324). Where she writes memory, he argues she writes becoming. Memory, heritage and becoming are constantly enfolded, if erratically, in our living (Crouch 2010b).

In this expression of space and energies she writes woman (Colebrook 2002: 155-157). Her writings neither express nor represent an already given female identity but of being/becoming woman, and identity as a flow of speech (Colebrook 2002: 2). This is more than the socially constructed body, gendered, ethnically framed and so on. Iris Marion Young recounts an observation of her daughter's discovering throwing a ball in a way loosened from a particular gendered frame. Whilst not *replacing* these contextual affects, other ways are discovered than how we are socially constructed, in the doing and feeling (Young 1991: 11). Contexts flicker and inflect; they do not determine.

As Woolf writes only of detachment so Thrift's writing frequently writes of the urgent necessity only of rapidity, the fleeting character and high-pressured intensity of flows, energies and affects; almost fevered connections and more so, disconnections and disorientation (Thrift 2004). Amongst other commentators this emphasis or insistence pursues a movement away from continuity and steadiness, and their associated subject-centred control and determination. Yet these urgencies deserve closer reference to complexities of living, interloping amongst other energies through which change, creativity, and the felt need to negotiate life as well as the significance of creativity amongst continuity and slowness that may be of no less power and significance, as Chapter 4 pursues. Spacing happens in a wide unlimited range of temporal and affective conditions, or situations.

Lefebvre positioned space as a number of relations between objects, combined in his triad of spaces: representation, design and the importance of the involvement of the individual, developed in his introductory approach to rhythm in the practice of space to suggest its relation from the point of view of the individual in action (Levebvre 1991/1974, 2004). His work and the enquiry of phenomenology offers ground for further critical interpretation of space and life around Deleuzian approaches, as does an alert and creative handling of social constructivism rather than their constitutive mutual exclusion. These informing threads contribute to how we may compile the everyday making of cultural and geographical practical

ontology or lay knowledge through everyday practices (Shotter 1993). Space is an encounter in which individuals are involved (Crouch 2001). The philosopher Michael Foucault 'worked with a philosophy of relation rather than object, to unravel complex relations that can be appropriated to life with a different generosity' (Raffestin 2007: 30). In the essays of this book the emphasis is on working from the dimensions of mainly human life and its complexity of energies, offering a way to rethink the relational workings of space through everyday life amongst multiple flows.

Whilst constructivist practices focus upon the psychological and cultural-political, Burkitt has developed this approach through attention to the body as sensory as well as social work (1999). Inflected in a multi-sensual process of subjectivity sight no longer holds a privileged position and, as Ann Game's sociology argues, everyday semiotics as visual sign-reading is engaged within a wider practice and process of material semiotics, or embodied semiotics (Game 1991, Crouch 2001). Despite its perceptual sophistication, the eye alone cannot necessarily go beyond a description of surface: '... sight says too many things at the same time. Being does not see itself. Perhaps it listens to itself' (Bachelard 1994: 215).

> The thinking-perceiving body moves out to its outer most edge where it meets another body (materiality, force, energy) and draws it into an interaction into the course of which it locks onto that body's affects (capacities for acting and being acted upon) and translates them into a form that is functional for it (qualities it can recall). A set of affects, a portion of the object's essential dynamism, is drawn in, transferred into the substance of the thinking-perceiving body. From there it enters new circuits of causality. (Massumi 1993: 36)

This offers a kind of working of meaning. Taussig writes that the eye makes its feeling way around space, profoundly tactile in its commingling of the senses (1992). Sight is felt, but in a mingling of senses, feeling and thought. Carrie Noland observes that gesture 'cannot be reduced to a purely semiotic (meaning–making) activity but realizes instead – both temporally and spatially – a cathexis deprived of semantic content ... gesture can ... simultaneously convey an energy charge' (Ness and Noland 2008: xiv). For Casey, meaning is framed in a kind of expectation (Casey 2005); and place is best understood as experimental living within a changing culture (Casey 1993).

Phenomenology from Merleau-Ponty sought to articulate the liveliness of living, and of space in interaction. 'Merleau-Ponty was attempting to produce a more robustly intuitive account of knowledge, one not predicated on the prior existence of the subject, but rather productive of it' (Thrift 2007: 54). In his earlier attention to a phenomenological notion of 'dwelling', social anthropologist Tim Ingold articulated a continuity of practice (Ingold 2000). More recently he has sought to amend, or update dwelling with 'inhabitation', but only as a footnote (Ingold 2008). In his other more recent work, on creativity and on lines, the

direction of his thinking is clearer. Far from understanding dwelling as continuity, his work points to the everyday potential actuality of 'the new', the emergent (Hallam and Ingold 2007). He uses the notion of lines to express his thinking; they are made non-linear in human living as they circle, scan and trace, and thus speak of performance and uncertainty, discontinuity, breaks and reformulation (2007).

Familiar attention focuses upon the idea of city and other similar aggregates and abstractions of life. Instead, Grosz fills out how this notion of space can be applied. 'By "city" I understand a complex and interactive network that links together, often in an unintegrated and ad hoc way, a number of disparate social activities, processes, relations, with a number of architectural, geographical, civic and public relations' (Grosz 1995: 105). Individuals do not live in a 'city' or 'country' but in groups of friends, families, looser and stronger networks, gardens; pubs and clubs, sport field and shopping malls, beaches where they meet and enjoy time, group leisure venues and workspaces; briefer moments in transit, relationally with other-than human things, emotions, dreams and fears. Space is fleshy, lived.

In terms of our engagement with the material and metaphorical world we inhabit, this kind of embedded-fragmented perspective emphasizes process and encounters and offers a way of reasoning individuals' participation in and of space. 'Spacing' is the potentiality of unsettling and possibly momentary re-settling of things, feelings and thoughts in the eruption of energies and in the vitality of energy and the interstices between things. It is in the liveliness that creativity emerges. Their notion of spacing opens up ways for further thinking and ideas through which to explain process, the way things happen in flirting 'with' space in a way that we can net energies of phenomenology and social constructivism. 'Spacing' emphasizes capacity and energies for change; abrupt or steady, mingling and diverging, non linear; part accumulating and non-accumulative, discontinuous and held on to, uncertain; the unexpected and unbidden (Crouch 2003a).

The energetic potential, or the potential of multiple energies around, in and of us is gathered in Deleuze and Guattari in their particular application of the notion of 'becoming': moments and occurrences of change, as explicated in Chapter 3 of this volume in relation to their notion of performativity as hybrid of performance. By engaging human activity in a wider world they expanded the complexity, multiplicity and possibility not only of things and [their] vitality, including humans, but also the ways in which we might address, consider and enfold things. With them we can, rather than forget phenomenology, take the becoming of phenomenology further.

Deleuze and Guattari articulated the potential that things have, and the ways in which things that we do may energize anew the world around us. They write of the blacksmith, working matter 'not a question of imposing a form upon matter but of elaborating an increasingly rich and consistent material, the better to tap increasingly intense forces' (2004, op cit. 363). As De Landa expands,

the blacksmith treats metals as active materials, pregnant with morphogenic capabilities, and his role is that of teasing a form out of them, through a series of processes (heating, annealing, quenching, hammering) the emergence of a form, a form in which the materials have their say. (De Landa 1999: 34)

Space is partly constituent of materiality, relationally. Space is not the distances between and amongst, or the outline of things. Objects and movements and mutual interactions include these elements in spacing. Soil and roots in the garden, cans in the street, stuff in our homes, sand on the beach, bollards by the supermarket become involved in spacing and become very sensual, emotive and experiential components of living. These reveal cogent reminders that human beings still desire encounters with what is felt to be real, as we speak, in an experience that is increasingly pre-occupied, in the writing at least, with virtual objects, representations and simulacra (Baudrillard 1988).

Elements of a contingent lay cultural and geography emerge, through a practical ontology of feeling, doing and thinking. It is emergent in spacing, a process that is kinaesthetically sensual, intersubjective and also extra-human in affective constitution, expressive and poetic. Creativity is informed through combinations of different times and life durations and rhythms, different registers and intensities of experience. Each of these is constitutive of life journeys: potentially creative, contingent, awkward and not blocked in representation. From this reflection on spacing, whilst 'place' may continue in popular exchange, it seems superfluous in the face of the interpretive power of 'spacing'. The term *place* may have significant fluid connotations, but it is also archetypal in for example popular tourism literature: the synagogue or temple to be visited, the 'vibrant city', 'vibrant city'. These 'places' offer new fixity. It is difficult to relate place to process conceptually. The *process* of constituting the knowledges is creative and is examined empirically and conceptually through the chapters of this book.

Thus space is in the action and vitality of living; in the co-ordinates of social, economic, cultural and physical influences as Massey has familiarly argued; but also, in this melee, the myriad and multiple energies of things and life, and between those things. As human beings we participate in that action. In an apparent need or desire to a feeling that we need to 'know', to momentarily settle things and our positions in the world, we imagine or feel moments of things that seem identifiable and so hold a grasp of what we call space, as momentarily objectified, given meaning in an objectifying/subjective way.

For me, *spacing* offers a new provocation to thinking, alert to more possibilities of the way things work and may happen, and their multiple (dis)connections. What they do not do is offer how flesh may be put onto, or rather inside, what may happen and how. Phenomenology offers ways of fleshing out life, and I soon engage this thinking in relation to spacing. *Deleuzian thinking* resists phenomenology because of its general omission of discussion of the way the world and its fragments of things interrupt and disrupt human subjectivity. Yet the kind of thinking that is engaged in phenomenology seems necessary in moving life beyond a series of

contact points and energies. John Law argued a similar frustration with Latour's actor network theory for its emphasis upon the lines of the network rather than, to paraphrase Law, the stuff, or flesh, of things and feelings (Law 2004). Perhaps ironically Tim Ingold's recent discussion on lines, that can sound too clinical and linear, offers a more 'fleshy' insight (Ingold 2007).

Spacing happens in and through moments of different intensities; unevenness, disarticulation and re-articulation in things happen in these moments. If we follow this notion of spacing, it becomes possible to address the emergence and character of significant feeling and thinking, meaning in relation to space as it emerges imagined. Later in this book I consider notions of identity, relationships, disorientation, belonging and meaning in relation to spacing. Space as intimate yet vital, that can be held closely and deeply valued in valuing life. Again, rather than needing a separate idea of place to describe this process, space bears, engages, is engaged in and emerges in, the traces and affects of human feeling and its widest interactions.

As people we get used to giving things representations, a sketch, a spoken description and so on, in ways that seem to render our relationship with them. Sometimes this giving of representations may appropriate what they are, and what they do, in particular, incomplete and even partial ways. Those ways may respond to value judgements rather than speak for 'the real' in those things we try to pin down. Representation may thus tend towards a duality, a marked difference and rendering of what *is*. Instead representation becomes, perhaps, our version of what is. Grossberg addresses attention to the difficulty in cultural theory in the way that representations are presented in a duality with cultural/social practice. The relationship between representations of, for example, space and socially/culturally lived or practised space is pertinent for our thought. Whilst this may offer a duality of context and lived experience, these pairs are not separate but constituted in merging flows of living, both become commingling multiple contexts, emerge and merge in many different ways and not through clear difference. I seek to unravel the representation-non-representation dilemma through attending to the flows amongst each and amongst them as they become considered as one multiple and fracturing complexity.

Journeys

I have suggested a character of flirting in terms of energies of and between things, and the apparent human need to hold on to some value or meaning of space. Lives, energies in the widest sense, and time are however not fixed. We flirt (with) space in journeys of our lives, in varying trajectories of time and in the movement or vitality of things; our feeling and intensity. Journeys are coloured by their commingling relationality with space and vice versa. Space and journeys commingle as felt, imagined and projected. Journeying in this sense is material and metaphorical; journeys are in the liveliness of energies.

Journeys happen in various trajectories of spacetime and its feeling. Some commentators search for the incessant potential of newness, its speed of occurrence and through the importance of the non-human, so to speak. An incessant possibility for change exemplified in political change, even a 'new politics' of 'affect' (Thrift 2004, 2008). Another strand of this hyper-thinking is in mobilities that have recently emerged arguably as a focal point for our contemporary world (Urry 2007). Changes and different realizations in life happen also slowly, arguably with no less possibility for affect. Things happen in low intensity and calmly, even in apparent stillness, that is not to be confused with emptiness (Cocker 2009).

An acknowledgement and inclusion of the complexity of space does not move away from an interest in the vital character of a dynamics of change. The wider existence of energy is full of possibility and liveliness, ever emergent rather than restrained and closed, Deleuze and Guattari acknowledged that in the potential power in striated space much possibility may be closed off (2004). However there may be further reasons, in living, that close off, delay, defer or frustrate possibilities and potentialities. Potential and pace may be affected by the mix of social circumstances and cultural capital. A possibility of variable space and pace opens up a number of threads relating to journeys. Some of these are more redolent with change, others familiarly associated with relative steadiness, and frequently these registers merge, relate over time.

Journeys can be felt to have long gestation but also instantaneous presence; to happen in tensions and adjustment in life. Life is, to say the obvious, complex. It has many different journeys simultaneously. These happen in slowness and acceleration, in the enfolding of different moments and times. My attention is drawn to understanding how these events happen, may become significant, changing or refiguring significances that are felt about things, relations, spaces of life and in relation with a wider, more popular abstract character that we express in terms such as global adjustments, mediated popular culture, broader politics.

Moreover change articulates with continuity, as nets of forces both complex and vital, rather than in nests of fixity and mobility. Whilst keeping an alert interest in the human in the wider world, and whilst subjectivity is relational it seems pertinent to enquire regarding the dynamics that seem to mark pieces of life with significance. It is possible here briefly to suggest something of the vital character that the human contributes to this process. The expressions of journeys happen in uttered feelings, words of shared stories, touch and the character of body-movement; laughter and tears, in ways as different as painting and patterning the ground in everyday living materially and metaphorically: dynamic, human and emotional processes.

'Becoming' is explicitly related to the countless possibilities of things, of life, emerging or erupting from what Deleuze and Guattari called an 'immanent surface' of energy. Our pasts, as half-held memories and presents and futures of desire merge:

> The past would never be constituted if it did not coexist with the present whose past it is. The past and the present do not denote two successive moments but two elements which co-exist. One is the present, which does not cease to pass, and the other is past, which does not cease to be but through which all presents pass. (Deleuze 1991: 59)

Thus the aspect of Grosz' argument of individuals negotiating their lives, maybe too their identities, is pertinent: she talks in terms of life operating in the tensions and tugs of 'holding on' and 'going further', which process is examined and unravelled in detail in Chapter 2. These flows are not in crude opposition but multiply emergent and relational. It would seem that we bear traces and desires, at least, of continuity amidst forces, willed, outwardly influenced and also unaware that hang with us and with and within which we become. We may find our journeys irksome or in longing. Alongside and flowing awkwardly amongst these forces we sustain a desire for difference, adventure, things new. This multiple 'tug' is germane of the journeys of living and the fleshy ways in which our spaces emerge and flow. Amidst life's journeys and journeying becoming happens.

The dynamic of becoming happens in movements, in vital energies between different forms of intensity and extensivity, low level and hyper-intensity (De Landa 2005). Different kinds of energy-intensity amongst moments of our encounters with the world contain the potential of different kinds of significance in how we feel, returning to familiar traits and opening to new ones. The space tracked may summarily disappear un-noted but that rootedness may however return in the cracks; and can emerge as powerful and significant: journeys grasp together and mix feelings, memory and the character of practice and performance. Although journeys can be delimited and trapped, this entrapment is only partial and temporal. Time becomes revised and revisited and moulded as our lives journey. The affects this vitality and complexity of time has profoundly influences, and is influenced by the dynamic character of spacing.

Bergson disparaged the importance of space in living due to what he saw as its only-representational, Euclidian – objective character as then thought only in terms of abstract space, not lived space or spacing, Deleuze's reworking of Bergson shifts the emphasis to space through his assertion of its power in terms of spacing. Thus space is also other than merely representational; it shifts and changes with the vitality of life, opens into reassessment, cracking time into relational pockets of significance and so on. Time is mobility in its qualitative multiplicity of open possibility. The idea that life has its 'own' if more broadly entangled assemblage of flows and mutli-connections complicates further the notion of the reclaiming and remarking of territories, as objectified lands but also as vibrant surfaces of influence iteratively upon our lives in an assemblage of flows of vitality. Deleuze and Guattari called these processes territorialization, de-territorialization and re-territorialization in acknowledging the shifting sands of the groundspace interactions, through which nomadic (smooth) and mechanic

(striated, institutionalized) lifespace is shifted between peoples, institutions and others (Deleuze and Guattari 2004, Buchanan and Lambert 2005).

Flirting opens to energies, Deleuze's immanent surface of infinite possibility. Amidst this complexity we flirt with space and with time, or its commingled character as spacetime amidst the dynamic of flirting spacetime changes: the unexpected in the familiar; the significance, rather than superficiality of both mundane and brief moments en route somewhere else, in ourselves and our relational lives. This notion is at the core of my handling of journeys. Ingold suggests something similar when he writes comparing wandering with ideas:

> Each time you revisit the (space) it is a little different, enriched by the memories and experience of your previous visit. Leading others along the same pathways, you may share the idea with them, though again, as each brings along the peculiarities of their own experience, it will not be quite the same for one individual as anyone else. (Ingold 2007: 9)

In journeys we can feel as disoriented, detached, or semi-attached to our own self, in the limits of subjectivity. In the way that Woolf wrote of herself, as limbs, movements and disconnections whether technological, human or otherwise, she acknowledged two things. Almost with total objectivity she dis-assembled things and movements, including her own, in a non-relation with herself. She made nonetheless a subjective observation from herself.

In his work on lines Ingold recently has gone closer to unravel the complexity of journeys in life that he discusses through the idea of wandering: a wandering mind as much as wandering feet; often the two coming together (2007). The space tracked may summarily disappear un-noted that may however return; but can emerge as powerful and significant. His lines meander; fold back, strike a different direction. They may cross geometrical space but not necessarily so. Crucially, journeys have varying thickness and fleshiness; often meandering and uncertain, however habitually tracked. Journeys grasp together and mix feelings, memory and the character of practice and performance. These might better be expressed as smudges, smears and partial erasure than the implicit and difficult to avoid draughts–personship of lines.

Journeys happen in durations. Duration for Bergson is continuity of progress and heterogeneity. Memory holds on to the past but the memory shifts. New experiences and feelings impact, rather than are merely added sequentially at the same register, upon the past. Memory refigures in and through journeys taken and found. Even the apparently only-habitual in life impacts, changes the character of what was done in the same habitual practice the previous time (Bergson 1911, 1999). Time is relational. Bachelard (Hodges 2008), powerfully fleshing out his notion of time in and as space he felt that instants of time became 'fleshed out and filled in later' (Bachelard 1994). Whilst identifying therein a thread of continuity he acknowledged too the complexity of heterogeneity, shuffling, refiguring too: time is diverse, vibrant and full of energy. Time becomes revised and revisited and

moulded as our lives journey. The affects this vitality and complexity of time has profound influences, and is influenced by the dynamic character of spacing.

Journeys are more than individual and private; they are inter-subjective in absence and presence. They occur in and amongst instants and moments but act relationally with time. Our pasts are mutually eloped, unevenly and awkwardly enfolded in this mass of convolutions, challenged and affirmed. Moments in journeys are not isolated, but prompt and are prompted by other loops and re-loops, temporary suspensions, threads of that commingling of space and time as spacetime of life. Memory is not simply 'placed' in time in a linear 'order-ing' of being but tumbles amongst others, or exists in a net with others, open to being re-grasped anew in other moments. Memory can be reasserted by its action. Contexts otherwise, institutional prefigured repertoire can inflect, affirm or flow by. In and out of these flows are inflected feelings across a range of being, dwelling and becoming. In journeys our feelings about ourselves and our relationships in the world are negotiated but also happen to us. Identity, belonging and creativity emerge in this complexity.

Creativity

Creativity appeals because it is vital. Through these chapters I examine ideas of the dynamics of creativity that embed it in everyday living; in things people do, how they get by, feel a sense of wonder and significance, and make or find becoming in their lives, personally and inter-subjectively. Creativity in everyday life is a dynamic through which people live. A particular consideration in this chapter is the expressive character of creativity in everyday life; expression in materiality and in friendship, thinking and feeling. Throughout this discussion creativity is considered through the relational character of individuals and space. Creativity is performative, 'the imaginative creation of a human world' (Shieffelin 1998: 205).

Creativity is familiarly cast in three forms. First in relation to the work of institutions and particularly the commercial sector, for example in relation to the notion of the 'creative city' and cities of culture. In their wide-ranging discussion of economies of signs and space Lash and Urry discuss possible ways in which 'the aesthetic reflexivity of subjects in the consumption of travel and the objects of cultural industries *create* a vast *real economy*' (Lash and Urry 1994: 59, my emphasis): art galleries, bars, taxi drivers and brokers acting in the flows of diverse cultural producers and mediators. They draw upon Sharon Zukin's book *The Culture of Cities* (Zukin 1995). Yet this 'real economy' and its real creativity conceals lived complexity and its affects on cultural economy. The different components, spaces and events used are combined through the performative encounters and practices that the individual, temporarily as consumer or traveller, makes. Through their performances individuals work, select significance amongst a complexity of things, feelings, relations and actions, and affect the vibrancy or vitalism of the city or anywhere as creative. The result may be a cacophony or

patina, part-negotiated; different semiotic and practised spaces given and giving embodied significance. The 'real economy' is worked through and mediated into individuals' own multiple relation with these other resources of economy. Prevailing discussions of cultural economies and complexities, as well as more recently of connectivities has tended to underplay these more human components of contemporary cultural and geographical worlds.

Sara Cohen's anthropological work (2007) shows the limitations of considering creativities only amongst institutional and business efforts to claim the cultural arena of Liverpool, City of (European) Culture, finding a wealth of creative pursuits among local music groups and individuals across the city. She contends that opportunities for creativity might depend more on freedom, openness and a lack of institutionalisation outside the policy-framed 'Allocated Core', the so-called 'Creative Quarter'. Anthropologist Ruth Finnegan found similar liveliness of creativity in Milton Keynes (1989).

Creativity is a culturally loaded term that is familiarly elided with the arts, invention, and increasingly, technology. In thinking of human life I explore the possibilities of more everyday human engagement in a complex world in terms of capacities, situations and processes of creativity. Art certainly exemplifies some of the character of creativity. Considerations of artwork as creativity have tended to concentrate upon the object, the performance, the painting, the musical score and music as performative. Yet the creative process, that I argue is universal, happens to the artist in a complex and nuanced process of living (Crouch and Toogood 1999). Hence I am interested in reflecting, in Chapter 2, upon the character of process or performance in the longer process of living through which an artwork emerges.

Thinking on creativity is also focused upon the creative process, of academics themselves, of technologists and their work in industry. For instance, Nigel Thrift emphasizes the exercise of creativity in highly self-conscious cultural economies, pointing to how the design of rooms in high-intensity technology centres encourages a 'creative sociability' in a mixture of cafes, informal meeting rooms and labs (Thrift 2008: 44-45). Yet this creative sociability is rarely explored in less staged, 'everyday' worlds.

In their recent critical discussion on creativity Hallam and Ingold develop the notion of relationality in living, through people's lives, but also in a way more broadly connected:

> creativity is a process that living beings undergo as they make their ways through the world ... this process is going on, all the time, in the circulation and fluxes of the materials that surround us and indeed of which we are made – of the earth we stand on, the water that allows it to bear fruit, the air we breathe. (Hallam and Ingold 2007: 2)

Creativity emerges in cultural improvization (Hallam and Ingold 2007: 10). This process of creativity is different from the familiar way of thinking of it

as innovational. It also contrasts with the notion that what people do in life is organized through a fixed plane of routine procedures. Two further distinctions emerge in this thinking. First, the habitual and routine necessitate adjustment and response as the world, the way we feel or the particular moment of using materials are never the same. Second, the vitalism of things affects the possibility and character of creativity that may emerge.

A more energetic reading of creativity arises from the earlier discussion on becoming interpreted through Deleuze and Grosz. Bergson's thesis on creative evolution renders the occurrence of performativity as breaks that mark significant change. Yet as discussed above with regard to journeys, flows of performativity can be less acute, slow, gradual and cumulative. Thus drawing from both Ingold and Deleuzian argument, creativity can be considered as varying in pace as journeys, and with similar diversity of the trajectory of its significance. Becoming is marked by efforts to negotiate life and its complexity. However these ways of thinking of creativity collide with the emphasis given to technologies and their researchers discussed elsewhere (Thrift 2008). These are also kinds of creativity.

Creativity can happen unexpectedly in the ordinary and mundane because each of these is open to accident, variety, disruption and change. Efforts can be made to sustain precision in practice but those efforts can only partially control. We negotiate in ways that resonate both with Hallam and Ingold's notion of creativity as everyday improvisation and the more insistent and dramatic notion of performance. Life becomes negotiated between the dragging desire of holding on and an awkward, perhaps impatient desire to go further or elsewhere and to do differently. Flirting with space we construct, handle, make sense of, cope with, respond to as we try and anticipate amidst a complex collision of influences, unbidden occurrences and desires. Our way in life is 'continually altered and responds to the performance of others' (Hallam and Ingold 2007). Unexpected gaps, ruptures and hybrids occur in the immediacy of performance and enfold individuals and groups in moments of excess; taking them beyond the present time and gathering them up in the excess of life, an experience which, for many, may seem profoundly emotional moments of chance or failure. As Goffman notes, however, space is vital as that which frames and advises performance, providing performer and audience with the expressive tools they require in order to interpret display in the way that it is intended (Goffman 1959, 1990). Creativity can offer meaning to feelings and depth, and reassure or unsettle subjectivity.

Creativity is and emerges in a network of activities and events in sensuous cultural life. Recent debate in cultural studies, demonstrated in the work of Grossberg discussed earlier (Wiley 2005), and in social anthropology by Miller on the dynamic, examines the creative character of consumption. Consuming can be a vital site or flow of creativity. (Miller 1998) The 'consumer' of culture creates culture in multiple and commingled energies and entanglements. The cultural and social power and politics of culture and its participation in and as creativity becomes produced through the acts of individuals as much as by any institutional forces. Thus, human lives are an important and so often overlooked and misunderstood

component of so-called 'new economies' (Crouch 2006). Rather, as Lee and others have reasoned, cultural economies are significantly built through mutual regard and care, a gentle politics (Lee 2000).

Creativity is also generative. That is, creativity is produced phenomenologically through the practice of doing (Hallam and Ingold 2007: 1). It is also temporal, not collapsed into an instant or series of instants but embodies duration, multiply enfolding and unfolding. Thus in the emergent and multiple character of duration in the more fleshy form of journeys creativity emerges. Creativity is also at the core of recent developments in becoming, in complex duration rather than moment-character of journeys, of holding on and going further. Of course the force of these ideas of becoming emphasizes the significance of intensities in and of performative experience and its greater openness to immanence of possibility beyond and in which humans are entangled, and a particular insistence on time as duration.

Embroiled in the idea of the 'event', eruptions of creativity mark life, call into existence something that the situation did not previously allow. In the immanence of possibility creativity happens; space comes upon in ourselves and in the material and metaphorical character of the earth and life. Hallam and Ingold insist that creativity is not merely synonymous with novelty. Creativity goes way beyond the contemporary excitement of creativity being privileged in highly self-conscious instituted cultural economies and its global commodified marketplace, and in technology laboratories.

There remains a difficulty with the notion of becoming as bearing limitless and effusive energy, styled as contagion, and possibility without limit; to be anything. My emphasis is in the possible in things that happen and are happening. I try to engage more modest things, events, and beginning to suggest threads that such instances pick up. It is in this gathered sense that things creatively matter in individuals' lives, too, though not easily acknowledged. Creativity can erupt in thinking and feeling; and can affect thinking and feeling through life journeys. Making sense of creativity in journeys of flirting with space can make more accessible the colour of thinking and feeling. I consider examples of artwork and mundane life; merging and overlapping processes.

Although Ingold's earlier work on dwelling is often critiqued as almost pre-modern in its Heideggerian connections with supposedly conservative notions of continuity and particular territory of practice, several similarities in the ground of his work and that of Deleuzian thinking have been noted. Moreover they share an insistence of processual becoming, if Ingold does position this in the *continuity* of everyday living. Yet continuity does not mean sameness but abundance. Hallam and Ingold point to the possibility of change, adjustment, recovery, and argues that 'there is no script for social and cultural life ... people ... improvise' (2007: 1). They draw out the generative rather than repetitive character of creativity, relational rather than of novelty. Creativity must be conceptualized in a world that is never the same from one moment to the other. It can emerge through the persistently creative performance of tradition, and 'can be truly liberating' (ibid. 3).

There is definitely a difference of emphasis in the ways in which creativity emerges through Hallam and Ingold's and Deleuze's thinking. Yet without pretending to conflate more phenomenological constructivist and Deleuzian perspectives, there are more than marginal similarities in their work. Re-interpretations of Deleuze have emphasized a concern for the potential of continual change and immanent possibilities in life.

> (C)reativity is a process that living beings undergo as they make their ways through the world ... this process is going on, all the time, in the circulation and fluxes of the materials that surround us and indeed of which we are made – of the earth we stand on, the water that allows it to bear fruit, the air we breathe, and so on. (Hallam and Ingold 2007: 11)

Creativity is emotional. In a sensitive discussion of dance therapy McCormack points to Massumi on the potential of thinking emotion and sensation relationally:

> a subjective content, the socio-linguistic fixing of the quality of an experience which is from that point onward defined as personal. Emotion is qualified intensity, the conventional, consensual point of insertion into semantically and semiotically formed progressions, into narrativisable action-reaction circuits, into function and meaning. It is intensity owned and recognized. (Massumi 2002a: 28, MacCormack 2003: 495)

Moreover:

> (T)he thinking-perceiving body moves out to its outermost edge where it meets another body [force, energy] and draws it into an interaction into the course of which it locks onto the body's surface [capacities for acting and being acted upon] and translates them into a form that is functional for it [qualities it can recall]. A set of affects, a portion of the object's essential dynamism is drawn in, transferred into the substance of the thinking-perceiving body. From there it enters new circuits of causality. (Massumi 1993: 36)

The following chapters unravel aspects of these energies, emotions, and meaning through flirting (with) space.

Chapter 2

Everyday Abstraction: Geographical Knowledge in the Art of Peter Lanyon[1]

Foreword

This chapter revolves around and seeks to get inside the doing, feeling, and thinking of English artist Peter Lanyon in the mid-twentieth century. Lanyon lived in the area that affected his artwork and was a member of the International Modern Movement. His work has experienced a considerably greater interest in recent years. The combination of local and international is evident in his work. He had a life embedded locally and working with great tensions and vitalism powerfully agitated in wider flows. I came across Lanyon's work serendipitously in a London Gallery in Camden. His work spoke to me in ways that connected with the direction I had come to in my own painting and resonated my thinking through ideas that came to be expressed in flirting with space, in terms of everyday life and the feeling of space.

The earlier stages of Lanyon's work were heavily geared in terms of identity, longing and belonging, notably through a period wrenched away from his familiar locality at wartime. He discovered new practices for artwork during that time, influenced by his working with simple materials in recycling, emerging into constructions experimenting with notions of space. His developing phases included a strong construction of canvas works of stark contrasts of human affects on the land. A strongly phenomenological phase followed. His constructions, working from his wartime job in the airforce, are either works in their own right or become informing of large painted expressions. Throughout his work there was a tension both phenomenological and in terms of belonging and disorientation. He seemed to flirt with space in his journeys of creativity.

In researching these kinds of practice we embedded ourselves in his art, in the locations that affected them in moments of 'fusion', and in conversations with his surviving family and artists currently working aware of his influences. These methods were combined with attention to his writings and broadcasts that he felt imperative in making his voice, challenging ideologies of art. Gillian Rose has cautioned against the use of artists' autobiographic writing of our work. I contest this as, although a case can be made against the positioning of an artist

1 First published in *Ecumene* (now called *Cultural Geographies*) 6(1) in 1999 as 'Everyday Abstraction in the Art of Peter Lanyon' by David Crouch and Mark Toogood. This version contains a new Foreword and Afterword by David Crouch.

in their work, I find no reason to feel this is the case with one group of subjective individuals than any other we may engage in depth, in ethnographic manner, in our work (Rose 2001). I suggest, instead, that it is a matter of broadening the source materials, allowing our own critical judgement to work out a narrative in a way that acknowledges the individual.

Journeys in Abstraction: An Introduction

Drawing on the painting, constructions and writing of the British artist Peter Lanyon, we explore how geographical knowledge is represented in modern abstract art. Lanyon had a deeply felt sense of Cornish identity and attachment to the history, people and place of West Cornwall. He also adopted particular practices – such as gliding – in which he experimented with bodily position and experience. We examine how these practices and cultural identity flowed together, constituting a kind of knowledge which was transposed into his art, the making of which was also an integral part of this dynamic process. We conclude that Lanyon's perspective departs from the surveying gaze of traditional landscape representation, and also from the autonomous aesthetic common to abstract expressionists. Lanyon's historical and cultural conception of landscape, as well as his spatial practices, suggest an awareness of landscape as socially defined. So, in a wider sense, we regard Lanyon's geographical knowledge as a distinctive exploration of the relationship between individual, society and space.

Abstract art provides a challenge for geographers. Part of this challenge comes from trying to understand the iconography of abstraction when abstractionism has been cast as art that is primarily concerned with form over subject-matter, so that, by and large, iconography is absent. The iconic detail of art and the relation of such iconography to the conditions of production of specific works, through culture, gender, race, for example, has been a major mode of analysis in the study of art. But abstract art, apparently lacking this iconicity, therefore lacks any readily identifiable connection between the work and the world it inhabits. In addition, there has been a literal expectation in geographical interpretation of painting as containing an explicit topography constituted through surveillance, perspective and detachment. The lack of iconic content which the social art historian, or cultural geographer, can analyse in terms of social context means there has been relatively little discussion of the geographical practices involved in the production of abstract art. This chapter argues that representation in abstract art should not be elided with representation based on mimetic depiction of the world. Through focusing on the cultural practices in the art work, methods and identity of Peter Lanyon (1918-1964), we relate how abstract art can function as representation: as knowledge of the world; as being like the world in an abstract way – as being more like the 'poetic geography' of the everyday as referred to by Michel de Certeau (1984, Batchelor 1991). As long as representation is not viewed as dependent of depiction, then abstraction can be seen as having a representational status.

Study of painting by geographers has hitherto concentrated primarily upon the work of landscape artists, especially British landscape and Renaissance artists (Daniels 1993, Cosgrove and Daniels 1989). Important interpretations of Constable, for example, have been typical of a genre of geographical work, approaching the artist in terms of wider practices of representation linked to power relations. This literature cogently explores the representation of the social and the political in pre-modernist painting, and the historical context in which it was produced (Berger 1972, Daniels 1989). However, there is little attention paid to the actual geographical – i.e. located cultural, sensory and intellectual – knowledge of the painter in relation to how art gets made. Some writers, however, have drawn attention to art as spatial practice: as practice unconfined to a special domain distinct from other ways of knowing the world, transgressing the orthodox claim of art practice to be inherently special (Bonnet 1992, Crouch and Matless 1996, Matless and Reville 1996, Pinder 1996, Gandy 1997). Art as a spatial practice also suggests bodily situated cultural practices, and we seek to engage with this in the case of Lanyon's art. Indeed, we argue, an emphasis on vision has prevailed in geographies of painting and inhibited the exploration of other dimensions of spatial practice in art (Jay 1993).

We particularly want to discuss the practices and social context that inflect Lanyon's art. That is to say we are interested in his art as social, spatial narrative. We suggest that practices and context constitute a geographical knowledge represented in his art, from different levels of relation to the land as well as his strong self-identification as Cornish.

This knowledge was partly constituted by his self-awareness of his conceptual position in relation to other artistic knowledge. This was cast as representation of the world through a culturally specific subjectivity which marks out Lanyon's abstraction and which may be contrasted with the intellectual abolition of the social in other forms of abstractionism. His work engaged certain ambiguities, particularly in the representation of culture and geography, notably of Penwith in the westernmost part of Cornwall, where he was born and lived most of his adult life. Lanyon's self-identity contains ambivalences. On the one hand there is a degree of essentialism in his assertion of Cornishness – seeing his art as including experiences of recording and resisting the postwar material exploitation and cultural appropriation of Cornwall. On the other hand, his work undermined fixed and stable essences about place, and he consciously engaged in different and shifting self-positionings in different places, times and speeds – different performances of place, perhaps.

We shall draw upon examples of Lanyon's work, and his wealth of writing contemporary with his paintings and constructions, to examine a nodal point in the elusive representation of geography in abstractionism and the boundary between 'representation' and art as 'cultural practice', without seeking to proscribe either of these. It is through this simultaneous investigation of writing and painting that we can explore an abstractionism which pulled away from the historically specific artistic construction of landscape as scenery, and from perceptual sensation which

was primarily linked to aesthetic appropriation. We justify drawing on his writing alongside his painting as the only existing transposition of Lanyon's spatial practices. These elements also position Lanyon's abstract art/geography in 1950s Cornwall as a process that encompassed situated knowledge, art theory, Cornish identity, landscape and the making of art.

Lanyon's art forms a distinctive cultural understanding of place which incorporated the politics of Cornish culture, work and dissension; about everyday knowledge of what was around him; and of mythic meanings of land and sea. A distinguishing feature of Lanyon as an abstract artist was his difference from many abstractionists who sought a Zen-like art free of precondition. To Lanyon, his art represented his knowing, and just as importantly what couldn't be 'known', of his world. His art can be thought of as a transposition of reflexive experiences of Penwith – and he used driving, walking and gliding to affect that experience. His geographical knowledge was not constructed through separated meditation but through everyday immersion in place and through bodily and intellectual exploration of that experience. Lanyon never saw himself as an abstract painter: he abstracted feelings and other knowledge of place into paintings. This is the reworking of landscape; for him, 'abstract' was a verb, not a noun: 'I make use of abstraction as a working method' (Lanyon, A. 1993a).

Further, Lanyon's bodily informed art stands outside two kinds of disciplinary discourse. First, by immersing himself within his art as an ongoing spatial process, he erodes the assumption of traditional landscape art that the artist observer might possess any given landscape by survey and mimetic representation. Second, his work breaks with the habitual placing of Cornwall in official and mainstream British culture as a romantic place on the socioeconomic margins. Lanyon's art strikingly lacks the fissure of distance made by standard narratives of Cornwall and by the distanciation of 'visual' knowledge. His art does not layout Cornish culture and landscape as 'mapped' objects, but produces 'tactile' knowledge, opening up an unforgetting of corporeal presence and cultural identity – something like that which de Certeau has called 'poetic geography on top of a geography of literal, forbidden or permitted meaning' (de Certeau 1984: 105).

Lanyon's Geographical Knowledge

West Cornwall is characterized historically by fishing, tin miming, small farms, failing industrialism and emigration. The area has attracted artists since the early nineteenth century. J.M.W. Turner journeyed through Cornwall in 1811, making sketches later published in Picturesque views of the southern coast of England. A full rail service from London to Penzance started in 1876, and a branch line to St Ives opened two years later. About the same time, a new wave of European artistic activity was inspired by the social naturalism of the artist colonies at Barbizon and Port-Aven in Brittany. These preceded the development of several artists' colonies in Britain including, from the 1880s, one in Penwith, based in Newlyn, St Ives

and Lamorna and known as the Newlyn School. As a youth Lanyon took painting lessons from a older local member of the Newlyn School, Borlase Smart.

Tourism in Cornwall has long been promoted through selling Cornish difference. In the second half of this century, the creation of romantic and mythic difference has become part of Cornwall's symbolic repertoire of the tourist consumption of place: Cornwall is remote, foreign, full of legend; the Cornish are figured as distinctive others: romantic sons and daughters of the sea, full of Celtic dialect. A 1949 Batsford guide recycles an image of the Cornish as a polyglot and unreliable race, of swarthy 'Spanish' skin, black hair and mysteriously named; childlike, yet quick to anger' (Manning-Saunders 1949). Cornish self-identity has also been marked by cultural revivalism, particularly of the Cornish language and Celticism, by a discourse of resistance to 'development' imposed by outside centralist forces, and by a politics of Cornish identity, marked by nationalist groupings such as Mebyon Kernow and An Gof. Mebyon Kernow ('sons of Cornwall') is a political party campaigning on nationalist issues, and An Gof ('the blacksmith') a more radical and looser nationalist grouping (Deacon 1993).

By 1939 Lanyon had come to know many of the abstractionists that had moved to the St Ives area to form what came to be known as the St Ives School. In particular, he became influenced by Ben Nicholson and the Russian émigré Constructivist Naum Gabo, and began taking private lessons from the former. Gabo's space constructions were highly influential on Lanyon and Gabo became a major and lasting influence on his work. Throughout the late 1940s Lanyon was active in the Crypt Group and the Penwith Society, both central to the artistic development of the St Ives School. Lanyon largely accepted the pure abstractionist position that the form and content of art were somehow mystically united, and his paintings and art reflect this. Lanyon was articulate and open about what he sought to do, making links between the intelligibility of his own and past art, and was very clear about rejecting the depiction of 'actual space' three-dimensionally across a flat surface by means of such techniques as perspective. He described the representational strategies of the landscape 'tradition' as 'a reproduction of the vision of landscape painters; it is artificial. That vision, based on a static viewpoint and recessions, is clearly inadequate for the creative mind of today' (Lanyon, P. quoted in Lanyon, A. 1993a: 289).

By 1950, however, a shift away from constructivist ideas began as Lanyon became increasingly aware that as pure abstractionism his work was not entirely consistent. Increasingly he talked about the relation of everyday experience to art, as opposed to ideas of art as a connection with immutable realities beyond subjective appearance. From the perspective of his geographical knowledge, or perhaps geographical conscience, he was uneasy with art that was not grounded in immediate experience and culture, not only with the way the world looked but also with the emotions, sense, memories and moods such experience entails. Still engaging with the pure abstract experiences of volume and relationships of form, he refocused his abstractionism onto the way his body encountered and interacted with the world and, more specifically, with Penwith. Lanyon's was an

art of landscape, to be sure, but one constructed from a deliberative strategy of multidimensional engagement with place. This practice inserted an intellectual distance between Lanyon's art and the imaginary landscapes of pure abstraction, the naturalistic orthodoxies of the formal landscape tradition, or the symbolic landscapes of Nash or Sutherland.

This shift in the way he thought about abstraction distanced Lanyon from some of his Constructivist former educators and friends. In May 1950 he resigned from the hub of the St Ives School, the Penwith Society, after quarrelling with Ben Nicholson and Barbara Hepworth over their plan to divide the Society into abstract, figurative and craft sections. Lanyon believed the distinctions to be meaningless, and felt too that the successful abstractionists in the Society were effectively marginalizing the creative 'ignorance' of art theory represented by the work of 'primitive' painters and craftspeople who belonged to the Society.

Lanyon was the only Cornish member of the Society's inner circle of artists with an international reputation, and his resignation at this time implied embracing his difference as Cornish as he moved outside that nucleus. Without compromising his own artistic position, he strongly identified with art that he called 'realist', in that it was based on 'a concern for the environment and its people' (Lanyon 1956). This period also marked the beginning of a new phase in his work as he became more openly immersed in Penwith and also began to explore myth, incorporating metaphors and correspondences of a 'female' land and 'male' sea into his work such as the Minotaur, in Europa (1954). His work also became more intense and less tonal in colour. One of the dominant trends in abstract art of the time to was emphasis on a flat picture plane. Lanyon did not conform to this trend, instead creating large-scale paintings that incorporated different spatial planes which helped visualize his geographical perspective:

> I wasn't satisfied with the tradition of painting landscape from one position only. I wanted to bring together all my feelings about the landscape, and this meant breaking away from the usual method of representing space in a landscape painting – receding like a cone to a vanishing point. I wanted to find another way of organizing the space in the picture. For me, this is not a flat surface. I've always believed that a painting gives an illusion of depth – things in it move backwards and forwards. (Lanyon, P. quoted in Lanyon, A. 1993a: 231, 263)

Lanyon's geography was directly concerned with Cornwall, but he had no project of elaborating a definition of Cornish culture, by acting as an abstractionist ethnographer, so to speak. People, their actions and the specific spaces they construct are all important in his geography. How did he reconcile the apparent contradictions of self-immersion in sensation and experience with his 'realist' political concerns with (Cornish) culture and place? Placing Lanyon's writings alongside the paintings themselves offer materials which help us reflect critically on a single process. This also provides an exemplar for studying the representation of particular knowledge in abstractionist art.

Lanyon's particular geographical knowledge was built upon his situatedness in Penwith, his sense of Cornishness, his social networks, his movement and his work. He deliberatively transposed such experiences as walking, riding the bus, cycling, driving or gardening into his art. Lanyon's geography is one of a social subjectivity in which in a phenomenological sense every human activity experientially reveals the environment as a predicate of geographical knowledge (Merleau-Ponty 1962: 220).

Two important elements within Lanyon's knowledge were memory and his notion of experiencing the knowing of place. Lanyon believed that the social practices revealed in 'landscape' provided the setting which justified memory. Memory is situated, a conception of something revealed, of things surfacing through being in place: 'my desire has indeed been to know the place, to be able to read the codes of, for example, the public footpaths and bridleways; to have a competence with respect to this landscape ... to be local and party to its stories, in a sense here is a desire to 'know' what cannot be seen' (Game 1991: 184).

This sense of knowledge 'surfacing' was animated for Lanyon by a linkage between everyday practice and environment in Penwith:

> The beginning of a painting may be down a tin mine or on top of a bus above the fields ... an abnormal sense of rightness in the presence of some happening or place ... in West Cornwall this whole existence of surfacing deep and ancient experience is obvious. Everything surfaces in a deep and shocking manner. After a north storm ... seamen can be seen plodding the beaches and picking objects out of the sand ... a fascination which has affected me. These are reassurances of the living I know in my paintings – the comparisons, the closeness and the edges of lives different in appearance but fundamental in their history ... so that the farmer, the miner, the seaman, all in their own journey make outward the under things. (Lanyon, P. quoted in Lanyon, A. 1993a: 292)

The presence of people in Lanyon's art is not usually translated into marks on the painting surface, but their lives are inscribed in the selection of knowledge used, as in Lost mine (1951); recalling a great loss of life in a mining disaster, 'lost' marking their lives, or in the symbolic marks such as the washes of paint in crucifix form in St Just (1951-1953). St Just town was the centre of the tin mining district on the coast north of Land's End; Lanyon passionately believed that it had been exploited and its wealth removed by owners who felt nothing for the area and its people. The town had suffered great loss of life from mining accidents caused by negligence and bad maintenance. Lanyon's anger is made explicit in the painting through the form of a crucifix which runs down the centre of the painting like a black mineshaft: 'They were landscapes but also mourners on either side of the cross' (Lanyon, P. quoted in Lanyon, A. 1993a: 121).

In the 1950s, then, Lanyon's art developed as geographical knowledge based on immersion in place, deliberately resisting the sensual dominance of the visual. Lanyon had both moved away from the pure abstractionism and the concept

of neutral space in Constructivism and yet was unhappy with the assumption of place and landscape as 'stimulus' or abstraction as based on 'naturalistic' perceptions. His complex conception of himself as abstractionist integrating space with social identity and cultural practice is explored below. While not abandoning a critical stance towards Lanyon, we want to let his voice talk about the direction he took in the 1950s and about the process of representing knowledge in abstract forms. In particular we work through a detailed study of the process of the making of 'Offshore' (oil on canvas, 1959).

Offshore Experience

Lanyon made his geography 'with both feet', generating knowledge through personal experience of places that included their people, and their lives as they were inscribed on the very land itself, allowing their actions to reveal more to him. This process is very significant in the painting 'Offshore' (Figure 1), the 'source' of which was a transposition of Lanyon's experiences and memories of the fishing village of Portreath.

The knowledge of danger, at least of difficulty, disruption and hardship amongst Portreath fishermen, informed Lanyon's sense of the place itself. He worked hard in excavating, making visible the 'underthings', through a complex and socially alert process of geographical learning, letting the 'underthings' be revealed, reworking as he scraped back his paintings before going on. The following sequence of writing describes the knowledge he transposed into 'Offshore' (the following quotes are taken from recorded comments by Peter Lanyon, transcribed by Adrian Lewis 1982, published in Lanyon, A. 1993b):

> The sea was piling in on the shore, the waves on top of one another, almost as if one were seeing it through a telephoto lens, the high tall waves behind the shorter ones in-shore ... I walked along the beach and this was on my right hand side at that time. Then I climbed up onto the Western Hill via the rocks so that the sea descended to my right and then I went up the side of the Western Hill, behind the rocks. The sea then became something down beside my feet.

See Figure 1 'Offshore'.

This experience is one of looking, not gazing but engaging, absorbing himself into the immediate experience, conscious of the change in shift and bend of his body as he steps up or across; leans down with the air and shapes – sensuously shifting forms, as it were – moving about him. These movements, observations, feelings, were the knowledge that Lanyon determined to place before preconception of making any art object. Visits to Portreath provided the immediate information, or rather bundle of knowledge, at once imagined, sensual and experiential.

Lanyon started 'Offshore' 'with a structure strong on the left hand side; as an essential blue space, indefinite'. He turned the painting on its side, the left becoming the top. He felt the painting in the early 'literal' position (in relation to his knowledge of the place) required this turn, although it became at once oppressive, one of many uncomfortable feelings that typified his strident efforts to resolve the problems of his way of working. At this point, he returned to Western Hill at Portreath, feeling he needed more 'information'. With enhanced knowledge the painting changed:

> The sea section becomes more amorphous, the hill more structured ... Cubist ... The whole thing becomes blue, with a little sea on the right hand side ... land at left; little "bits" of sea at the other three sides ...

He continues in more detail:

> I found an ease ... I found that things were happening, that flowers looking at me were actually happening ... things were stronger, that a car, for instance, sitting by a house had an extraordinary sitting power. A gate was agitated with its bars, that a house was standing up gaunt beside me that the road as I went back up into the town was hedged either side, but the sea was on one side, and was blowing up over the hedge and all the small grasses were moving, moving with a curious blowing, twisting dropping action. Now, that's the sign to me that there is a fusion, that there is an interest being created that connects this thing growing in yourself. I can pin it to the place as it were, and the place clicks with me ... to establish itself in time and space.

The knowledge of Portreath as a place transposed into the experience of making art based on place knowledge reveals in Lanyon a sense of the process as a 'journey ... out from this very simple experience of sea, and grass and shore'; a journey he made several times to get the feel for the right green in 'Offshore'. This actual experience of place and imagined place unite: 'I returned to the place ... in the painting itself.' However, this is no mystical process. Lanyon states that it is

> not anything magical or unusual. I think it is the logical result of this constitutive process which, starting in an extreme awareness of oneself in place, ends in an extreme awareness of oneself in painting.

'Offshore' was one of many paintings that Lanyon prepared by making constructions – he had made six – as well as mimetic sketches (see Figure 1) – for his painting Portreath in 1949. These constructions mark the influence of the methods of the master constructivist Naum Gabo. However, Gabo's intellectual conception of space in was characterized by a strong sense of emptiness:

we in creating things take them away from their owners ... all accidental and
local ... leaving only the reality of the constant rhythm of the forces in them ...
we renounce colour ... line ... [even] mass in sculpture ... We affirm depth as
the only pictorial and plastic form of space. (Gabo 1920)

Lanyon felt intellectually stifled by his proximity to Gabo and did not completely
share the Russian's notion of depth. But he did use constructions as a means of
building up a complex knowledge of space and as 'patterns' which may 'click'
with paintings produced later. However, Gabo's ideas about spatiality did help
Lanyon reconcile his own position on artistic objectivity:

By removing the static viewpoint from landscape and introducing an image
constructed or in my case evolved out of many experiences the problem of
landscape becomes one of painting environment, place and a revelation of a
time process as an immediate spatial fact on a surface. (Lanyon, P. quoted in
Lanyon, A. 1993a: 290)

Equally, Lanyon could not engage 'totally abstract art' like Gabo's and Nicholson's,
stripped of all supra-natural (i.e. human and cultural) impositions on natural truth,
because for Lanyon that did not relate to life itself:

The idealism of Constructivism was therefore to be applied to art made as
a sensuous response to experience: the painter's task ... to create forms and
relationships between them that convey the urgency of this response; hands
making an object release meaning. (ibid. 230)

The construction that influenced 'Offshore' was in a continuing negotiation of
knowledge, so that when he returned to the Western Hill on a stormy day he still
held in his mind the construction, further adding to his knowledge:

I can assume from this constructive process that a space form, not only a space
form but also an awareness, is taken round with me ... this awareness appears
outside myself ... but all the way through the process of the painting there is
this spatial awareness ... This construction, which was already made in glass
and Bostik, governing the sort of expansion/contraction, pushing in/out and the
problems of the way that a painting is made; that space construction actually
governs the volumes and spaces which are employed in the finished picture.
(Lanyon, P. quoted in Lanyon, A. 1993b: 61)

This knowledge is worked through an overt use of the body in four-dimensional
knowledge – the usual three, plus a constant surrounding volume – to which we
could add time, even over a very short period, as Lanyon identifies the knowledge
of space recovering, adjusting, reappearing, over numerous visits and through

working the paint itself. Patrick Heron calls this knowledge 'multi-perspectival' (Garlake 1992: 12).

In his spatial practice, Peter Lanyon acknowledges sight, standing and looking and feeling. In the coarse-grain imprint of the foot too as the ground rises and falls, supported or contradicted by the experience of balance, and in turning, sweeping the body along, bending and rising, he makes new contacts and connections with the immediate place.

Abstraction as Spatial Narrative

We may argue that this geographical knowledge, so essential to Lanyon's art, constitutes his conscious intervention in the wider context of abstractionism in the 1950s. This intervention was to construct an art that made no pretence to autonomous meaning. Lanyon's abstractionism was cognisant of the conditions out of which it arose. Lanyon didn't refer to 'geography', but his art was so much one of geographical knowledge that it was also an art conscious of the conditions on which it depended. Representation of his geographical knowledge constituted a strategy that marks out his relationship to other forms of abstraction.

Those representations of his multidimensional experience constitute an activity that signifies its own situatedness (Crossley 1996: 107). His art can be seen as a kind of performance of knowing the world through a bringing together the experiences of bodily activity, imagination and cultural situatedness (Merleau-Ponty 1962: 222). Lanyon seems to encompass in his knowledge a flow of experiences each of which implies and explains the other, as a multiplicity of what Merleau-Ponty defined as 'heres', constituted 'by a chain of experiences in which on each occasion one and no more of them is presented as an object, and which is itself built up in the heart of this space' (ibid. 281). For Lanyon's abstracted realism this may suggest too harmonious a gathering; his knowledge, and his representation of that knowledge, is a more fractured patina.

Lanyon's geographical knowledge reflects and seeks to represent an everyday situatedness founded in movement, observation, engagement, sensitivity. Heron notes: 'if the "sky" crawls down one side of the canvas and the sea creeps up the other – that fact is based upon two things: a certain memory, something seen firstly, and secondly, the pictorial demands' (Heron 1992: 12). 'Trevalgan' (oil on canvas, 1951) is a painting of an almost spherical piece of land, moored at its lower section to beyond the edge of the margin. The central 'ball' of surface in this picture is alive with markings of fields, slopes, rock and cliffs. There is an ambiguity in the horizon, which is suggested on the left-hand side only, with sky, as Heron says, on three other sides, suggesting cliff, promontory, aerial view or a swirl of geographical information made in various moments and movements. In gathering this knowledge, moving across space and making gentle adjustments, body's time is not simply externally constrained by the succession of clock time, it arises in relation to where we are, and also to the complex changes, timings, contingencies and rhythms that pervade

the interwoven interactions of modern industrial society and nature (Merleau-Ponty 1962: 412). Lanyon's paintings represent time simultaneously, a phenomenology of memory, cultural history (as in St Just), the distance between the experience, and its transposition onto the surface of the work.

Throughout Lanyon's painting, constructions and writing there is a sense of movement along with time. Lanyon celebrated modern technology for enabling new dimensions of experience, and escaping the entrapment of the artist's fixed position. He does not depict movement, but represents a sense of it. He understood this multidimensionality of knowledge as the informative element of twentieth-century mobility:

> The static spatial concept is not altogether any longer our normal experience of environment. Much more so is the experience of the car driver who accumulates impressions behind him (in the rear mirror) and telescopes them into new impressions at the same time experiences through the machine the contours of country. (Lanyon, P. quoted in Lanyon, A. 1993a: 291)

Lanyon's use of the car has been described as 'one of the unique contributions to landscape painting of this century' (Canney quoted in Lanyon, A. 1993a: 213). Moreover, the artist's knowledge also was built on wider bodily practices: scuba diving, walking, standing upside down, and numerous other strategies of bodily awareness.

Lanyon's concentrated internal experiences altered further towards the end of the 1950s when he modified his painting technique, affected by the loose animations of material by American artists. However, he felt that his position was confirmed rather than undermined by a 1956 Tate exhibition called 'Modern Art in the United States' which showed expressionist works by Pollock, Kline and de Kooning. These abstractionists did not manifest the same sort of knowledge that Lanyon represented, being predominantly concerned with form as expression. However, the boldness, scale, coloration and, indeed, expressive power in New York abstractionism undoubtedly found their way into Lanyon's work after the mid-1950s. He did not reject American abstractionism wholesale; indeed, there was a two-way influence between Lanyon and Willem de Kooning after some of the former's work, such as 'Silent Coast' (1957), was shown in New York – most notably the latter's atmospheric landscape-based paintings in the Parc Rosenburg series, such as 'Boston Landing' (1958). Lanyon also had long-standing friendships with Mark Rothko, Robert Motherwell and Franz Kline (Cross 1984).

Lanyon began to make work based on temporarily moving himself 'outside my environment', producing looser paintings with an absence of line, literally atmospheric space, drawn from his experiences of gliding which he took up in 1959. Here too, Lanyon was always conscious of his relationship with the places, memory and experiences he passes over:

> Far below, out of reach of one's feet, is the landscape from St Agnes, looking eastward into Cornwall. It's an ancient country, scored and marked by centuries of mining. This comes into the picture, but so does the sudden event happening in the present, for the whole idea of painting began when flying over a cliff I disturbed a bird on its nest. It is this range of experience – from the immediate to the historical – that I want to include in my pictures. (Lanyon, P. quoted in Lanyon, A. 1993a: 213)

A distinctive and explicit movement is present in the later flight pictures, typified by increasing expanses of single colour and marks of sweeping movement unhindered by ground but often carried on the wind itself ('Silent Coast', oil on canvas, 1959, similarly 'Thermal', oil on canvas, 1960; 'Fistral', oil, PYA and plastic collage on canvas, 1964). This bodily awareness of shifting position could leave residues of a variation of the classical gaze. Lanyon's work did not copy sensation, however. Neither does it detach the artist from culture in search of unmediated 'qualities' of landscape. Lanyon's was no 'absolute eye', rather a discovery of representation through de-objectivization.

Abstraction and Representation

The paintings, seemingly abstract, disregarding familiar anchors of horizon, perspective, rules of scale and position, are nevertheless representational of a geographical knowledge of landscape and culture. Lanyon's art is 'nothing unless it is constructed out of experience and returns to experience' (Lanyon, P. 1963a, Recorded talk on Cloudbase, in Lanyon, A. 1993a: 229). The significance of this experience is that painting becomes a part of his own situated knowledge, of his own geography. Lacking perspective and horizon devices, or a fixed position, Lanyon's art and words disrupt the conventions of landscape: 'I paint the weather and high places where solids and fluids meet. The junction of sea and cliff, wind and cliff, the human body and places all contribute to this concern' (Lanyon, P. quoted in Lanyon, A. 1993a: 293). Instead of using paint in traditional ways of transferring geographical knowledge, Lanyon lets the body sweep the paint, lets memory scrape the paint's layers, and allows the whole to be embedded in a sensibility at once cultural and phenomenological:

> The gesture made in desperation or joy is not enough, it is scything the air. In painting gesture must attach itself and become its opposite and be cut and thrashed and extracted from a wealth of soil-based and rooted knowledge. (Ibid. 290)

Lanyon believed that his representation of situatedness in his art could take on a metaphorical quality for audiences. He did not see his paintings as messages

comprehensible only by elite sensibilities. He realized that art as a contingent image

> may be attached to a specific experience in time and space. I would argue that
> this is essential but it may reveal other and often conflicting experiences ...
> References to content in the final work may not be obvious; they operate on the
> senses outside the painting. (Lanyon, P. 1962)

Abstraction is both the representation and knowledge of cultural identity, body, memory, myth, allegory and revelation. This ensemble is a means of telling spatial stories, waiting to be told through what de Certeau has called the 'putting into practice of the 'pain or pleasure of the body' (de Certeau 1984: 105). Lanyon is not the only abstractionist who consciously sought to represent a geographical knowledge of landscape rather than to depict the landscape formally. De Kooning has already been mentioned, and he shares these qualities with others such as Richard Diebenkorn (Diebenkorn 1990).

Lanyon's work has been seen by some as beyond being 'about' place. The painter Roger Hilton asked him: 'Why don't you admit that you're an abstract painter, instead of all this stuff about Cornwall?' (Interview with Andrew Lanyon 1994). Patrick Heron argues that Lanyon's work is an attempt 'to reconcile the shallow space of Cubism with the infinite depths of landscape' (Heron, South Bank Centre, London, quoted in Lanyon, A. 1993a: 6). But Lanyon was also confident in asserting a defiance of the conventions of abstraction.

Lanyon's process art geography of place is historical, bodily and emotional. The crucial feature of Lanyon's geographical knowledge-making through the work of painting, from 'picking up the clues' to scraping and reworking the paint surface, is the awareness of space, features, memories, events, artefacts, movements around him. Being bodily informed, his knowledge moves his body: bending, sensing the changes in land surface, turning. There is too a sense of the multiplicity of events, of numerous bodies and things around him. It is equally a knowledge immersed in the everyday lives of people of which he felt a part. It does not record a place, a landscape, but combines moments, events and action across a complexity of fragments. These fragments are not separate in his painting, nor are they evident: all collide and inform.

Conclusion: Abstraction and Geographical Knowledge

Lanyon offers a means – an exemplar – to help comprehend how the 'poetic geography' of situated knowledge (or stories) of landscape is put into practice in abstract art. He also helps to extend geographical inquiry from the nineteenth-century picturesque and romantic through to postwar abstractionism (ibid. 12). Lanyon is at once local and universal; his art would seem to be part of a very situated geography, one that connects globally not only through his artistic friendships with Gabo, De Kooning,

Kline and Rothko but in the way he was reaching those similar meanings, worked around the same time as these artists: 'to be parochial … is to be very different from local or rooted' (Peter Lanyon quoted in Lanyon, A. 1993a: 299).

From the historical perspective, the rejection in 1960s conceptual and pop art of, inter alia, the subjective spatialities of abstractionism might indicate the highly contingent relevance of Lanyon's geographical knowledge. However, shortly before his death in a 1964 gliding accident, Lanyon had welcomed the possibilities opened up by pop art, such as the erosion of the mass culture/high art dialectic and the destabilization of the art object. Lanyon's work must be addressed in context, and his inflection of abstractionism does to a degree represent a rejection of such distinctions. Embracing both his identity and abstraction of Penwith as crucial geographical components within his art distinguishes Lanyon from others of the St Ives School in the 1950s and 1960s, and within abstractionism in general. He did not embrace abstraction as an expression of alienation from the world. Unlike other abstractionist ideals, especially constructivism, he did not seek to develop his work by disciplining of eliminating situated bodily experience and everyday knowledge from his work. On the contrary, his geographical knowledge was based on experimentally representing a fully social subjectivity.

Aside from his cultural politics, Lanyon was also concerned with expression of internal concepts, with the knowledge he made, albeit through intense immersion in the social. Another concern was relations with to the concepts of empty volume and 'neutral space' found in Constructivism. His art moved away from neutral space towards knowledge of the world as one of living, of cultural situatedness and of contingency. But the tension between these defining concerns and his intellectual grounding in Constructivist neutral space was a problematic one that recent artists have addressed more specifically. The sculptor Richard Deacon, for example, in a 'post-humanist' interrogation of prevailing constructs of nature, attempts a critique of the Enlightenment understanding of space as a neutral continuum which he takes as threatening to human situatedness (Newman 1991: 177-204).

Painting is geographical knowledge-making as well as representation. Understanding painting is understanding the making of geographical knowledge; Lanyon was acutely aware that such making is about process and not product, or statement: 'a continuous process fed by sensation' (Lanyon 1962). His metaphorical reconfiguration of the Penwith environment constituted what we may call a series of spatial stories (what de Certeau called receits d'espace): representation of the narrative flux of everyday practices which constitute the Penwith landscape. Instead of 'uninformed others' being objects within the painter's narrative, Lanyon's art arises within, and pays due attention to the memory of, those everyday practices that constitute place. Referring to one of his inspirations, Lanyon wrote:

> When the spectator is drawn to the horizon through a vortex of spatial forms in paintings by Turner there is some physical participation, the subject of the picture begins to be the person looking at it. (Lanyon, P. c.1952. Untitled note, in Lanyon, A. 1993a: 288)

He also commented:

> I would be at great pains to say where is the painting I am looking at. For I do
> not look at it as a thing; I do not fix it in its place. My gaze wanders in it as in
> the haloes of Being. It is more accurate to say that I see according to it, or with
> it, than that I see it. (Merleau-Ponty 1961)

He described 'painting as an event, not a site for a set of events defined a separated
by spatial absences but one event every side of which is presented and revealed
all together at once and immediately' (Lanyon 1956/1993: 92). He called this 'a
gathering process', soaking up experiences and references 'like a sponge' (Canney
quoted in Lanyon, A. 1993a: 159). Lanyon's allegorical abstracted landscapes are
a compilation of a contingent patina of knowledge, not smooth but fragmented,
which resonate situations, places and people's lives.

Afterword

This chapter has concentrated on unravelling the multi-sensual character of motilities
and emotions in which Lanyon opened. There is evidently strong performative
character present. Prefigured contexts remain significant and disrupted. His attitudes
and values concerning materiality, nature and things he could touch and feel,
reverberate across his accounts and his artistic expression. If we can call his work
representations those are of feeling, doing and emotional imagination, provoked by
an openness that expresses becoming in a very profoundly performative way: of
doing and becoming. His use of gesture is far beyond decoration and extends itself
from the work in an expressive presence (Ness and Noland 2008, Noland 2009).
The character of performativity close up is considered more closely in the following
chapter in a way that drags understanding of living, doing and feeling across to
everyday practices and their performativities and the mundane.

Frequently Lanyon's lines on the surface of his work are lines of movement,
mobility, not of borders and boundaries but inscribed in living (Stephens 2000:
124). In this his work resembles the artist Paul Klee's 'taking a line for a walk'
and like Klee these lines were not detached from resonances in living but full
of openness and possibility (Casey 2005). Lanyon articulated these as they were
emergent in multiple reflections through other streams of influence.

Lanyon clearly took a critical position regarding the familiar and official notion
of landscape. He veered away from the notion of landscape because it was too
laden with a dominating surveillance and the constraints of how we are supposed
to encounter life and 'work' space. Chapter 5 pursues the performative character of
working art, and also the tensional forces of belonging and disorientation. Chapter 6
propels new considerations concerning emergences of landscape, a term that troubled
Lanyon. But first I seek to unwrap the character of performativity and becoming in
everyday living, in the next chapter.

Chapter 3

Spacing, Performing and Becoming: Tangles in the Mundane[1]

Foreword

Following on from the embodied phenomenology and implicit performativities of Peter Lanyon's wider art practice I take forward the occurrence and feeling of performativity in two examples of what one might call everyday life practices, perhaps mundane, perhaps extraordinary: community gardening and caravanning or recreational vehicles. The character of phenomenology and inflections of social constructivism penetrate this critical account. The work considers close-up the nuances and complexities, prefigured character and contexts of performativity in the practicalities of becoming.

A concurrent concern is to amplify discussion on cultural and geographical knowledge, as emergent in kinds of processes as those discussed around this chapter's two focused investigations. In this it joins an emerging field of work (Crewe and Gregson 1994, Miller 1998, Wall 2000 amongst others). Domosh acknowledges the potential of everyday micropolitics in practising alternative, or just distinctly 'owned' relations, human capacities, attitudes and values, towards human and not-human energies (Domosh 1988). In practice and performativity there is an inter-subjectivity and expressivity. In considering the performativity of everyday living the complexities of subjectivity, the affects of contexts and the doing and feeling of life are provoked.

In the community gardening research I engaged individuals sourced through formal and informal networks national, international and very local. I had personal friends who added to these networks of contact. For years I had gardened and found, without hard self-consciousness, a ready and easy rapport with the individual gardeners. Sometimes Colin Ward accompanied me in the early fieldwork, and we made interviews at individuals' homes as well as meeting them again on their plots of ground. I was aware of the challenge of positionality in this, and realized the complexity of engaging individuals across genders and of diverse ages, social situations and backgrounds. I spent an initial year in the empirical stage, and have returned at different times to engage fresh ideas and corners of what gardeners do over the intervening years.

1 Originally published as Crouch, D. 2003, 'Spacing, performing, and becoming: Tangles in the mundane', first published in *Environment and Planning A* 35(11), 1945-1960. Courtesy of Pion Limited. Presented here with a new Foreword and Afterword.

For the recreational vehicles work I was very aware that I had no experience of spending time in that way, save a few weekends as a child. This was an intended challenge after the allotments work. My research assistants had no direct experience of it either, but they each had experience of camper vans at folk or rock festivals; three men and one woman. One in particular found it worked better, more engagingly to relate with individuals when his partner accompanied him. Four researchers spent over fifteen weekends and longer durations caravanning, and making additional visits to individuals as follow-up. In many cases we were invited to join in events yet our feelings of doing were not necessarily equated with our subjects – they were familiar with what to do, knew others in many case. We felt *othered*. Our subjects did not invite us to do the work, yet we sought to investigate what they were doing. They seemed aware of their popular image tends to be one of some disdain; othered for pulling an awkward and rather 'anti-style' box along the road and parking in the countryside. They seemed concerned to present themselves, in a way, as ordinary and 'straight'. Our interviews and participant observation extended over long periods, with intervals of intense participation in their events. There was plenty of opportunity for participant observation. In several cases we followed up interviews from home to their trips, and sometimes back afterwards. We felt awkward too because we were acutely aware that we were seeking to engage individuals in reflecting on what they were doing when they were (just) there to enjoy themselves. Of course we did not 'become them'. We engaged, and over the timeframes we were with them relaxed and had conversations (Crouch 2001). In the development of each of these investigations individuals who talked with us are mentioned in given first name terms.

Introduction

The main concern of this chapter is to consider and interpret ways in which space is performatively encountered. I critically compare ideas of performativity with those of embodied practice and their combined contributions, oriented to an exploration of spacing, with particular regard to the means to adjust, reconstitute, and reimagine one's life through encounters with space. The argument seeks to bring space into discussions of performativity, through a consideration of empirical narratives and observed encounters with surroundings, from ethnographies of the apparently mundane activities of allotment holding and caravanning. Through this discussion I examine the significance of spacing in performativity. Particular themes, worked in terms of spacing, are the emerging tensions between, for example: being and becoming; routine activities and everyday creativity; the desire to experience change or to 'go further' and to 'hold on'; and, in relation contexts and flows, time and identity processes. Through the discussion the encounters and imagination of the research are reflexively considered in terms of the accessibility of performance to research investigation.

Recent discussions on performativity have suggested dimensions of human activity whereby the individual may be understood to deviate from, as well as emerge through, the ritual and repetition of contexts found in everyday life-protocols. These arguments follow discourses on embodied practice, informed by the recent reworking of MerleauPonty's insights, on the individual's encounters with space (Crossley 1995, Radley 1995, Thrift 1997). In this chapter I seek to bring the discussion of space closer to a practical realization of performativity and explore the potential of the individual to reconstitute life through an articulation of spacing. The term 'spacing' is used to identify subjective and practical ways in which the individual handles his or her material surroundings. Spacing is positioned in terms of action, making sense (including the refiguring of 'given' space), and mechanisms of opening up possibilities. Empirical ethnographies of two activities – allotment holding and caravanning – are used to explore these mechanisms. Issues that emerge include the handling by the individual of tensions between: being and becoming; routine activities and everyday creativity; desire to experience change or to 'go further' and to 'hold on'; and, in relation contexts and flows, time and identity processes. These are focused through a discussion of particular moments or events in what people do and think. Through the discussion, the encounters and thinking of the research are reflexively considered in terms of the accessibility of performance.

I begin with an outline of how to use the awkward term 'spacing'. This is then developed into an orienting discussion on related themes of embodied practice, performance, and performativity. The choice of empirical work is reasoned and the difficulties faced in this research are introduced by considering my field notes. I then consider what individuals do through spacing, and what they say about what they do and feel. Particular attention is given to the ways in which spacing, as a dimension of performativity, can also be a manipulation of things as they are for the individual, and may have the potential to go further-and to be reconstitutive as well as unexpected. Tensions that individuals may feel in terms of holding on and security, on the one hand, and going further and making life adjustments, on the other, are explored. The workings and possible limits of time, and contexts or culture, are then discussed. In a final interpretative section I consider the potential for spacing and identity.

The term spacing is used to focus the performative character of what people do. I seek to bring space, and agentive and subjective acts of spacing into the discussion of performativities, and their relation to conceptualizations of embodied practice. Furthermore I explore the possibilities, through empirical investigation and interpretation, of engaging, in particular, the performative in making sense of the terms which determine an individual's capacity to renegotiate his or her life. Although geographers have recently shown keen interest in performativity, there remains a keen need to explore its argument through empirical investigation. It is now well known to consider space as metaphorical or symbolic, and material. Crang (2001) has argued for the processual, constituted character of space; in practice temporally contingent in open-ended multiple flows. The modes of practice and

performativiy through which individuals may give different character to space have been critically explored through theoretical contributions in geography (Thrift 1997, Thrift and Dewsbury 2000).

These interpretations have added to the familiar notion of spaces as signified in representations, and other contexts; described as a non-representational theory (Thrift 1996). It has been argued that the practice of space constitutes lay geographical knowledge: through the power of individuals to configure and refigure knowledge in a process of embodied spatialization (Crouch 2001). Crucially this discussion concurs with the argument by Nash, that it is unrealistic to counterpose nonrepresentational interpretations of space, to representational claims-as the individual operates in relation to, rather than only controlled by, those contexts (Crouch 2001, Nash 2000). In this chapter my emphasis is on the mechanisms of spacing and in particular how the individual negotiates tensions. The idea of practice in the making of lay geography is taken further through a focus on the nuances and facets of performativity and the uncertainties and possibilities that performativity may produce; using the notion of spacing in a Deleuzian sense of folds, complexity, and possibilities.

The particular thread pursued here orient towards the notion of performativity as 'going further', that is, in containing the possibility of the unexpected. The different and risky. These themes and their distinctive contribution to making sense of spacing are worked into my empirical narrative through the difference between 'holding on' and 'going further'. Similarly it is suggested that this couplet provides a useful means through which to include spacing in a discussion of performativity. Space is considered in terms of its distinctive contribution to furthering the interpretation of performativity and the ways in which individuals can use this in making sense of their lives – alongside the developed work on embodied practice. As the next discussion shows there are considerable overlaps between these areas of debate. The pertinent theoretical positions are given in the next paragraphs.

Pertinent Theoretical Positions

Recent reworking of Merleau-Ponty's interpretations of the relation between space and the individual has invigorated the understanding of how individuals engage and encounter their surroundings in terms of the embodied character of what they do (Merleau-Ponty 1962, Crossley 1995, 1996, Radley 1995), The notion of embodied practice as expressive provides a useful direction for thinking about the relationship between touch, gesture, haptic vision, and other sensualities and their mobilization in feelings of doing (Harre 1993). The word 'doing' distinguishes what people may do without particular practical outcome, from that oriented around a task. When expressively encountering, the individual engages in 'body practice' as an everyday activity of living (Radley 1995). Burkitt (1999) has drawn together ideas of body practice and the social

constructionist notions of identity; in particular Shotter's notion of ontological knowledge argues that embodied practice may be important in working identity. Similarly, Ingold (1995) identifies a process of *dwelling*, whereby encounters with objects, individuals, space, and the self, progress life (Harrison 2000).

These ideas can be used to think of space in terms of negotiating life in the act of spacing. It is in recent debates on performance, and its performativities, that the possible constituents of spacing offer a further step. In particular, Deleuze and Guattari's (1988) attention to how the uncertainties of flows and the momentary character of performativity elaborate the uncertainties and complexities of spacing, and its potential, as part of performativity, to reconstitute life (Grosz 1999). There are resemblances between performativity and embodied practice that are briefly considered in the succeeding summary of certain themes of performativity.

The difficulties with performance and performativity, and between the performative and embodied practice, are in the divergent perspectives surrounding the term performance and the overlapping reasoning between performance and performativity – as Tulloch (2000) has discussed in the literature of cultural studies. First, performativity and embodied practice are both profoundly bodily (Dewsbury 2000). Second, each emphasizes the importance of the expressive body (Radley 1995, Tulloch 2000). The nature of performance is contested. Butler's emphasis on performance and performativity is in terms of: being ritualized practice, working to pre-given codes, habitually repeated, and conservative (Carlsen 1996). However, she acknowledges the possibility whereby relations with contexts may be reconfigured, broken, adjusted, or negotiated (Lloyd 1996, Thrift and Dewsbury 2000) thus affecting, as well as being the affect of, context.

Although performance can emphasize the framework of everyday protocols, the performative errs towards the potential of openness. The reconfiguring, or reconstitutive, potential of performance is increasingly cited in terms of performativity; as modulating life and discovering the new, the unexpected, in ways that may reconfigure the self, in a process of '… what life (duration, memory, consciousness) brings to the world: the new, the movement of actualisation of the virtual, expansiveness, opening up' – enabling the unexpected (Grosz 1999: 25). Patton seeks to distinguish performativity, from what de Certeau called 'tactics' in his discourse on practice and, from performance; arguing that only in the performative can new strategies be constituted (Patton 1999: 183).

In contrast, Roach inflects practice *and* performativity as 'cultural act, critical perspective, a political intervention', and argues that performances may be considered as practices that contain the transformative (1995: 46). Radley (1995: 14) argues that individuals create a potential space in which they can evolve imaginary powers of feeling. Performativity is identified as the mode of articulation of practices (Schieffelin 1998: 195, quoted in Tulloch 2000: 4), and Dewsbury refers to '… general performance, *practice let us say*, … is constituted in the performative' (Dewsbury 2000: 475). So performativity concerns the minutiae of practice; a detailing of the performative enables *closer interrogation* of practice. Further, dimensions of 'performativity as becoming' share character with Ingold's

notion of doing in terms of 'dwelling' (Dewsbury 2000). Ingold distinguishes between the idea of things, space, and so on, as prefigured and determinate, with the motor of dwelling that sustains the present and future; from which contemplation and new possibilities of reconfiguring the world, in flows, can occur.

Both the performative and embodied practice are characterized in doing. Each is articulated for the individual in terms of doing as constituting or refiguring their own significations, as material or embodied semiotics, and may respond to other representations of the world (Crouch 2001, Game 1991). Performance as performativity is taken further as ongoing and multiple interrelations of things, space and time in a process of becoming in engaging the new that may be similar to Radley's consideration of embodied practice: unexpected and unconsidered, not only prefigured, and suggestive of a similar performative shift beyond the mundane and routine habituality. It is possible that going further may emerge from exactly those apparently momentary things (Dewsbury 2000). Moreover the borders between 'being' – as a state reached – and 'becoming' are indistinct and constantly in flow (Grosz 1999), although they may be focused in the 'event' (Dewsbury 2000: 487-489). In the present discussion becoming is distinguished from being in the sense of Grosz's *becoming* as 'unexpected', where performance's performativities may open up new, reconstitutive possibilities. It is in the notion of multiple routes of becoming that the discourse on performativity is particularly powerful.

Throughout this chapter there is a tension between the related threads of performance, 'performativity', and the embedded practice and how they are making sense of the way of the world and aspects of it may be adjusted. Significations and their ontological potential, in relation to performance's significance in making sense (temporally, unevenly, nonlinearly, multiply, or performative structures of feeling) may be seen as affecting an individual's protocols and contexts (Harrison 2000). Through performativities, practice and performance individuals are able to feel; are able to think and rethink. Although Dewsbury (2000: 481) suggests that we may eschew performativities as 'not being moments of synthesis' they may constitute as important informing elements; their fluidities merging in events, nodes or knots of complexity, awkward and of both apparent resolution and potential contradiction – exemplified in Roach's performance as 'transformative practice'. Their significance may be in advancing the individual, intimate worlds, beyond where individuals are felt to be.

The expressive character in performativity is especially significant in becoming. The significance of becoming tends to be considered in terms of profound rearrangement of the self, and the niches and nuances of getting along in life that may or may not make life more enjoyable and bearable, and may consist of numerous momentary performativities that may themselves be significant (Dewsbury 2000). The potential existence of so-called 'ordinary', mundane or routine practices for becoming may seem limited. Instead performance generally, and expressivity have tended to be interpreted from powerful projects, around the borders of staged performances of theatricality and more intentionally and

self-consciously expressive practices such as dance (Carlsen 1996, Radley 1995, Thrift 1997). I am wary that to argue that people doing apparently ordinary things may have potential of becoming in terms of, for example, Grosz's 'unexpected' may seem either condescending or romantic (1999). It is my intention to take these discussions, on the apparently mundane, to explore the potential of working ideas of the performative and of embodied practice through the unremarkable, with the possibility of their becoming remarkable for the individual subject, and thereby provide insight into the everyday working of space as spacing.

If performativity and embodied practice, in their different nuances, can reconstitute life situations, or constitute the transgressive, then there is the possibility of their being constitutive of a refiguring of identities. These possibilities emerge in terms of embodied-practice perspective and performativity (Burkitt 1999, Lloyd 1996). Yet how doing may negotiate identities through a process of becoming remains uncontested (Burkitt 1999, Butler 1997, Dewsbury 2000: 492-492, Lloyd 1996, Parker and Sedgewick 1995: 16). These arguments push further the debate of whether contexts are as adequately understood as 'background' and structures of feeling, for what people do (Barnett 1999, Crossley 1995, Harrison 2000). Expressivity may provide a focus for further consideration of the nuanced character of everyday becoming, in terms of the negotiation of identities. The degree of potential performativity, intended or accidental, used for the scrutiny of the self, and for others, remains an issue. This issue may be significant in terms of the power of the performative to be involved in identity processes. These complexities are explained in the discussion of the empirical material.

In summary, because of the evident overlaps and mutualities of performance and its particular distinction of performativities, and embodied practice, I use the reasoning of both embodied practice and performativity. Insights of performativity emphasize the divergent and multiple possibilities of reconstituting life. These varied themes are interwoven through a discussion on empirical work and, iteratively, the challenge of identifying and of interpreting performance, and its significance, in and through spacing.

Performativity provides a particular focus to the possibility of opening up, in a Deleuzian sense, to the unexpected and the divergent in the 'excess' of multiple possibilities of what people do (Dewsbury 2000). There is a potential fluidity between being and becoming; of holding on and both a realization of a state of being (that can be found in repeated performance, of a return into a feeling of security) and also of reaching forward (going further, in sensation and desire) than may be habitually felt in other parts of their life. These components of theory, discussed here, are worked through the flows of encountering and constituting space in spacing, as a means to comprehend what space, particularly in the performative emphases of going further or becoming, contributes to understanding performativity.

The cases considered, through empirical material, are recreational caravanning and allotment gardening (community gardening). Both cases are drawn from ethnographic work in the United Kingdom. Caravanning is an activity of taking a

'van like a recreational vehicle or Silverstream 'on tow' usually to the countryside for a weekend or longer, sometimes alone and at other times to meet up with friends, sometimes to go to a site where a caravan may be hired. These different practices have contexts such as club lore and the subsequent contextualizing of who they might be: their gender, their home background, and the particular traditions and television images of the countryside. Both cases may be considered conservative: caravanning an unthinking and rule-bound way of passing time; allotment holding as merely growing plants in regimented plots, and keeping out of the way of aspects of liberatory cultural practices and their discourses-exemplified by some genres of dance (Nash 2000).

Allotment holding emerged in a moment of nineteenth-century working-class agitation, and more recently is inflected by ecological and land movements – but these tend to be relatively marginal. Even caravanning has a historical reference; to freethinking individuals seeking to escape late-nineteenth-century urban culture, but this heritage is today found only in the nostalgic writing of club magazines (Crouch 2001, Crouch and Ward 1997). However it is these characterizations that are significant in making a general activity, such as caravanning, so interesting for exploring ideas of performativity – simply because of their apparent closure of space for opening up the self, going further, and rethinking life. The test of performative potential surely lies in activities such as these (Nash 2000: 661), and can be found by working from diverse narratives; as Matless (1999) has historically done. However, there is an effort to move rapidly to the empirical narratives to reduce a linear discussion from contexts, as Doel (2000: 421) urges, working more 'from the middle', whilst not privileging them. The contextual elements have been discussed elsewhere (Crouch 2001, Crouch and Ward 1997). Here, contexts are considered through what people do and say, and the contexts to which they directly refer.

For my research, both practices were chosen and investigated from an interest in how people do things, the content of doing, and how this may be informative in understanding the way they make encounters with the world, and with themselves, and their immediate others, in a process of doing and 'making sense'. Each activity contains a large amount of practical action as 'getting things done' routinely, getting by, and coping-for which there are protocols communicated through the respective organizations. What is apparently repetitive or mundane is explored in relation to ideas of becoming; with regard to how we may modulate interpretations of the fluid, open-ended, and generative, in terms of becoming, in relation to the habitual and repetitive.

Grounding Performance

> I am just out ambling, "mooching about" as caravanners seem to call it. I walk
> across the site, from the green where the 'van is and onto the track that leads to
> the shop. I am momentarily aware of people moving and the smell of breakfasts

cooking is significant all around me. I hear people talking behind me and notice a group of children cycling around. I am still tired from a night in the van and feel my body to be slow. Two women have just met, apparently not come across each other for over a year, but they are animated in conversation standing along the track. The soft grass under my feet gives way to a hard path and I turn and feel the wind as I step out from the relative enclosure of the vans. My next steps are more hurried as I express a sense of freedom by shuffling down the slope that leads to a calm hollow surrounded by trees; my walk feels looser. I wonder where to go next, so far having been moving at random. Rejoining the track I note several people walking back from the shop and some half nod to me, I gesture to them. My body feels gradually alerting to the morning, and as I half bend round I pick up the activity from several vans, a little away from my track, in different directions, as people spill out and across the wider field around which they are parked. I arrive back, having wandered through what feel like private spaces close to the vans and Jock offers me coffee.

In these field notes I sought to pick up a sense of activity and movement, of how I performed in space and responded to it. I spent time amongst individuals who were on a weekend caravanning rally. I made an effort to report my own performativities and the awareness I felt in relation to myself. I note the multi sensual encounters I made with spaces, the intersubjectivity apparent in the way others move and gesture, and influence each other in the space I and they cross. I am not a regular to caravanning and my intervention is one of visitor and observer. I am using someone else's caravan and do not need to do many of the tasks that I notice the others doing, although I join in with getting things ready. Such an intervention perhaps idealizes the everyday awareness individuals have of what they are doing, as they may be more focused on tasks; at the same time I may interpret the world in a way too rationally performative. Some of the individuals are getting routine tasks done-collecting water and so on-others are out enjoying a 'mooch'. These seem to be everyday, uneventful, things. In these field notes, components of the performative are realized in a heightened awareness of hyperreflexivity. How much do these notes record and communicate the ways in which individuals perform activities in space and time?

A weekend caravanning and working an allotment plot incorporate a number of body-performance activities. These performances happen across spaces in relation to the surrounding physical world of objects, and other people, amongst which the individual moves and acts, and enacts, responds: they are contained in setting up the caravan, meeting friends to have tea, sorting out the barbecue, resting and just 'hanging out', or participating in various club activities. Activity is marked by protocols that can include: times for some activities, ways of doing things, and so on. The material spaces of the cases are marked by a flat field on which to park vehicles; the field is commonly surrounded by evident physical boundaries, and a stretch of open space usually marked out in parallel rows of small plots. When caravanning, or allotment gardening, the individual handles equipment,

just sits, greets or ignores others, and copes with anxieties in relationships. Each of these doings is performed bodily, contains numerous gestures, mobilities, turns, and touching. They may be envisaged tasks, and may be done according to a preconsidered performance, club rules, routine practical tasks, or habitual performances that fill the time between one task and the next. However, their character of performance is, I suggest, more complicated and nuanced than that suggests. By drawing on conversations held with individuals I acknowledge the significance of what they say. Performance can be considered to include a flow of performativities, gestures, plural and unrelated moments. It may be that simultaneously it is possible to think of performance in terms of nodes, gatherings, moments, collisions along flows where the particular character of performativity is felt significant-like Dewsbury's 'events' (2000). This may be significant in terms of lay geographical knowledge and sense of the self and its identities, as components of an ongoing and fluid practical ontology.

Mundane Potential

In their personal narratives many individuals talk in a matter-of-fact way about the capacity of the caravan and the convenience of a site; the result of their gardening and the difficulties of vandalism. In these arenas of the mundane everyday there are many body gestures, movements, and activities. People bend to collect water for their caravan and to lift plants or tools; they turn to sort the barbecue and to drag compost and piles of weeds-in getting things done they can also enjoy themselves. They engage other people in conversation, sharing preparation of activities at a caravan site and clearing overgrown corners on an allotment garden; disagreeing over the layout of the caravans and arguing over weeds. Their gestures appear routine and habitual, emptied of content. However, in this section I note brief narratives, and I examine two in depth here, and then again in the next section-in order to consider how far the doing may be interpreted out of the merely mundane and into a field of more open practice; from being to becoming. Moreover, much of the time in each activity is 'time-out' from these mundane actions. Yet time-out and 'time in' may not be mutually closed. I focus on the expressivity of what people do, and how they reflect on what they do. Before engaging the performance of becoming, or how becoming is performed, I identify ways in which people speak of the experiences they make.

'It's nice to be away from the humdrumness of life at home' (Ann, 45, Weardale, 1997). Ann talked of the liminality of the experience of caravanning, similarly in the case of a gardener who said:

> I have lived in flats all my life and currently live on a busy council estate. I have
> no hope of ever being able to afford a garden, since my work is rather low status
> and underpaid ... My allotment has enabled me to find a side of myself I did not

know existed and it also helps me to cope with an extremely stressful job in a stressful city. (Yvonne, 35, Weardale, 1997)

In another response, again from a caravanner, this liminality is described through a sense of being and of doing: 'It is great to sit outside as late as this, something you would never do at home, wearing few clothes' (Doris, 70, Hertford, 1996).

In the next sequence two community gardeners and then a caravanner talk of their experience through relationships; this helps to show the intersubjectivity of what they are doing, and how they appear to value it. First the two gardeners, a black man in his seventies and a white woman in her sixties talk and express values and relationships nurtured through their hobby: 'we learn things from each other. You are very social and you are very kind. You make me feel good, you don't come and call at me. Things in your garden you always hand me, little fruits, which I have valued so much' (John, 75, Birmingham, 1994). 'And I've learnt things from him. I've learnt some ways of planting, I've learnt real skills about planting, Jamaican ways of growing and cooking. And I've also learnt about patience and goodness and religion too. It all links in' (Alen, 60, Birmingham, 1994).

Second, Mick, a caravanner commented: 'In the middle of a field there is a group of vans. We have a barbecue and good booze. All you need is a few cans' (Mick, Essex, 1997).

In each of these cases individuals suggest the transformative possibilities of the simple, apparently uneventful things they do, in terms of feeling rather than outcome. They carry on. In each case there is an acknowledgment of possibilities being worked, or performed, through the ways things are done. What they do and feel is enacted in relation to spaces. Space takes on, or is given, new significance in a process of spacing. What they say appears to exceed the prefigured and emerges from doing. As Taussig (1992: 14) argues, the features and gestures of performance are operated not of 'sense so much as sensuousness, an embodied and somewhat automatic knowledge that functions like peripheral vision, not studied contemplation, a knowledge that is imageric and sensate rather than ideational'. To argue for attention to the non-ideational is not to eschew the resonance of ideas and of doing, no more than non-representational interpretations disclaim representational ones. However the ideas may not be just prefigured but refigured in embodied semiotics. Ideas, doing and feeling are not unknown to each other; rather ideas and doing work together.

The individuals discussed may have an 'external' awareness that they are physically and mentally 'somewhere else' but discover that, and what it means performatively. In these examples performance is presented as being, holding on, and security, but also suggests the liminality of performance in which the self and the world are transformed. Although the power of liminality may be performed by going somewhere else if this becomes habitual much of what is performed is seemingly routine. However it is in the cracks of habitual acts that significance can be found. The mechanisms of performativities are considered more closely in the next section.

Mechanisms of Performativities

> Caravanning, it all makes me smile inside. I mean, everyone just comes down
> to the ford and just stands and watches life go by. It's amazing how much you
> can have pleasure from something like that. I just sit down and look and I get
> so much enjoyment out of sitting and looking around and doing nothing. We
> wake up in the morning, open the bedroom door and you're breathing air into
> your living ... We walk and talk ... I love to cycle and fish. (Tim, 42, Weardale,
> 1997)

His moving to the edge of the ford by the water and 'just stand(ing)' is a
performative act. He discovers feeling by doing. His performance comprises haptic
vision, caring, relating and finding it uplifting: touch and other performativities are
experienced as he feels his body encounter the space between the caravan and the
water's edge, space that is suspended as he revels; when he breathes, the air smells
different. He is aware of these things and constructs his representation of what he
does, through an interpretation of how he constitutes space as spacing. The space
becomes his own through what he does and the way he does it. He gathers his
sense of what he is doing through these components of performance, not only from
other-figured information.

Carol describes her experience at her allotment in the quote below:

> Working outdoors feels much better for you somehow ... more vigorous than day
> to day housework, much more variety and stimulus. The air is always different
> and alerts the skin ... unexpected scents are brought by breezes. Only when
> on your hands and knees do you notice insects and other small wonders. My
> allotment is a central part of my life. I feel strongly that everyone should have
> some access to land, to establish a close relationship with the earth, something
> increasingly missing in our society, but essential as our surroundings become
> more artificial. (Carol, 40, Durham, 1994)

Carol describes what she does, and what she makes of this activity, through how
she spaces herself; her body engages in intimacy of space, significantly on her own
terms, with movements amongst multisensual encounters. Carol touches, bends,
and kneels; she moves her body and spaces the gaps, and their objects, between
vegetation, earth, insects, the air, and herself. She finds her feeling of life through
what her body does there. In this extract there is greater ambivalence between the
content and process of performance, and reference to prefigured intentions and
working those ideas through doing. In the extract, Carol talks of her performance,
and refers that back to contexts; maybe it could be regarded as double checking
or confirming performance with prior context. Performance and prior contexts are
engaged simultaneously in the way she makes sense of what she is doing.

In each of these cases, the performance informs, discursively and
prediscursively, thinking-doing-thinking. Carol is not thinking everything through,

but at each moment confronts, works, and performatively encounters through a feeling of doing. Space is grasped through the doing, not as an object 'out there' or merely 'felt' through the body; rather it is constituted by the numerous feelings, sensualities, and, in particular, the character of these things being expressed together. Expressivity is in the way individuals do things (and thereby the way in which embodied practice is felt in a relationship with others) and the way objects and space, and things, are changed (Radley 1995). It is in the encounter, the body performativities of sensibilities, body thinking and feeling: in the act they are, at that moment, doing. Deleuze goes further in emphasizing the sensate: 'all begins with sensibility' (1994: 144, quoted in Harrison 2000: 497). Moreover, individuals do not perform only in response of the prefigured to the performative, or to a space, or to others; nor do they perform a given self through particular moments, or intentionally do things in an exploration of the self-but they can do so unexpectedly. Spacing is the constitutive part of performativity in relation to surroundings.

Of course, individuals are aware of the multiple contexts which interact through performance. Members of the caravanning club, for example, are familiar with its orientation towards activities and the club slogan of going 'where you like when you like'. Allotment gardeners are aware of the possibilities of growing food that influence the way they do things and what they make of the doing-growing crops in particular ways. Each refers to these in describing what they do. Other possibly less self-conscious contexts, such as gender, influence what they do and the way they do it, but these contexts may be drawn into their performativities rather than crudely prefigure what that performance is. These individuals do not merely perform in an expressivity, of anything as such, of anticipations or contexts. Through performance they engage, discover, open, habitually perform and enact, reassure, become, create in and through the performance. So expressivity is both engaging and momentary, not necessarily prefigured by either 'contexts' or representations, or even wanting to respond to what is felt to be 'out there'. They do not bring expressivity 'with them' but constitute it in the now. Furthermore, as Burkitt (1999: 75) argues, our selves and the surrounding world are not engaged as data but our expressive relation with it.

Performing Becoming, Becoming in Performativity

So far I have considered what people do and say they do, and what moments of doing mean to them. In this section I seek to go further in an exploration of spacing in the sense of performativities potentializing the unexpected, complexity, and 'going further'. It is around the possible fulcrum of holding on and going further that this chapter pursues spacing in terms of the performative and seeks to work notions of the performative, in an effort to advance an interpretation of spacing.

Examining individual's accounts and their acknowledgement of what they do, ways in which elements, moments, and nodes-these 'knots' of performativity-

may be signified as becoming, are considered and critiqued. Time embodied: they 'know' it is suspended because they are there, but also because they are performing in particular ways. Things they do may not seem so different if they are considered in isolation from other things.

However, they encounter and know they are doing something in immediate intimate contexts they have created (by choosing to go, by moving to do something) that may use ordinary objects but be touched, shared, engaged in space differently. Sitting outdoors in a deck chair may seem hardly significant, but for one caravanner, Doris, it was, because of the way it was performatively achieved. Standing and staring at a view of water and grass is similarly significant for the caravanner Tim because of the whole series of movements it involved, and the plurality of situations that it invoked, as I discuss below.

In this section I return to the two accounts of Tim and Carol. I suggest that the encounter the caravanner Tim makes is not only a matter of being, but of Grosz's becoming. In Tim's narrative, time spent at the caravan site is spoken of very much in terms of his son's disability. At the site, the son is able to (re)discover his confidence, interact with other people, feel at ease. The family cycles, walks, and can enjoy a barbecue. Particular places on the way to the site are marked with the significance of doing the journey ('Once you pass C-you feel different'). Tim feels that because of what he is doing not only his son, but he too, is opening up to a feeling, that moves beyond what is discovered, of himself and the world about him-they may be said to 'open up'. He feels a suspension of concern and constraints over how to feel. He is feeling doing. Thereby he constructs gaps in his life that he performs and fills. Thus he feels (as) he becomes. He recounts this as something he does from time to time, almost habitually, but rediscovers its feeling every time. He is aware of others doing the same thing, or so he feels. He encounters this performance as his own, and intersubjectively. He expresses his feeling and becoming in language, but it is constituted performatively through his poise and disposition.

In Carol's case, however pertinent her ideology may be, what she is doing is not adequately understood as ideational. She thinks about it as she is doing, and through performance she gets by and discovers. For her, what she is doing is more than an enactment of ideas and values which are prefigured. The character of her ideas is changed; her values elaborated but also grasped afresh, opened up through what she does and the feeling of doing, of which she is aware, as she makes her own spacing of things in relation to her own life. In spacing she is also open to the alternative possibilities of her life and the spaces she encounters. Furthermore, each time she does this it reasserts her beliefs and enlivens them, moves her on beyond merely thinking and being-to becoming. Her ideas become qualitatively different. Sometimes when she gardens she sees or talks with others and that is part of the power this doing holds for her, other-awareness, intersubjectively. She is able to connect values and feeling of doing, and this persistently enlivens and takes further her commitment to what she is doing. Her ideas are opened up in the

process, their significance enlarged. Thus her performance may be said constantly to constitute and refigure meaning.

Gaps, as spaces of possibility, can be created in the particular combination of events, encounters, moments, and flows. Individuals feel differently about themselves, their lives, people, places, and things they value. Activities such as allotment gardening and caravanning can signify the 'disruption of the everyday'. Becoming, temporarily, may be significant in the desire to return and to become again. Caravanners doing rallies usually choose new places to go, and can rework their performance memory. Others return to the same site, perhaps risk failing to repeat their becoming but also may revisit it in what they do, where perhaps the possibility and potentiality of becoming are increased. In each example individuals may be driven by the desires of tasking, in a performance of their identities as they understand them to be. However, their performativity can overflow the limits of tasking and identity play. Risking disappointment and frustrations, in the tasking and the becoming, they return to their performance as a route that offers being and becoming. In both examples there is a transfer of time and space and a refiguring as well as a revisiting of memory that becomes embodied performatively. In these cases, individuals negotiate what they are doing, how they feel, and cope with, or reject, the performances that precede and follow, and occur 'now'.

The complexities of time are invoked in a narrative of ideas and performance. A caravanner explains: 'It's a bit of a sanctuary. I don't think people started camping and caravanning for that sanctuary, it probably comes out of what you're doing because of what you're doing' (Denis, 37, Sheffield, 1998). He considers what he does as productive, not expressive of something else. It may be both. For Carol, each time she performs this space and these activities their character is intertwined and mutually engaged with her ideas in a progressive remaking of their meaning. The nuances of performativity, as she does them, characterize what the activity and its spaces mean, and animate the ideas. At each moment as she encounters, shifts, and dwells in her performance she not only carries through her ideas and values, but elaborates and enlivens them. Similarly, for Tim, the caravanner, 'standing and staring' also draw his performance again and again, serially becoming. What they each do is empowered through the encounters with space: spacing.

As things are done, other events are remembered and re-placed into the present. Memory is also temporalized and can reinvigorate what one is doing now, but also is reinvigorated and can be rerouted in the 'now' (Crang 2001). This is suggested by Denis: 'I get my memories from childhood and camping, which is another important thing, the memories you've stored up. If it were hot you'd put orange juice in the river to cool'.

Spacing in memory is engaged afresh. These memories colour his performativity in the now, but not in a rerun of the past. Individuals refer to previous rallies, planned rallies, and what they have talked about with work colleagues, of what they intend to do and what they value at the weekends. Performing time and spacing appears to be more than a linear 'moving on' from ideas, and memory is operated as an active character of performativity.

As Bachelard argues, we have 'only retained the memory of events that have created us at the decisive instants of our pasts' (2000: 57). These are drawn into a focus through the character of performativity, in nodes and knots of what they notice. When individuals speak of what and how they do, they compile events reduced to an instant. Although we 'may retain no trace of the temporal dynamic of the flow of time' (Bachelard 2000: 57), moments of performance, when and through which things are remembered as significant, can be revealed. In the doing, moments of memory are recalled, reactivated in what is done, and thus memory may be drawn upon to signify; it is less that memory is performed than it is 'in performance'. Thus memory and the immediate are performed as complexities of time. The informants do not simply remember by picking the memory up momentarily, they return to it through performance and reform it. Time, too, is performed again and again, differently, and embodied; thereby grasped from the clock or another time and instead wound up in body performance.

The several strands of happening are negotiated in the performance 'made sense', in complex time as body-thinking beings (Burkitt 1999). This process of negotiating leaves room for the individual to 'take it' where he or she likes. Harvey distinguished 'routine' and transformative action (1996). I want to suggest that in the apparently routine there can be the transformative. Domosh suggests that routine practices can generate their own micropolitics (1998). This can be developed in performance, as in Carol and Tim's expression of values and relations with the world and others. Their performances are significantly in excess of prefigured meanings, tasking, and membership allegiances. Performance-as-becoming is evident in what another allotment gardener says: 'My allotment means peace and quiet, relief from stress; it means creativity, the love of creation, … it means everything to me. I would not be anywhere in the world but here' (Deirdre, 54, Northampton, 1994).

Tim and Carol each make a sketch (Radley 1995); it is this capacity of performativity to be productive that characterizes becoming. It produces feeling, changes the intensity and pitch of how things are signified: what things mean. Yet becoming is not, as we observe, isolated from other parts, or contexts, of life: it is negotiated. As Crossley argued with reference to 'culture' and embodied practice: people do not act independently of culture (1995, 1996), culture is felt bodily (Csordas 1990). When caravanners' value being able to 'go where you like when you like', they compare it with 'the humdrum' of life and 'touch base', but their life moves on through what they are doing. To say 'go where you like when you like' captures the feeling of freedom they discover themselves, but also reiterates the slogan of one of their clubs; even though the planned freedoms are within the choice confines of local club-arranged weekly venues, in agreement with landowners. In both cases there are regulations and constraints, yet these do not necessarily have a priori constraining influences on the ways in which individuals may performatively space them.

Spacing and the Negotiations of Performativity

Shotter argues that the intimate plurality of ongoing performative encounters is invisible to us, thus unacknowledged (Harrison 2000: 502; discussing Shotter 1993: 2). The body is elusory (Radley 1995). Taussig warns against overinterpretation, particularly in looking for codes of others, of being 'simple minded and manipulative in presuming meaning on others (1992: 141). However, through a consideration of narratives that connect the actions that individuals make, their commentary on those actions and how they feel, it has been possible to get close to the mechanisms of performativity. In each case discussed there is a reference, often barely explicit, to space.

Although evidence of becoming does not emerge in all the narratives researched this discussion has drawn upon particular cases that appear to demonstrate the mechanisms of performativity in spacing. Through encounters with, and in space, individuals can express. What individuals do may not routinely offer, or be done as a means to offer, an opportunity for becoming; or at least individuals may not seek to connect the significance of what they do with any more than its 'passing time'. Yet 'killing time' and 'just being lazy' may conceal the possibilities of their performativities. Frequently respondents in each activity situate what they do in the habitual, in repetition and in tasking, in narratives of journey manoeuvres and equipment, club procedures and places visited, preparing ground for planting and fixing fences, getting on with each other and not doing so. This regularity and knowing in advance what they do can be intimated as security in what they do: in not having to bother, in avoiding disruption. In these varied ways individuals can contest and negotiate the tensions of the unexpected and the habitual (Carlsen 1996, Grosz 1999). There is a pervasive tension in the narratives between holding on and going further that many respondents appear to negotiate, and these can be played out in their encounters with space. Their apparent holding on suggests a safeguarding of the parts of their lives which they feel provide identity, control, and being able to engage repetitively on the ground they know and perhaps at the same time, perhaps for others, this performance emerges as something new.

Does the performative bear upon identities? Burkitt (1999), from a perspective of embodied practice, argues its importance in the refiguring of negotiations of the complexities and fluidities of contemporary identities and values, and argues that 'the bodily' is significant in the ways that identities are constituted. The reconstitutive suggests potential refiguring of identities. Identities may be characterized in practice and performativity, and then negotiated with contexts. Through our bodies we expressively perform who we are. The fluidity and openness of performativity may be used to refigure identities, working alongside (other) contexts in the way that Barnett has argued the 'flattening out' of contexts and practices (1999). The body, in its performance, signifies, as well as is signified by, our identities; and, as Butler argued, affects and is an affect of our identities. Identity can be significant in the intersubjective character of performance, in its embodied semiotics and in being and becoming 'in relation to others', in structuring

feeling through doing (Harrison 2000). The identities of individuals such as Tim and Carol are not constituted only as gardeners or caravanners. Although they can define themselves in relation to a club they self-define as people through their idiosyncratic performativities. They thus negotiate, unevenly, routes and roots (Bell 1996: 9).

Performativities can distinctively colour geographical knowledge. '(T)he ability to reflect consciously on thought and sensation, which are initially spatially located, comes through this symbolic dimension. This dimension is blended with space and time, for symbols are used for a means of communicating with others a means of communicating with ourselves' (Burkitt 1999: 80-81). These events are engaged in multiple flows, across events and amongst contexts in plural ways, as practical or performative ontology (Dewsbury 2000: 477, Shotter 1993).

Conclusion

In this chapter the practical content of how individuals act performatively has been sketched through narratives and field descriptions. In particular, the performative capacity of everyday habitual tasks has been reconsidered in terms of individuals' imaginative and reconstitutive possibilities, in an effort to bring both the activities and the conceptual debate to life (Thrift and Dewsbury 2000). Performativities, similar to expressive, embodied practices, can produce numerous hybridities, exemplified in the diverse interpretations and in the way individuals do, discover, and speak. I suggest that through these hybridities new possibilities and connections may be made. Although the events considered here are only slices, relatively isolated, in peoples' lives, they matter to them. These connections and the working of these events in relation to other spheres of life-work remain important areas for further affirmation of the significance of performativity.

Performativity and embodied practice each provide valuable resources to interpret the ways in which individuals may adjust the significance of things; they also assist in focusing attention on the mechanisms, and their potentiality, through which spacing may work. These individuals demonstrate a tendency to use performativity, in a tension of holding on and going further, in a process of self-monitoring. Those tendencies are influenced by the contexts in which they live, but in complex ways. Individuals may be attracted by the popular image of an activity that others may regard as regimented; each possibility symbolized in particular representations of space that may resonate in divergent ways. In each case their performativities may follow or diverge from these contexts. The spaces in which these activities happen are not unprepared in popular culture and its representations, but what each individual may make of them may be significantly 'theirs'; just as the encounter does not merely 'refer back' to these representations nor act on a tabula rasa. Individuals arrive at what they do and feel through a complexity of performativities and contexts (Nash 2000: 658) and thus may have the power of refiguring and of being reconstitutive, and may do so through spacing.

Across several of the individuals' narratives in this chapter there is a process of selection and identification of particular performative content and character that emerges, and is significant, according to the respondents. These nodes, knots, or events may be of particular significance as they draw upon, and may be compared with, multiple times and spaces in their lives. Performativities collide and these knots contain the potential for numerous tensions that mayor may not be negotiated, coped with, or realized in becoming. The unexpected may emerge during and between the time spent in tasking.

Finally, there is ambivalence between being and becoming. There are continual tensions that individuals cope with between holding on and going further, between adherence to contexts and their protocols, and moving away from them. At the same time, when the habitual appears closed, it may not be. In the cases considered, performance-as-becoming does not necessarily orient to dramatic adjustments of structured relations, but the intimacy of performativities can unsettle and reconfigure. Insights such as these may provide orientation as to what matters to individuals and to the way worlds are constructed, and how 'what matters' may be constituted. Moreover, although the power of contexts have, explicitly, been underplayed-though not unacknowledged-in this chapter, there is a need to explore consistently the mechanics of the performative, and the contextual, and its protocols in terms of the diversities of gender, age, ethnicity, and other cultural and social frameworks, and their representations. Furthermore, in thinking through the gaps and cracks in making sense of the world there is fertile ground for considering how far performance in the mundane can extend and leak into and across other values, relations, and significations through which individuals may act, feel, think, and adjust.

Afterword

Amongst these experiences there is a commingling of an imagined, almost utopian community, individuals getting along with life and getting together in a variety of ways, in a physical proximity that familiarly varies across time. Neither case purports to unravel a utopia, rather the everyday character of flirting with space. Antipathy and conflict can emerge too. This is a politics not of trivia but of identity, values, feeling, belonging and meanings; of expressing oneself in relation with and to others through working the ground. These concerns emerge in mutual care and regard, but can reveal deep tensions of apparently simple things: between individuals or subcultural groups whose aesthetics is of a neatness and a performed patterning of the ground, and others who have a passion for growing crops in intense periodic family group cultivation; or letting wildness in that can blow unwanted seeds to adjacent plots, or growing chemically in that can produce pollution.

Themes of stillness and slowness emerge in an apparent 'mobility': 'Sometimes you just sit down and look at trees and things, it's nice to get to the

quiet' (caravanner, Harry, Weardale, 1999). 'This is my little bit kingdom' (plotter Jack, Newcastle, 2001). Feelings of belonging occur, yet also disorientation: 'the field' in which these events happen are more than simply being outdoors: 'in the middle of a field, in the middle of nowhere' (Derek, Essex, 1998); 'I started putting ornaments in the "van" because of Sarah. She kept saying "fancy coming here with a van and not having anything of your own inside". She dresses hers up with ornaments. It becomes a bit of a mickey-take. You dress it up like home. You take the dressings with you' (Sheila, Essex, 1996). Embedded in becoming, whether in the expressions of the plotter Carole or in a very different expression 'the countryside does not matter; all you need is a few cans and a field', is a feeling of adjustment, of making the thing happen and feel its resonance, of human relations, nature-relations. Field, countryside, sanctuary, community, are decoded from context-explicit meanings (Crouch 2001).

Lay geographies and lay popular cultures emerge in practical ontologies and their shifting, shuffling identities that move amongst worlds of holding on and going further. The apparent duality that this implied coupling involves is of course not a duality. The energies participating in these terms are multiple and complex and felt in different strengths. These are some of the themes pursued in the next chapter that reflects further the evidence and insight of this chapter forwards with a number of other evidences and an expansion of key threads of debates concerning the unpacking of the spacetimes of things we do.

Chapter 4
The Play of Spacetime

Introduction

The idea of 'going further and holding on' articulates multiple tensions at work in living. These prompt particular aspects of doing, feeling and thinking through which our worlds are encountered and realized in and across sites, their spaces, practices and times. In this chapter I focus the character and occurrence of these energies through particular themes of current theoretical discussion. These open up the character of different kinds of journeys we may make across spacetimes, and moments of creativity that can emerge through flirting with space. In doing so, I hold on to the importance of social, cultural and other contexts, in ways that can be as much background as foreground. The representational character of flows is considered in ongoing, fleeting, fragmenting and re-gathering forms and modalities. Moreover, commingling of affects amongst things we can touch and feel; materiality and non-human life are engaged. I seek to elaborate further the theoretical building across the previous chapters in relation to the diversity of our lives and processes at work.

The first of three main themes in this chapter is a consideration of complexities and relationalities of our performing spacetimes and how individuals work things out temporarily and contingently, of practices, moments and emotions. Memory and ideas of individual and shared feelings emerge to problematize frames of identity and relations. This first concern connects very directly with the second: ideas of belonging and disorientation. Amidst arguments of de-differentiation and distanciation, spacetime compression and the greater reality of the (un)real emerges some very different evidence that prompts closer thinking that involves more attention of everyday life, of living.

Third, I engage the often intense debates concerning intensities through which change and creativity can occur in order to question the more extreme considerations of contemporary living that privilege huge, mega-intensities of affect. A greater nuance and complexity is revealed. I relate the notion of intensities to recent discussions concerning play as a means to unravel how the making of significance, meaning and feeling are handled across different parts of living. I suggest that play is drawn through what are popularly felt to be 'leisure' and 'tourism' as working categories. These are not ideal categories but offer opportunities for critical reflection on process in the flirtive handling with space, feeling and becoming. 'Work' easily offers itself as another combination of energies through which life is worked relationally in spacetimes, and merges with play. A feel of more everyday

influence through living and its diversity of affect engage materialities in a tactile and emotional way that further affects sense and meaning.

Through each of these sections a range of empirical material, including some that emerges from earlier chapters (2 and 3) is engaged in keeping attention closely related with doing and the feeling of doing, its becoming and creativities (Crouch 2001). Through each of these sections there is an amplification of sociologist Alan Radley's sensitive reading of flows and the relationality and commingling of affects:

> The body's imaginary grasp involves a transition of sensory conditions that anticipates its meaning in the sphere of objects. This might be the careful application of wax to a wooden table with a woollen cloth that lends warmth to everything it touches. In the sphere of social relationships, the way a dancer touches her partner with a lightness that signifies (that opens and invites) gentleness rather than distance. (Radley 1995: 15)

We might readily add the affect of the cloth, the table's response as well as signification in touch and sight, the smell of the wax; the gesture of the touch embedded in its extension of emotion and relation. In these sections the mingling affects of plants, soil; sand and metal pursue this feeling. Affects merge less from different segregated orientations, but in mingling, are ongoing and disrupted.

There is a particular sensuousness and a tactile way of knowing that is central to everydayness, in a feeling of 'finding and losing the way' (Cocker 2007). This 'includes much that is not sense so much as sensuousness, an embodied and somewhat automatic 'knowledge' that functions like peripheral vision ... multiplicities of often reductively understood 'gaze' of vision' (Taussig 1992: 141).

As Vergunst remarks '... therefore sensuousness rather than study ... pervades the everyday' (2008: 108). Bachelard argued that 'phenomenology of the imagination cannot be content with a reduction which would make the image a subordinate means of expression ... Image ... lived directly, that they be taken as sudden events in life ... when the image is new, the world is new' (Bachelard 1994: 47). In a similar expressive liveliness he contends that the image 'is at once a becoming of expression, and a becoming of our being. Here expression creates being' (Bachelard 1994: xxiii). Loosened from the representation/non-representation duality, the representation has expressivity.

Relational Spacetimes

The writer W.G. Sebald's reflections in the book *Austerlitz* engage some of the complexities of spacetime; the emotional character of our flirting with space; its relationality in journeys, time and the adumbration of memories. He expresses the ways in which such journeys can disrupt our feeling of spacetime and work

relationally in interflows of dislocation and disorientation and provoke emergence of creativity:

> ... It was only by following the course time prescribed that we could hasten through the gigantic spaces separating us from each other ... there was *something illusionistic and illusory about the relationship of time and space as we experience in travelling, which is why whenever we come home from elsewhere we never feel quite sure if we have been abroad.* (Sebald 2001: 14, my italics)

Here he reflects on his character's memory, grasped awkwardly in Antwerp railway station's waiting room. He realizes this waiting room must be the one where he arrived over 50 years earlier, a young Jewish refuge from Germany during the second world war. Sebald loosely offers rather than constructs a somewhat chaotic patina of fragments of feeling and memory, cuttings from different publications, rail tickets and family photographs. He likens experience and feeling to the notion of the traveller, someone living in different places and times whose wider life journey is felt to be one of fragments, ill sorted in spacetime, and in relation to his life. Frequently the fragments give a sense of bewilderment: they do not easily compose. Yet nonetheless these fragments are reflected upon in ways that curiously articulate and merge with different feelings of living, in an effort to assemble something of belonging and identity. These moments of reassembly have a potential to create, revisit and unsettle identity.

This dislocation can also hold a translocatedness, as later in his story he recalls:

> a late November afternoon in 1968 when I stood with Marie de Verneil – whom I had met in Paris, ... when we stood in the nave of the wonderful church of Salle in Norfolk, which towers in isolation above the wide fields, and I could not bring out the words I should have spoken then. White mist had risen from the meadow outside, and we watched in silence as it crept slowly into the church porch, a rippling vapour rolling forward at ground level and gradually spreading over the centre of the entire stone floor ... (Sebald 2001: 192)

Flirting with space across different sites can correlate, however awkwardly. These memories are felt rather than ordered neatly or held in polarization. They emerge unselected, flowing as if around him and in him:

> Memories like this came back to me in the disused Ladies' Waiting Room of Liverpool Street station, memories behind and within which many things much further back in the past seemed to lie, all interlocking like the labyrinthine vaults I saw in the dusty grey light, which seemed to go on for ever. I felt ... that the waiting room *where I stood as if dazzled contained all the hours of my past life, all the suppressed and extinguished fears and wishes I had ever entertained, as if*

the black and white diamond pattern of the stone slabs beneath my feet were the
board on which the end-game would be played, and it covered the entire plane
of time. (Sebald 2001: 192, my italics)

Unexpected and un-routed juxtapositions of unsettling and recovery of self and
belonging appear in unbidden manipulations and mixings of spaces, multiple
memories and presents.

Sebald grasps at the moments of memory and journeys happening in spacetimes
across different moments of spacing. Grasp is problematic and agitated, coloured
with memories of delight, alienation and disorientation. Things cannot neatly be
related, engaged and simulated. It is interesting to consider ways in which his
assemblage of spacetime journeys differs from John Berger's moment by a field.

> It is a question of contingencies overlapping. The events which take place in this
> field – two birds chasing one another, a cloud crossing the sun and changing the
> colour of the green – acquire a special significance because they occur during
> the minute or two which I am obliged to wait. It is as though these minutes fill
> a certain area of time which exactly fits the spatial area of the field. Time and
> space conjoin ... the field that you are standing before appears to have the same
> proportions as your own life. (Berger 1979: 193)

Berger's feeling of time and space as conjoining, perhaps commingling, and into
moments of spacetime imagination are engaged, drawn forwards. He felt as though
'inside' the field, not merely looking upon it. He expresses being surrounded by
the living of the field. His expressive account suggests a unity, a holistic character
in the moment and its antecedents; felt for a moment. The existence of its moment
actually avoids fixity and stasis, and is actually full of life and ongoing. He points
to a moment in the same way as Sebald, in a different register.

Some recent work on 'mobilities' has sought to underline the importance of
increasing detachment and dissociation in the ways in which space is noted in
crossing distance rather than being engaged (Urry 2007). That work clearly pursues
the primacy of the gaze that has become evidently widely contested (Urry 1990,
2003). Life is most importantly multi-sited; identity can occur in translocationally
(Conradson 2007), but also in ways much closer to 'home'. There is an effort
to claim the relative importance of mobility over familiar and acknowledged
sociological and social categories of class, gender, ethnicity and age. The growing
importance of mobilities (things, human and non-humans, virtual communication
exemplified habitually in conference and tourist trips, the net and suchlike) require
critical understanding of process and life's everyday complexities, not forgetting
the varying emergence of social class and so on, not to be reduced to the barest
Latourian bones of networks.

Rhizomic character includes nodes; immigrants often project themselves
in relation to specific origins that do not necessarily undermine multi-locality
or transnational connections (Fortier 1999: 41). Even in an exaggerated use of

information technology, for example, we sit at a connecting screen but wander a bit to take coffee, visit the bathroom, meet family, buy cigarettes from the shop, feel discomfort where our body meets the chair. As Malpass observes even concerning the 'world-connected practice' of internet use we are not outside 'the real', even in playing online games: 'one's interaction with the game is itself dependent on its physical locatedness' (Malpass 2009).

The emergent discussion of mobilities tends towards elision and confusion with Deleuze and Guattari's discussion concerning immanence, becoming and potentiality. Occasionally mobilities 'touches the ground' of everyday life (Creswell 2005). It is more exercised in the often chimeric significance of wires, trains, 'plane windows and digital cameras (Urry 2007, Larson and Haldrup 2010). The mark of mobilities emphasized in this way evinces an ahistoricity of movement and migration. It seems to give little to understanding processes through which meaning or feeling may be affected. Creswell has been more connected in saying that 'mobility is becoming', that gives mobility a stronger engagement with performativity, of 'placed mobility' and its relationalities (Creswell 2006: 47). Frello wisely draws attention to the risks of romanticizing mobility that sought to avoid the romanticism or reification of fixity (Frello 2008). The writing of 'mobilities' generally lacks engagement with the character of feeling, performativity and becoming. The individual is, in the height of the Latourianesque, merely caught in nets that go elsewhere.

In the following sections I examine more closely the character of practising and performing space, through the tentative and incomplete notion of flirting. I engage the often very visceral as well as imaginative ways in which depth in moments of experience emerge, are part-constituted and yet negotiated in feeling, thinking and doing. The relational potentialities of spacetimes are pursued in the following section through attention to belonging, disorientation and becoming.

Belonging, Disorientation, Becoming

What is familiarly termed 'experience' is entwined with 'being' and 'becoming'. Each of these may be in continual flux (Jackson, M. 2006), yet, as this chapter folds, there is a complex, if loose-fitting relationality of flux, contexts and affects. Being can be grasped, then, in relation to a search for self or of belonging and circumstances of some control in life, its doings, feelings and thought, thus identity (Andrews 2009). Being and becoming fold together. In a reflective epilogue to a collection of essays on experience Geertz found that it is 'the elusive master concept ... that none of the authors seem altogether happy with and none feels able entirely to do without' (1986: 374). Indeed 'it will not do to identify what we are getting at with a negative term, as something non-representational' (Csordas 1994: 10).

Identity has been familiarly held in sociologies of prefigured contextualizations of class, gender, ethnicity, generation and cultural capital (Louis 2009, Bourdieu

1984). As socially transmitted identities become understood to be less intransigent and fixed, identification became increasingly referred to commodification, presumed linear processes of contextualization and consumption as major conduits through which contemporary meanings occur (Featherstone 1995). The diversity of subcultures and resistance complicates this framework (Hebdige 1979). Increasingly the debate has shifted to acknowledge the active participation of the individual (Miller 1995, 1998). However, through an attention to bodily action, knowledge and the potentialities of performativity, Burkitt positions identity in a much more subtle, complex arena emergent through practices and their contingency; individual encounters and practical ontology and their multiple interplay merging with contexts. Indeed, with Burkitt, I would argue that this is how most people function in their everyday lives: by acting on the basis of a sense of what ought to be done, drawn from experience of previous situations and the tacit knowledge that has developed, along with 'gut feelings' about which is right in the circumstances. Most people refer to this as intuition or common sense, where it is actually a complex interplay of knowledge and feeling (Burkitt 2004).

Feelings, recall or memory and materialities become unsettled and shuffled in new ways in our composition of self and its grooved relations. Emotions are increasingly acknowledged in their affect upon our lives and identities, the spaces that emerge in our doings, vibrations of space that affect us; a spatiality and temporality in emotions and 'how emotions are produced in relations between and amongst people' (Bondi et al. 2004: 1, 3). There is a relationality of belonging and identity that draw on our pasts and presents (Fortier 1999). Identity is an embodied event (Budgeon 2003).

Space can feel 'belonged' through how we express and feel; the combination of relations and practices through which we contribute to the constitution of spaces. Multi-sensual experiences and their immanence and possibility draw practice and performativity of spactimes into remembering, presence, absence and loss (Radley 1990, Wylie 2009). In a sensitive essay Owain Jones expresses autobiographically emotional significances of belonging (2005). He is concerned particularly with the merging of memory and contemporary, happening, feelings of belonging: drawing disoriented alignments in recall, connecting and feeling loss. He says 'Memories mobilise, a landscape within me comes alive, yet into something fresh. I change' (Jones 2004). Jones' belonging and identity are not fixed in a particular spacetime, but draw upon it. Resembling the passages of Sebald, Jones explores his life, his space that he acknowledges through emotions as intensely political, gendered, and spatially articulated.

Belonging and disorientation work in practices of emotion, becoming and the negotiative tensions of 'holding on' and of 'going further' in relation to particularities of space and its encounter. In this narrative Jones' belonging is situated in a particular past and its memory, not Sebald's constant refugee flux but as powerful because the sites of memory rather than its life and materialities rendered of that space have been literally erased. Sebald and Jones do not engage a linearity of belonging or loss, rather the tensions of belonging and

disorientation. In ways that resonate with this complex process of belonging and disorientation anthropologist Daniel Miller draws together materialities and their memories in his consideration of making comfort amidst the complexities and turmoil of everyday living (2008). In Miller's investigations of consumption he finds habitually its cultural contextualized, but also its practised and performed, character (1995, 1998). The relevance of Bourdieu's cultural capital continues, as long as its' changing character, across flows of changing difference and relation, are engaged (Bourdieu 1984). As Lee explains, the polarisation of consumption and production, and their creativities, has seriously misunderstood the way things happen (Lee 2010).

In the following paragraphs of this section I address the ways in which identity and identification in relation to spacetimes occur in our lives. I attend to the potential of belonging through contemporary presents, particularly in performativity, The discussion draws across a multiplicity of experiences, performativities, memories and other 'belongings'. In a narrative of his habitual journey to work the cultural theorist Wise comes across feelings of 'home':

> ... A familiar road, landscape, even traffic. The trip's rhythm is marked by mile markers, exits, radio stations whose signals strengthen or collapse, struggling, into a haze of static as you cross that crucial hill that marks the curve of the earth. Books on tape ... lend a sustained thread against the further fragmentation of time. Other temporal rhythms follow: the slower pace of the change of seasons over the well-travelled hills of eastern Georgia; time marked by encroaching or receding kudzu vine. After a while the trip falls into routine, into habit ... The space outside recedes into a blur ... Like a hermit crab, I carry my home on my back, my stuff scattered about, bags packed in the trunk. (Wise 2000: 295-296)

Out of this seeming chaos belonging appears:

> The marker (wall, road, line, border, post, sign) is static, dull, and cold. But when lived (encountered, manipulated, touched, voiced, glanced at, practised) it radiates a milieu, a field of force, a shape of space. Space is in continual motion, composed of vectors, speeds ... Beyond the walls and streets of built place and the song of the milieu, we mark out places in many ways to establish places of comfort ... Home is not authentic or inauthentic, it does not exist a priori, naturally or inevitably. It is not individualistic. The relation between home and the home is always being negotiated, similar to what Foucault once called "the little tactics of the habitat. (Wise 2000: 297)

Wise inflects the dynamic character of belonging through a consideration of home in everyday living through reference to Deleuze and Guattaari: 'habit *draws* something new from repetition – namely difference' (Deleuze and Guattari 1994: 73, emphasis in original). This is not the difference that is the simplistic measurable distance or even timespace that is resonating; this is the difference that is introduced

in each iteration of a repetition; a little chaos in the interstices of order. Indeed, it is that difference that allows for the home resonance in the first place. 'What makes home is the repetition and difference of habit' (Deleuze 1994: 304). In emotion and feeling, the expressive is present (Deleuze and Guattari 2004: 315).

Using journeys metaphorically Bachelard suggests that '(e)ach one of us, then, should speak of his roads, his crossroads, his roadside benches; each one of us should make a surveyor's map of his lost fields and meadows' (Bachelard 1969: 11). To argue relationality and connectivity as well as disconnectivity is crucial because only then can we begin to disarticulate the idea of home from ideas of stasis, nostalgia, privacy, and authenticity, which, as Doreen Massey has argued, are then coded as female, and present a more open and dynamic concept that does not tie identity to static place or reproduce gender inequality by articulating women to enclosed prison-homes while the men wander free, wistfully nostalgic (Massey 1994). This is not to argue that homes are not gendered, they are also but not only so (Miller 1998).

Cultural and social theory has until recently been concerned with identity. Serious thinking concerning belonging, embodiment and emotion has drawn richer lived character into familiar discussions of identity, engaging clashing flows, divergence and convergence (Smith et al. 2008). They merge as fields of human relationality in the world, not least through spacetime and its contingent constitution. Instead of being only socially constructed ethnic identity, for example, is routed in contingent subjectivities in the intimacy of life situations and relationalities, engaging self and others, daily practices and memory. Noble refers to the messiness of gendered identity (Noble 2009).

Hester Parr's work on the sensitive, dynamic performances of inclusion amongst individuals with particular disabilities resonates with the potentialities of belonging amidst disorientation; through and of caring and doing, discovering new feelings and possibilities, as well as through repression, detachment and loss. She considers the experience of individuals with especially mental disorder in the Highlands of Scotland. Belonging can emerge through expressive, emotional and practical ontologies of care (Parr 2008). As Davidson and Milligan explain, emotion is profoundly embodied: '... bodily tasks of resting and eating, working out, or just getting around can be "fraught" with fear, guilt and shame or fused with adrenalin thrills, cravings or dreamt-up desires' (Davidson and Milligan 2004: 523); '... emotions are produced in relations between and amongst people' (Smith et al. 2004: 3). Emotions affect belonging and are affected by it. They inflect character, significance, meaning, pain, loss, clinging, re-realization and comfort.

Henri Lefebvre suggests rhythmanalysis as a possible method of investigating everyday life (Lefebvre 2004). Lefebvre's notion focuses on rhythm as *already related* to space and body (Simonsen 2005). The concept of the everyday already implies rhythm in a focus on activities that occur every day (Amin and Thrift 2002, Crang 2001, Edensor and Holloway 2008). Our lives occupy space of heterogeneous temporalities and rhythms of clock time and work hours, seasons,

timetables, emotions and our own time or times; calm, hectic, dense or superficial in mixtures. Negotiating our lives partly through the feelings of these spaces we get involved in reassembling, constituting and refiguring their flows and rhythms (Crang 2001), avoiding the dualistic use of synchrony/diachrony (Massey 2005: 36). These dynamics are embroiled in the relationalities and interconnections of nature and space as emergent, creative and ambiguous qualities revealed through social practices (Hinchliffe and Whatmore 2006, Whatmore 2002).

Repetitive doing involves us semi-aware in a process of feeling complicated by the varied social and cultural contexts of bodily practice. This process has become fairly well documented in terms of walking, its cultural geographies and histories: wandering, rambling; a leisurely stroll and being voyeur (Edensor 2001, Ingold 2007b, Watson 2003, Wylie 2002, 2005, Pink 2010). Thrift particularly emphasizes the importance of going beyond walking to automobility as a better trope in what he argues to be the increasingly more contemporary modality of mobility (2008). Whilst each of these may be inflected with gender, or age, (dis)ability and so on, they are loosely woven into what these walkings mean to our lives. In the following paragraphs I take the insights of walking to other possibly more multiple 'doings', complexly negotiated in living (Szersynski, Heim and Waterton 2003, Crouch 2003, Cloke and Jones 2003, Ingold 1993: 192).

Increasingly diverse practices have become a focus in critical attention to encounters with space, phenomenologies and investigations of performative becoming in dance, much influenced by performance studies (see Noland and Ness 2008, Thrift 1997, Nash 2000). Gardening has emerged from an embarrassing conceptual mundane into a field of active enquiry (Crouch 2009), as an array of other nuanced and complex practices and their performativities (Crouch 1999, Cant 2003). In examining a diversity of practices and their potential performativities a richer insight into the complexities of living and becoming begins to emerge, but these individual investigations tend to throw light on one slice of living and relations amongst individuals. Such an attention tends to be practice-specific rather than investigated relationally in terms of different things individuals do. However, the close-up feel of human feeling, doing and living pushes much further *than a consuming of spaces perspective that has* survived too long (Urry 1995, Goodman and Redclift 2009).

Fluid time persists as an awkward, chaotic thing; an awkwardness of belonging in moments of presence that resonate the way in which sociologist Anne Game conceptualized the dynamic character of belonging. Belonging is often conceptualized in the nostalgic characterization of the past. In contrast Ann Game (2001) argues for a belonging that is experienced in our everyday living yet not divorced from memory and which emerges out of feeling like a child.

> Moments when we feel wide-eyed, wide open, in love with the world. Running into the waves, the salt-smell spray in my face, or feeling the sand between my toes ... these are moments of feeling "this is right", "now I have found what I

have always been looking for, what I have always known". I get that "coming home" feeling ... that might best be described as a sense of belonging. (Game 2001: 227)

Belonging emerges through the duration of life and across its journeys, both momentary and over a long trajectory; they produce flows of time that can be detonated into significance, in the way that Grosz discussed the potential of performativity (Grosz 1999). Journeys in life happen in durations, across time and times. Belonging in disorientation can be worked out.

Stories from gardeners and caravanners considered in Chapter 3 express the journeying across daily tasks through which particular kinds of creativity emerge: of the relation we may have with plants, equipment, insects, dragging materials, soil, individuals. Feelings are come by in quiet and slow actions and doing that can produce new ways through which individuals discover and lend character with spacetime. These fragments of process can contribute to belonging, to self and inter-subjective identity. Gardening's journeys are numerously faceted: from home to the plot on foot or by cycle or car; in the heavy intimate distances of the plot and of the surrounding plots, in simply standing and feeling the space of non-human material around one; in trawling memory and objects, actions, separations from home. In the creativity emerges an expressive act, in waves, a few words, in sharing crops. Of course it can be argued that gardening is highly gendered or technologized (Longhurst 2006, Hitchings 2005), yet a richer feel of belonging and the complexity of its relations emerges.

The caravanning stories express a series of journeys. These can be across varied distance, regularly and infrequent. Feelings of belonging can occur. These accompany emergent creativities of feeling, association, isolation, inter-subjectivity, doing something different but bearing mementoes or tributes of home and continuity. That continuity can be sustained by the transfer of simple, reassuring tasks. These fragments of creativity are expressed in movements, talk, actions and shared memory. In the allotments and in the caravanning stories there is a commingling of the site of doing, memory, emotion, materiality and belonging. There is rhythm in their matterings too (Edensor and Holloway 2008). In each case things happen with some relation to the context and institutional history and politics. These journeys and their quiet creativity resemble Miller's account of the comfort of things through accumulated material goods that give meaning to individuals' lives, histories and presents, in emotion, comfort and identity (Miller 2008). Shopping, 'do-it-yourself' pastimes, car boot sales and plant-buying tactics can help to crack familiar conceptualizations of contemporary consumption in a way that acknowledges neither the splendour of the 'availability' (sic) of consumer products, in some cultures aplenty, nor the terrible reductivity of human life it delivers (Miller 1997, Gregson and Crewe 1997, Lee 2004). The media, as Morley explicates, is not merely 'consumed and used in context ... (it is) better to connect patterns of media consumption to the material geographies in which audiences live out their lives' (Morley 2001: 426, my parenthesis).

Tensions occur in the complexities of belonging. We visit people across town, across country and across continents; across the road, next door, downstairs, into the park. Pearce's story emerges during a journey to her parents at the other end of the UK, she participates in flows of living, time to reflect. Lynne Pearce captured her own complexity of feelings:

> ... travelling "back home" is always, of necessity, a *journey through home* as well as space. Things are changing – in the house, in the surrounding villages ... my parents are ageing. My returns blind me to a good deal of this. My apprehension of this home, indeed, has all the qualities of a dream where past and present mix and coalesce ... my parents are seen and remembered as they were; sometimes they are now ... My own ghost, meanwhile, flits around the place in a state of intermittent erasure. (Pearce 2000: 163)

Tugs of emotion mix multiple belongings; their tensions experienced in a wide variety of cultural character in, for example, being with friends and relatives across the city or across the world.

Norwegian geographer Inger Birkeland narrates an unfamiliar wonder of being that transforms her from feelings of detachment from the familiar and entwines her in something much more significant, a seemingly 'remote' sense of belonging, visiting the Arctic Circle at midsummer in Scandinavia:

> In the evening I was waiting for the deep red midnight sun. I was alone but didn't feel lonely. We were many who shared the act of waiting for the midnight sun ... Even if we were strangers to each other, there was a mutual feeling of waiting for the midnight sun ... as more and more visitors arrived at the cliffs, I felt like I was walking in a multicultural, multicoloured city ... The words uttered were the uncomplicated, the kind of words that sound trivial outside the there and then. But they were not trivial, rather they represented another way of creating meaning out of the meaningless, Order out of Chaos, light out of darkness. (Birkeland 1999: 17)

Inger explores her experience through the writing of Kristeva, as engaging the poetic character of our experience of being contained in the world as in the womb. 'A womb-like state where all needs are (felt to be) capable of being fulfilled' (Birkeland 1999: 27). Her experience felt shared yet semi-attached. The iconography of the 'Northern Lights' provided an aspect of anticipation, but the moment became her own and 'immediately took us beyond an immediate feeling of fun and enjoyment to one of wonder'. Creatively she finds the journey complex, away from home but belonging, somewhere unawares became intimate. In the moment of her performativity creativity erupts as a change of register, not in habituation or ritual.

There can be a sense of protection in the feeling of something as 'sacred' in a configuration of ground. The feeling about its materiality and embodied metaphor,

protective and against violation by the banal can happen anywhere. To consider
the sacred in terms only of the preordained sacred or bourgeois-romantic is to
ignore the lives and space of most people. The idea of 'escape' in disappearance,
in the crowd, or in the familiar, becomes more complex (Crouch 2003). These
reflections are pursued in a later section and in Chapter 7.

Recalling the significance of passing time on the beach at Bondi, Game
expresses the feel of sand on her body as she moves, as she lies; the feel as well
as assurance of the book at her side or in her hands; her memories of how it *felt*
doing similar things when she was younger; the water splashing around her, and so
on (Game 2001). She understands the encounter of being on the beach in relation
to spacetime and belonging, in moments spread across fragmented durations. Her
enaction of memory in gentle movements and moments makes for a powerfully
felt realization of belonging.

Reflecting upon Bachelard's insightful and evocative intimate notes on spaces,
times and intimacy of moments Game identifies 'the combination of "I know
this already" and "this feels new"' (Game 2001). The present can include 'a re-
living' in a living heightened by the presence of a living past; re-engaging the pasts
anew in the present. From this and Bachelard's writing (1994) she underscores
the power of his phenomenology in understanding imagination and creativity,
of going further and transcendence and a sense of wonder. 'Out of this mutual
improvisation one loses the sense of nature as prefigured and merely being played
out; instead, the performance of nature appears as a process open to improvisation,
creativity and emergence, embracing the human and the non-human' (Szerszinsky
et al. 2003: 4).

Tim Winter's fascinating sociological investigation of individuals visiting
Angkor Wat in Cambodia engages the ways in which a prefigured site can be re-
interpreted in an embodied way (Winter 2007). Here emerge feelings and meanings
of a dynamic heritage-in-the-now, as moments of belonging in disorientation.
Memory, identity and its politics emerge through the diverse ways in which
individuals, collectively and in distinctive cultures encounter a prefigured,
labelled 'heritage' site in doing, feeling and thinking in the process of visiting and
emergent in disorientation (Crouch 2010b). Our heritages are perpetually being
formed; particular marked 'sites' resonate through what happens in their flirtive
performativity, including our memories. 'It' (heritage) is not crudely proscribed and
works through our connectedness and not with anywhere, in any moment of flow.

The anthropologist Hazel Andrews spent holidays with English package visitors
in Magaluf in Mallorca (Andrews 2004). She documents a range of activities
shared amongst individuals who by and large did not know each other before
their visit. Many of their activities are significantly racist, sexist, homophobic
and nationalistic. A likely, or lively excess of alcohol and cross-over references
between food and sex, food and nationality (characterized in the ubiquitous all-
day English breakfast) combine with these other characteristics in constituting a
sense of belonging, and an English identity that they feel yearned for in England.
Their imagined identity is with a distanced but fantasy past of who they are: an

imaginary community of practice. Thus their doing in this location and its ambience crosses over their belonging and identity: in clubs, pubs and in how they disported themselves paradoxically reminding them they are 'at home' in the more-than-home that they create.

Belonging and identity through doing spacetime are always emergent and in process; open, fragmented, contingent, full of possibilities and potentialities, never reliably constrained. They are too dynamic and vital to be so:

> I have become a collector of shards. Shards of memory, things passed down: told to me at the end of this long line of telling. I want to catch these shards, this half-lit, often, paste jewels. I don't know how authentic they are, does it even matter? For me it doesn't matter. I am making anew, building something from the remains. Wanting to honour the fleeting; the fragment, fractured histories and stories. Not passed down, but dredged up. (Terri-Ann White, 2004, 520)

Although we may retain no trace of the temporal dynamic of the flow of time, moments of performance when and through which things are remembered as significant can be revealed (Bachelard 2000: 57). For many of us the trailing of feeling can be less dramatic, less dramatically felt. We may try and make effort to knit things together, in relation across spaces and times that can be felt in abrupt change and gathered in a grasp of some smoothness. It may be that there is an effort to discover belonging amongst uncertainty and change that can at times seem overwhelming. Such an emotional negotiation in relation to holding on to who we feel we are, in the varied contexts of our living: desire for feelings of belonging, desire to open ourselves in fresh ways. These strains of tension are not dualistic or oppositional but embedded in multiplicities of feelings and durational space. We may not be able to create ourselves anew, but in fragments (Francis 2006).

Belonging in disorientation; disorientation in belonging; becoming in each. Becoming incorporates subjectivity in a recurring and shuffling process. The diversity of ways in which we 'space' in the cracks of flirting in the materiality of things we can touch and feel prompt the following discussion of the matter of intensities that may be considered in their complexities and diversities through a notion of play.

Intensities at Play

'Becoming' is frequently overstated as bearing limitless and effusive energy, a contagion of anxious murmurings; eruption without limit; to become anything (Thrift 2008). Yet amidst much writing on the high-speed, high-powered pace through which significant things happen, there is gradual acknowledgement

of the slow, the nuanced: '… not everything is focused on high-pressured intensity. Embodiment includes tripping falling over, and a whole host of other such mistakes. It includes vulnerability, passivity, suffering and even simple hunger. It includes episodes of insomnia, weariness and exhaustion, a sense of insignificance and even sheer indifference to the whole world. In other words, can and do become overwhelmed' (Thrift 2008: 10). Of course, we can insert more comfortable doings and feelings too. Moreover, intensities are of many different registers, or, one might say, intensities: calm, slowness, unevenness, stillness. 'Play' is serious, with political engagement (Lee 2000, Crouch 2007, Crouch and Desforges 2003).

Stillness is a 'phenomenon, state, pause, symbolic field or geopolitical struggle fizzes, (it) vibrates and resonates … Against the buzz of (an over-technologised) mobility and animation, a typology of stillness haunts the space of flows' (Bissell and Fuller 2009: 1, my parenthesis). Anxiety and calm, like speed, distance and being still do not act or flow as a merging duality, but in multiple origins, affects and commingling: tendencies not tropes. There is a fascinating, vibrant if quiet intermixing of different registers and modulations in living: of anxiety and calm, slowness and speed, feeling nearness and far away, or outside the body, 'holding on' and 'going further'; the timbres of memory.

'A movement is carried out when the body has understood it, that is, when it is incorporated it into its "world" … it is to allow oneself to respond to their (things) call … motility is not a handmaiden of consciousness' (Game 2001, Merleau-Ponty 1962: 139). 'Learning a move, embodying it, might be described as an "inhabitation"' (Bachelard 1969: 14-15). For Game it is through rhythm that for example, as rider and horse, we come to inhabit riding, as a musician inhabits a piece of music, or a writer text (Game 2009). The movement of music, riding and writing lives in us as we live in it.

Our experience of living 'materialises truth and does not permit it to be torn away from the earth …' (Bakhtin 1984: 285). Bakhtin constantly reminds us of the importance to 'draw down – or up', our considerations of the way it is to live, and relates this observation with imagery: 'The encounter of man (sic) with the world, which takes place inside the open, biting, rending, chewing mouth, is one of the most ancient, and important objects of human thought *and imagery*. Here man (sic) tastes the world, introduces it into his body, makes it part of himself'. (Bakhtin 1984: 281, my italics).

Bakhtin's has a visceral take on life, his curiosity with the carnival, the carnivalesque, and Rabelais, an earthiness and fleshiness of living; touch, smell and taste. 'Here man (sic) tastes the world, introduces it into his body, makes it part of himself' (Bakhtin 1984: 281). His pinpointing of events in carnival tends to privilege the opportunity of life becoming in terms of particular moments of exceptional openness. It is possible to identify a wider range of situations. I extend his consideration of carnival to diverse examples of play in

flirting and becoming: 'being lazy', lying in the garden or on the beach, 'doing nothing', sitting the day out at the caravan site watching the world go by. Yet, excusing our oppressed guilt, these moments can be profound.

The self-deception or simple romanticization of much writing concerning 'tourism' is manifest in the over-emphasis of the power of contexts and representations in determining, not even just influencing, what happens. Consideration of process, practice, performance and character of becoming punctures this mirage. Contexts and representations of visual culture and other media are part of the possible materiality and imagination on which individuals draw in affecting the character of encounters yet any more than that shares the romance of the tourism 'business' (Crouch and Lubbren 2003, Crouch, Jackson and Thompson 2005).

Richard Powell, an anthropologist of emotions, argues that emotional interaction in what people do in spacetime is an important means through which individuals conduct their lives, and the linkage between negotiating life, belonging and identity. He calls this process play (Powell 2009). Whereas anthropology has tended to understand cultures having particular play that happens around and in relation to ritual practices, in notions of the sacred, Powell draws the notion into more contemporary play as no less significant. Caillois considered play to be where 'the ordinary laws of ordinary life are replaced ... arbitrary, unexceptional rules must be accepted' (Caillois 1961: 7). Powell's approach is one that 'the spaces that compose such an organization (of play) are contested and thus involve competing, but always interacting, communities of practice ... dissent being *performed* in and through the spaces of play' (Powell 2009: 118, my parenthesis, my italics); '... the notion of play ... acquires a special meaning: it continues a modality which allows the community to connect itself to transcendental agencies, and to establish a sense of community and co-operation between the participants' (Stuckenberger 2005: 213, Powell 2009: 119).

Such approaches take play seriously, unlike Thrift's approach to play: 'play excludes power, rather than confronts it ... as a world of virtual forms, it cannot be connected in the way that is time of work, since it is not made up of fixed means-ends relationships' (Thrift 1997: 95). There is a curious duality in Thrift's claim: work, play. Rather than grasp these respectively as one bundle of experience and another, these are multiply merging and commingling, as on a flat surface, chaotically linked in complex ways, mixed together in life rather than having essentially different isolated character and affect. Play is active and expressive in the tugs of 'holding on' and 'going further'. Play is serious business. Play participates in all aspects of life. In the following paragraphs I engage two aspects of living and its play: doing that is habitually polarized as 'leisure' and 'tourism', in order to pursue further the relational dynamics of living, space and time and its creativities. Explicitly these considerations avoid dualities and insist upon the repositioning of these suspect dualities in multiply merging flows, not oppositions, as play. They draw forward the examples and arguments progressed in the earlier discussions on belonging and identity.

Caravanners tend to do 'holidays' doing caravanning; for the poorer members in particular, their caravan is 30 miles away and their venue for the annual holiday or two. Many allotment holders go abroad for a holiday, others stay in the country for their holiday. Exactly how the temporally mixed flirtings with space they make on from home to their site of particular activity, to be with friends, have a holiday, go shopping, there remains is a huge dearth of evidence from which to make interpretation. Yet this serious lack does not seem to stop literatures across the social sciences and humanities; a great cultural and performative drive 'between' what are argued distinctive spheres of life: leisure, tourism. There are some emerging efforts to unravel this confusion.

As anthropologist de Botton skilfully narrated autobiographically, we take our lives with us when we go away: relationships, ideas, feelings of belonging and wanting to 'get away' (de Botton 2003). Edensor has engaged the mundane character in holidays (Edensor 2006). Most people seem to want to know they will be largely secure when 'away' with guided, often detailed information in television programmes (*Guardian* newspaper travel editor 1990). If our lives are dominated by a search for happiness then perhaps few activities reveal as much about the dynamics of this quest – its ardour and paradoxes – than our journeys of all kinds. The anthropologist Jonathan Skinner discusses the problems with a particular holiday: continuity and discontinuity of relationships, ill health, taking life with us (Skinner 2010). People on holiday talk about things they do 'back home'. One holiday that we made some years back did affect our lives beyond its timeframe. But this happened as much a result of meeting a couple who became great friends for many years, who lived nearby us; knew the guy with whom my wife worked. They had been families who escaped from South Africa after Sharpeville. He was a practising acupuncturist, and introduced me to it, naked on the beach, embodied feeling of sand, edge of the water, and the warmth of the sky; awaking to a crowd of curious naked people. I still pursue acupuncture; it followed me. Things commingle. I find Pau Obrador Pons' naked sunbathing interviewees remarkably coy about the sensuous character of their enjoyment (Obrador-Pons 2007).

What we tend to call holidays are frequently, familiarly marked by their everyday not extra-ordinary character. The merging of theme parks (the contemporary 'end of the pier' or fairground) and high class hotel and health venues with the kinds of things we may like to get up to 'at home': the city fair, in each the feeling and not of wellbeing in doing things and in thinking we are being lazy. The habitual everyday is widespread in being on holiday, where the being is of multiple fragments and moments, from resting, as in the garden, park or armchair, to the beach or hotel poolside; the adventure of white water rafting or dropping into an unexpected club on a Thursday night, with all the possibilities of meeting and uncertainties (Malbon 1999, Cloke and Perkins 1998). In these accounts, observations and narratives there is scarce voice of Baudrillard's fantasy of the super (hyper-) real unreality (Baudrillard 1988). Things commingle, relate and contrast in multiple ways irrespective of attempts at enforced dualities, rhizomic threads across living are adumbrated with negotiations and tensions of holding on and going further.

Complexities of identities and feelings and not of belonging in these playings have numerous multi- and trans-sited character that may include elements of nearby and longer distance trips. To think that 'People are tourists most of the time' is surely eccentric (Lash and Urry 1994: 259). Non-relationally considered conceptualizations of life slices pursue their category-driven isolations and lacunae. Ironically, what is familiarly called 'tourism' 'we are all tourists now' is submerged in the conflicting ideas of its superficiality (Urry 2003, Ingold 2007a: 79-84); significance of experience in as a search for authenticity (MacCannell 1999); escape (Rojek 1993), or a rather ironic, self-conscious playfulness (Urry 2003). In ways it can be all of these, shifting and changing along the way and differently registered by different individuals. But the complexity and diversity is greater than this. As Cohen and Taylor adroitly expressed, escape can be anywhere, anytime (1993). Our being 'all tourists now' makes the wrong point: we all have open to us possibilities of being performative and becoming in a multiple holding on and going further anywhere, any time and anyhow in our living. Another isolation and occlusion of what happens in doing tourism is its peculiar privilege.

Rather than long-distance mobility's gaze changing the sensory register, play has a very embodied and felt character, with potentially severe limits of the imagined 'noblest of the senses', a detached visuality. Sally Ness narrates her feeling in visiting Yosemite Falls:

> flowing energy, a moving subject, not a thing. In this context, it seems unremarkable that I had no desire to photograph the Falls during the hike. When I took them in visually, I did so in order to change myself as I was moving. I gazed at them, "drank" them in, in order to receive energy from the reminder of their presence and the invigorating movement it was continually bringing into my kinesphere … my gazing inspired not an image but the sustainment and continued performance of relatively fatigue-free hiking movements, a kind of phenomenolological experience that current theories of the tourist gaze, anthropologies of place, and of non-place. (Ness 2007: 84)

To photograph, to take out or lift up the camera would be fixity of the moment's flow and potentialities and of the fluidity of motion and motility of spacing. Indeed, as Game expresses, '"being in" space is not primarily spectacular, but relates to touch' (Game 1991: 167).

The matter and feeling of everyday living is drawn and grooved contingently, part chaotically, across and amongst the diverse felt moments of being alive. Through a consideration of play, its doing and performativity bring the multitude of similar things normatively categorized as a duality (leisure: tourism; work: non-work) into a dynamic multiple relationality. Neither is polarized but fragments related in ways that open up their character of belonging, disorientations and commonality. Sites, spaces, memory and duration are focused in a revealing of the character of relational space, and the identities, belonging, emotion, a gentle politics at work. Play 'can be invitational where it includes others into the sphere

... together creating a potential space in which individuals can evoke imaginary powers' (McRobbie 1984). These feelings and energies can be mixtures of positive and negative, as in the case of mixed joys and otherwise of walking the street (Morris 2004). Metcalfe and Game express that 'holding space is important because it allows for states of un-integration and formlessness; states of just being where identity can be suspended in creative play, in the absorbed exploration of potential ... Potential space is holding space because it can hold possibilities without seeking to resolve the space through definition' (Metcalfe and Game 2008: 18-19).

Ongoing Observations

Ingold appropriately speaks of 'making sense'. Individuals, alone, intersubjectively and collectively can try and make some sense of things. Ingold comments 'We are in place, the argument goes, because we exist as *embodied* beings. Now embodied we may be, but that body, I contend, is not confined or bounded but rather extends as it grows along the multiple paths of its entanglement in the textured world. Thus to be, I would say, is not to be *in* place but to be *along* paths. The path, not the place, is the primary condition of being, or rather of becoming' (Ingold 2007b). Ingold has since expressed regret regarding his dwelling perspective, in a more recent footnote he now prefers 'to speak of life in the open is a process of *inhabiting* rather than of *dwelling*' (2008: 1811).

Ingold's argued shift from dwelling to inhabiting; from place to paths is not merely, for me, a shift from fixity (or nothingness) to vitality, mobility and complexity. When he writes of multiple paths in life he addresses the vitality of living as well as its complexity and entanglements (Crouch 2003). 'Places do not so much exist as occur ... (not) that living beings exist in places, ... Places occur along the life paths of being' (Ingold 2008). He engages implicitly the ideas of becoming, spacing and the character and dynamic of potentiality, what may occur, not necessarily within a confinement of the expected; new combinations, new colour (Crouch 2003, 2010).

In the several aspects of discussing the concerns of flows of time, space, feeling and doing sources of affects do not occur from polarized quarters nor act in a dualistic manner, but merge, disconnect, recombine. They also create potentialities that individuals feel in relation to their fragmented and embedded dynamic of negotiating their lives, our lives, in 'going further' and in 'holding on'. Thus we seek to make sense of our lives, however contingently, incompletely, and with frustration. We have not de-differentiated or de-territorialized, but adjusted; the modernist idea of organized fixity never was, except in theory. Life as ever continues to be negotiated; things and relations continue to shuffle and shift, to be shuffled and shifted. Class, as other social and cultural distinctions continues as ever; they are simply not fixed.

To acknowledge 'being human' is necessary to make sense of how the flows of energies, rather than the apparent multiple constellations of detached body parts and fluids may mix with everything else and everything else mixing with them. Otherwise a feeling of nausea beckons. Instead, in the serious attention to human living that engages the significance of the unbidden, the held onto, the unexpected and affects of non-human in feeling and its emotion, a different more nuanced character of emotions and of being human – relationally – emerges. The gathering of feeling and its informing role in, for example, relationships, is brought into focus with the disruption and perhaps re-settling of emotion that thus becomes more complex. Reflection can be disturbed. Emotions as and of performativity have powerful affects upon how we relate with and in space. Whilst Radley discussed the power of space aligned with 'doing' in memory, so that relationality of memory, space and doing can have a complex and uneven trajectory in life (Radley 1990). The way of each of the felt experiences of this chapter is one of gesture of expressivity, in words, movements or palpable silence. In the following chapter these creativities, expressive character and multi-durational journeys in flirting (with) space are examined in terms of a wider understanding of artwork.

Chapter 5

Expressive Encounters

Introduction

Consideration of the relationalities of lives, worlds and spacetimes developed in the previous chapter is developed further to engage the work of artists. The doing, practices and emergence of performativities are tracked through a wider perspective on art processes than is familiarly engaged. This wider perspective to understand the practice of making art draws upon a dynamic relationality with spacetimes; the threading of desire, discovery and holding on. The phenomenological thrust of Chapter 2 drew upon the ways of flirting with space that emerge in different expressivities in Peter Lanyon's art. Chapter 3 developed this attention through a closer consideration of performativity through other practical contexts and ontologies. The themes worked through in Chapter 4 are taken up with different emphasis in this chapter.

The dynamics of flirting with space are not as differentiated between everyday life in play and in making art as may familiarly appear to be the case. Artists work a practical ontology of living and that can emerge in performativities' feelings of and in doing. Thinking 'artwork' in this way extends beyond a focus on the particular contextual enframing of the artist's work and her/his objects. I examine further the complexities and nuances of this more inclusive way of thinking artwork in process. Connections and relationalities emerge in making art that inform an explanation of the making of everyday life more generally. The discussion draws upon particular recent interventions in art theory and cultural, geographical and performance debates.

This chapter is organized around three related themes. First, Lanyon's work is taken further to develop a discussion concerning the liveliness of the wider art process and includes theory on 'working hot' and the expressivity of gesture and emotion. The discussion engages critical commentary on the wider working practices of encounter and performativity of several artists. The second section works further with the performative character of artwork-in-the-making, flows of belonging, disorientation and becoming. These dynamics are pursued with regard to the commingling and potentially discordant relations amongst art-makers and participatory art practice; each grappling with the flows of flirting with space and their time journeys. The particular skill and self consciousness of artists is acknowledged. The concern is to unpack and unpick what is at work across diverse creativities: opening and closure; possibility, performativity and becoming. As Anna Dezeuze cites, the artist Rauschenberg expressed that '(p)ainting relates to both art and life' (2006: 143).

The third section of the chapter pursues the non-representational-representation double bind that distances and detaches, rather than relates art and everyday life. Through O'Sullivan's discussion on Deleuze art encounters and for example Casey's thinking on Diebenkorn and De Kooning a consideration of expressivity is developed as a more relational way of thought.

This chapter considers the fleshy, imaginative and felt emotional character of the process of art, its multiple and tense contingent flows These flow, as it were, to the street, the field, the gallery, the lab. O'Sullivan talks of art practice that 'calls its audience into being' (2004: 7). He says that we may ask 'what is the meaning of art?' or 'what does that painting mean … Art becomes predominantly determined by the question you have asked … This (familiarly representation) is an operation that produces a kind of hollowed out entity, in this case of 'art objects' (O'Sullivan 2004: 14, my parenthesis). Such an entity removes art from the participant being in its presence, unable to build a relationship with the work without an expectation, requirement, of surety. The art critic and writer Laura Cummings has unsteadied tradition and etiquette by engaging the sensuality and emotion of the artist (Cummings 2009). She writes of the expressive rather than its confinement in and as representation. Artists appear in their everyday feeling. The connectedness of sensuality, emotion and simply practice is evident in David Matless' argument that representations are the product of living and emerge through practice (1992). What are the practices, feeling and sensuality? Representations are part of practice and its performativities. Perhaps paradoxically, the so-called 'non-representational theory' that is influenced by Deleuze is not antagonistic to representations, but regards them as fluid and engaged (Dewsbury et al. 2002).

In the last two decades of the twentieth century cultural studies and cultural geography, for example, had also focused their concerns upon representations that were often mainly of a visual character (Duncan and Ley 1991). In cultural studies, for example, the body emerged as object; an objectification of the gaze (Featherstone and Turner 1995). Landscape has been identified as a tract of country ordered in a masculine vision (Rose 1993). Social anthropology's emphasis has typically been less restricted to visual representations because of its disciplinary interest in what people do, yet the signs of rituals, for example, have tended to be focused as opposed to what those participating felt and thought in the doing. As Taussig argues, the features and gestures of performance happen in action and feeling (Taussig 1993).

For some time geographers and others have collaborated with artists to produce interventions often to evoke character of particular sites, occasionally to make unfamiliar the familiar (2006). Some collaborations have politically engaged through ecologically sensitive projects in intervention, in creating actions, performances and other artworks (Grande 2006). Conceptual development has also been worked through post-war Situationism and de Certeauesque self-consciously resistant art interventions. (Pinder 2005, Ryecroft 2006). Often these enforced events have crumbled into the self-serving and naïve – and others may head for the same, such as claims of information technologies (Rycroft 2007, Trampoline/

Radiator Festival 2009). Of course any technology, new, or old used in innovative ways, can open possibilities; brush, stones, discarded metal, wireless technology, sawn wood. There is debate amongst different contributions. For example in a critique of Goldsworthy's site-specific sculptures it is argued that 'artists seizing the aesthetic and regressing purely into a design and objective vision of the landscape … Rather than art that seeks to reform, to reassess our place in nature …' (Grande 2006: 32). Yet many of Goldsworthy's works express a sensuality of spacing (Matless and Reville 1996).

In his interventions of thought Bourriard presents his era (the contemporary) of new relational aesthetics, heralded in pivotal claims of the internet's possibility of political resistance (Martin 2006). Martin criticises its open claims, its example of this fallacy:

> … a new theory of arts theatricality, affirming it and radicalising its consequences … generating inter-subjective space that not only incorporates the beholder but also reduces the art object to this incorporation in ways that exceed Minimalism persistent interest in the object … Yet (it) remains a double-bind and prone to ironic inversion … (Martin 2006: 386, my parenthesis)

Martin cites the brutalism of Serra's work as being non-productive of conviviality amongst subjects, instead merely commodification. Bourriard argues the liberation of conceptual art, amongst others, to have a social (and political) reference that was excluded from abstract and related artwork, a seemingly absurd polarization. Martin again: 'It may seem paradoxical to conclude (from Bourriard) that we may need simple, often literal, forms of art to tell us about the complexity of everyday life. And it may seem rather pathetic that we need to be told that everyday life is complex in the first place' (2006: 150, my parenthesis). In these paragraphs I seek to open other ways of thinking art.

What has long been considered to be representational in a way separates art from life, art from non-representation. Representations are part of the multiple materialities we encounter in living and are derived relationally. Thought in this way representations cease to have an aura of context-making. The problem with representations, like that with meaning, has been the effort to 'fix' either into place; to claim priority of particular kinds of meaning in either case, that can be the trap of power.

Artists' work is interesting because it is not necessarily encased within the production of an object. The notion of art as objects that are finalized has long been displaced. Rather, artists engage in productive tensions and work on the edge until there is a feeling of completeness; not completeness in anything but the expression they feel; through working with material. Not to be confused with expressionist art, 'art as expression' is universal, even the most rule-constrained high Renaissance painting expressed feeling concerning how the world looked, felt or seemed to be, or was intended to be seen. Art expresses an idea, 'a concept', a feeling; a collation or patina of things, including the gathered and momentarily

gestured flirting with space; space of model and artist, object found and object put together, 'set up'. They are in and of the world, they live in the world. Their embodied movements, however intimate or boldly expressive, walk the world, reflect upon it, and move with gesture through to wielding the materials they use.

There is a fluidity of energy amongst artists, people at large, materialities and life generally that can connect and disconnect them. This process occurs long before 'a work' is seemingly started to wherever it 'goes', metaphorically at least. These aspects of process thus flow from taking a walk or gardening, or more proverbially drinking; amongst the making of notes, collection of things, storing them and finding them again. The process continues awkwardly multi-referencing in the tensions of emotional movements and moments wherever performativity affects the eventual compilation of work. In these considerations I happen to focus on particular kinds of more visual artwork, but fully acknowledge that similar considerations would seem very likely in any particular field of art.

Flows, Intensities and Gesture in Working Hot

In wandering around parts of England the Cornish and International Movement artist Peter Lanyon wanted to express in words as well as paintings and constructions his affective emersion in what he called 'environments', as a means to break with traditions of 'landscape', that I discuss in Chapter 6. These environments or spaces provoked responses, feelings and ideas in his process of painting (Crouch and Toogood 1999). His paintings sought to express movement, and the tensions he felt in wandering, turning, and so on. Of course the immediacy of these encounters combines with other durations of feeling and encounter at longer trajectories.

He felt the many gentle and sharper striations of his journey in life and the affects of materiality, politics, flora and fauna. Feeling his locations in being surrounded and also in fragments drew upon his experience of repairing damaged planes in wartime; he had heard, and continued to hear, stories of the hardness and insecurity of labour in his craggy corner of the world, in deep mines under the sea, in working at the edge of rocky cliffs, a line of beach and the sea. His own tuition with more traditional artists gave him the ability to see and to structure. His later conversations with his friend the Norwegian constructivist sculptor Naum Gabo engaged him in a strange fascination for both immanence of possibility, almost infinite manual and emotional performativity with space in making constructions, that for Lanyon's case meant wielding the same bostik and plastic that he had worked in the war. His vertigo also challenged him literally to risk, to be 'on the edge' (Stephens 2000). These 'contexts' developed with his phenomenological encounters and a feeling of going further, even though, as his diaries indicate, earlier he had enjoyed holding on, in being at home, if his children were at times held at a distance (Lanyon, A. 1995, Lanyon, A. 1993a).

Chapter 2 mined the embodied character of his encounters that were evidently profoundly performative. As Lanyon walked he felt surrounded by space but also,

implicitly, he was feeling varying intensities of different moments and memories. Varying sensualities, movements and stillness merge and flow through his work, commingle inter-subjectively and with expressive character. The work involved walking in the areas he sought to paint, and later gliding, as considered in Chapter 2. In doing his artwork he would walk an area, return to his studio, paint, return to the area, and so on, reworking his art (Crouch and Toogood op cit.). Painting and making constructions were mutually enfolded in the way he worked.

As developed in Chapter 2, he wrote of feeling an intense awareness of things around him, but in a way that these things were influencing and having an affect upon him and his relationship with what he felt surrounded him: of 'flowers moving', 'gates uneasy' with themselves; at one moment the cliff and sea being on one side at one angle; the next, at the other In dance theory the idea of performativity has been applied in the way a dancer can feel detached from her or himself outside their own body and instead feel part of the wider milieu. In a recent consideration of artwork Casey acknowledges the utility of Deleuze and Guattari's notion of becoming as opening up possibility, through unbidden or unanticipated happenings that can prompt landscapes of performance, exemplified in de Kooning and Diebenkorn as well as land art that he renames 'earth art' (Casey 2005). He pursues aspects of Deleuze and Guattari's thinking with regard to the openness of becoming through land art or earth art and painting that '... fosters connections between fields, the removal of blockages on bodies without organs ... to do with performance (not alleged competence)' (Casey ibid., Deleuze and Guattari 2004: 175, my parenthesis).

Lanyon worked bodily in intimate and large movements against the canvas, inscribing, scraping, turning his body in expression of his ways of moving and of experiencing space. He likened the rhythms of painting to those of gardening, but acted also in urgency and anxiety with the tortured histories and lives in what he painted. Lucy Lippard wrote of a character of art that 'it is digging into the earth, into the past' (Lippard 1996, Casey 2005: 225).

Anne Game writes in terms of the newness of the image. In terms of image in art, her remarks are pertinent (Game 2001). Following Bachelard (1994), she draws out the idea of the newness of the image that invites abandonment: 'we don't know quite what is going on, but it feels like a connection with something more, something beyond. And to attempt (or to read as) representation would be to lose the quality, for what is communicable is exactly that which defies representation ...' (Game 2001: 232, my parenthesis).

Creativity emerges in Levi Strauss' bricoleur of recombining, thereby reconfiguring scraps, fragments of material objects previously existing otherwise (Gardiner 1999). Such practice is now familiar in artwork, from collage to installations. Yet this is also of the everyday: in gardening in the technical skill that is engaged is of various, diverse complexity and invention. Rhythm can be important in modes of tying, binding, wetting, tearing, and so on. It could be argued that improvisation merges across everyday getting by, negotiating, and in what we identify as and in artwork. As Noland argues, 'gesture cannot be

reduced to a purely semiotic (meaning-making) activity but realizes instead – both temporally and spatially – a cathexis deprived of semantic content but powered in expressivity, conveyed in an energy charge' (Noland 2008: xiv). In contrast Casey seeks a familiar semiotic, meaning 'enframed' in a kind of expectation (Casey 2005).

As philosopher Bakhtin explains:

> on the one hand, Bergson recognises that the body is first of all an object amongst other objects. Thus it may serve as the orientation point for making judgements about the location of things: "the size, shape, even the colour of external objects is modified according to my body approaches or recedes from them, that the strength of an odour, the intensity of a sound, increases or diminishes with distance, finally that this very distance represents above all, the measure in which surrounding bodies are insured, in some sort, against the immediate action of my body ... But insofar as my body is the *centre* of action ... it cannot give birth to a representation ... The body, then, is dependent on activity other than its purely physical functions ... for shaping the world into coherent images. A total description of an act would have to include a body, objects external to it, and *a change in the relations* between the body and other images". (Bergson 1912: xvii-xix, Bakhtin 1990: xxxiii-xxxiv)

Bakhtin goes on to mark out the multiple affect amongst what an artist does: 'from within my actual participation in the event of being, the outside world is the horizon of my active, act-performing consciousness. It is only in the cognitive, ethical, and practico-instrumental categories that I can ... orient myself in this world in an event and introduce a certain order into its composition with respect to objects; this is what determines the onward aspect, the "face" of each object for me – determines its volitional tonality, its value, its significance' (Bakhtin op cit., 97-98).

His horizon, like Lanyon's acts not as a physical finiteness or framing determined by a particular way of looking or composing, but a horizon of current possibility and potentiality.

Lanyon was performing (with) the materiality of flirting with space and his perpetual creation of metaphor, of which he was intensely aware, through his consciously and unconsciously embodied performativities in space that flowed across his work into the studio. Whilst long influenced by his early development of a personal creative mythology of land and sea as mutually engaged sexes, this mythology mingled amongst the multiple performative vibrations (Porthmeor 2009). His constructions and paintings frequently and significantly express the materiality of handling and of touch in the performance of his work. His paintings express a poetics of his journeys walking, driving, motorcycling and, riding on the top of a bus, through to the physical emotionality of painting. Despite Jay's concern of the denigration of vision, the survival of the renaissance fetish of the formalized aspects of vision as detached, ordered, even 'correct' is difficult to

defend (Jay 1993). Gazing emerges as only a part of living and indeed of vision. The encounter is acknowledgeably more complex. Art is not different (De Bello and Koureas 2010).

The two dimensional surface in art operates as an immanent surface, that commingles with the immanence the artist has performed along the way. In Schnekcloth's rich discussion of drawing she argues 'The surface of the drawing affords openings for gesture's potential to convey meaning beyond the semiotic and as a site for ongoing physical and aesthetic intervention on the part of the spectator' (2008: 277). She cites Bergson: 'Whereas my body, taken at a single moment, is but a conductor interposed between the objects which influence it and those on which it acts, it is on the other hand when replaced in the flux of time, always situated at the very point where my past expires in a deed' (Schneckloth 2008: 277-278, Bergson 2007: 88).

For example whilst Kandinsky later became absorbed in a particular spiritual philosophy, his work at the cusp of his shift from more figurative part-representational work to the amoebic and crystallic character of his abstraction, was highly performative (Taylor 2007: 3). His paintings then grasped the temporality of the performative encounter in spacing: he arrives by train at an unfamiliar Russian village. He is moved by what he encounters. He stops and gets out, senses people enlivening the space in which he flirts: 'I experienced something I have never encountered before or again since … They taught me to move within the picture, to live in the picture. I felt surrounded at all sides by the painting … into which I thus penetrate' (Taylor 2007: 3). He wanted the viewer to stroll in/to the work.

Schenckloth argues that:

> (i)n the gesture of a drawing, there abodes the question of how human beings hold memory. A trace of the body, the projection of an emotion, a record of seeing are woven into the work … Vision is a quick flight through time, churning through intensities felt and recalled and made present, surges of remembered experience made manifest as a drawn trace on the page. Internal experience here is the stuff of the psyche, memory and emotion … (2008: 277-278)

She captures the energy and potentiality of artworking, art at work; the visceral-expressive feeling of the act: 'Gestured marks are an embodied language – a flutter of the gut, the heave of breath, shoulders clenched and released' (Schneckloth 2008: 278).

In a recent challenging discussion of artwork, Barbara Bolt examines the notion of 'art beyond representation' (Bolt 2004). First I consider her discussions of working hot, a kind of intensity-consideration in artwork. She notes that Heidegger talked of the power to go beyond; that art is more than the intention (ibid. 185). She finds in Deleuze a means to address and engage the character of what she calls 'working hot' in the performativity of art in ways that I will argue informs our grasp of the flows of landscape. In her work on the 'material productivity of the performative act' Bolt addresses the performed materiality of

plastic arts and thus refutes the distinction with conceptual art as a 'Cartesian leftover ... in the carnal acts between bodies (human and non-human)' she argues, 'the work of art exceeds its own structures in a radical performativity' (ibid. 190). Non or post-representational art may also be working with and through life, confounding categorization. Working with Bolt's ideas it is possible dynamically to relate categories: so-called non-representational art is also representational in its expressivity. Her argument presses the perpetually contested distinction of 'abstract' and what I prefer to posit as 'not-abstract' art (Rycroft 2005).

With an early and continuing identity with aspects of Lanyon's work the English artist, a key player in the British Midland Group of artists and London Jerwood Prize winner David Ainley's work of the land is felt deeply in amongst people using materiality of mining, working with it, and its affects (Ainley 2004, Ainley 2010). Ainley's work seeks to express the work of mining and minerals; of the underground depths and the surface contours he walks in his particular flirting with space. In some of his emblematic work he paints numerous layers of oil, acrylic and pencil; repeatedly scraping them away, revealing unexpected colours and juxtapositions; adding more layers, continuing the scraping. He is not seeking to emulate or shadow the miner's work but to express the experience of hard, serial, habitual labour and offer their practice through his own gesture. The layers facing miners and the labour emerge, now familiarly unnoticed from above.

Similarly the English artists Richard Wentworth works with found objects; speaking in unknown and potentially revealing ways about the lives of those objects, their journeys, the people who accompanied them, and so on, in translation through to their becoming re-engaged by the artists to new affects (Swenson 200). 'Art does not reproduce the visible but makes visible' (Klee 1920, 1961: 76). For Klee, art becomes the energies, affects and performativities of becoming, in a becoming that is wholly new, in his energies, drawing on emerging moments and various durations in his life, rhizomatically in his more abstract(ed) later work.

It is easy to forget, in Deleuze's considerations of Klee's art that he worked in a very stylized theoretical framework as a key theorist in the Bauhaus. He set out particular rules of artwork: 'A theme with accompaniment or several themes. Single articulation of intermediate positions: neither purely frontal nor purely vertical, nor purely horizontal', but also 'rules made to be broken: divisive formation ..., multiplying formation and so on' (Klee 1920, 1961: 17). Both opening and replacement his approach sets out a priority for 'Every expression of function must be cogently grounded. Then there will be a close bond between beginning, middle, end. They will be joined by necessity, and there will be room for nothing doubtful, since they fit so tightly. The power of creativity cannot be named. It remains serious to the end ... we ourselves, down to the smallest part of us, are charged with this power' (Klee 1961: 17).

It can be difficult to engage such work from the middle, as it were. Yet Klee was, despite his apparent replacement rather than erasure of rules, acutely sensitive to the possibilities, even if these became possible through his own rules. Dewsbury and Thrift have drawn attention to Klee's ideas and in his own later

work, as an example of the plane of immanence, through Klee's observation on continual emergence, yet his work persistently refers into life too: 'Genesis as formal movement is the essence of the work of art. In the beginning the motif, the harnessing of energy, sperm. Work as form-making in the material sense: primordial feminine. Work as form-deciding sperm: primordially masculine' (Klee 1961, Dewsbury and Thrift 2005).

The art of English contemporary abstraction painter Peter Cartwright can seem 'purely' abstract: blocks of fat lines with/out direction that can change and turn back, opening possibilities. Cartwright is heavily influenced by the Bauhaus work of Paul Klee. His seeming abstracts immanent surfaces of energy and its potentialities. Yet it emerges through numerous notes, of one line or more, hastily drawn in moments from things he sees out and about; a broken edge along the street, a tool on the table, someone's lower trouser leg and shoe, a distorted plant in winter. These are drawn on a bundle of sheets, scraps of paper that he carries in his pocket. They work through to give him the expression he finds energized through his arm, brush and gesture as the work completes: its engagement with materiality, its use of such prompts to feel and think beyond their immediacy or 'actual' reference, yet is captured first in immediacy. 'In my work I am preoccupied with the endless question of issues of abstraction and imagery. I make intense unpremeditated responses through drawing, to fragments, objects and situations, creating a stock of images that feed the working process. In my paintings, watercolours, and drawings, work continues in a state of flux, of exploration' (Cartwright, Personal conversations 2009a, Cartwright 2009b). This kind of direct but explorative way of working, though mutually engaged with motifs and cool semi-detachment is evident in the British twentieth century artist Bob Law's work. At first apparently still empty fields: abstracted, metaphorical, that have just enough suggestion of movement to vibrate, sometimes using words tumbled into a reverberation of wandering and thinking (Law 2000).

Casey argues that a 'mapping' character of cool west coast Californian abstract expressionist artist Richard Diebenkorn's Ocean Park series is dominant in this period of his work (2005: 143 et seq). Yet the sensuously expressive renderings, rather than 'mappings' of the 1950s Berkeley, Alburquerque and Sausilito series, are present in the abstract-titled yet uncannily loose yet contained later 'cigar box lids' series. Ocean Park takes on merely a development, not a break into enforced geometry. Their colour, as much as the lines and their mutual expressive force flavours Diebenkorn's words: '… I like to think of it as … it's like throwing a ball around, bouncing it off here and there, and things are so unpredictable' (1998: 18). He was hardly into cartography, but a sensuous encounter of expressive openness; he let the colour flood in expressively from his flirting with space.

Diebenkorn wrote tips on how he approached doing an artwork: process, not object. 'Attempt what is not certain. Certainty may or may not come later. It may then be a valuable delusion' (1998: 115). When I feel my encounter and its becoming with Diebenkorn's earlier series (Sausilito and others) I feel the power of flirting with space in all sorts of rhizomic relationality: his spacing – the

spacing between the gaps – his spacing, my spacing; our feeling, our emotion; our expressions, not in any sense as me-artist, but me-participant.

Belonging, Disorientation, Becoming

The contemporary site-specific sculpture, or installations of the British artist John Newling engage and express profound embodiment and performativity in a very distinctive way. In his project 'Chatham Vines' Newling was able to take over a redundant, largely abandoned church southeast of London. He found this building full of curiosity, suspended time and felt potential. Lanyon worked his encounters and feeling of artwork in that encounter as well as in his own histories, feeling and potentialities. Newling too works directly and indirectly with his journeys that he offers to others, themselves open, of course, to their own multiplicities of feeling and meaning.

In a narrative of his project 'Chatham Vines' the performance artist John Newling unravels 'The journey of the grapes':

> Intoxication
>
> The material and symbolic journey of the grapes reveals a conceptual aspect of the project. Organising inside an abandoned church, the grapes travel through the chemical transformations of the wine making process. The grapes are then transformed again, symbolically, within the service of the Eucharist. More wine will be consumed in a secular environment. The grapes enter our blood bringing the possibility of intoxication. (Newling 2006: 63)

The strange, evocative and fleshy process Newling describes involved hydroponics, an abandoned church, a small team of growers, people blessing and/or drinking more freely. Vines were grown along the pews. The space combined the performativity of all of these players and the affect of the vines growing, in a space once familiar for many of those involved, their multiple and uneven affect emerging and flowing expressively and poetically.

See Figure 2 'Chatham Vines'.

This project is typical of a series that he has worked on for over 30 years. He explores and expresses a fluid ongoing tensions of belonging and disorientation in ways that speaks of Bolt's working hot and its work beyond representation. His works are performative events, involving people, inviting their participation in the ongoing artwork. He feels resonance and uncertainty in sites he visits, he reflects and revisits, returns. He negotiates a site throughout this developing participatory process. He assembles a group of technicians to set up with him the materials; beech trees, vines, hydroponics, soil. In one case John simply set up a

stall in the marketplace of a north west England market town. Through several weekends individuals visiting the stall were invited to contribute to an invitation to pay symbolic money in pursuit of insurance against the loss of mystery (Newling 2008). He energized their memory into performativity, changing the character of the market. Two hundred and fifty individuals joined in with their stories that we may read as spectacular and ordinary.

In a way that resembles Lanyon's practice he engages in the feeling and materiality of a location; he mixes these with feelings of possibility. Whereas Lanyon generally worked with a familiarity of location yet often came across it unawares, Newling enters a new location. Both felt mixes of degrees of disorientation. As Newling considers: 'when I cross the threshold of a space that might house a project, I am aware of a transition of thinking. The relationship between the threshold and what the space could hold is undermined, open and ambiguous' (Newling 2005: 38).

He acknowledges the contexts, pasts and other presents that a space can have, and calls this collision of feelings and awareness, openness, disorientation, the character of the tacit agreements individuals may have had and still have with the space are dislodged in his mind and in the project that may follow. 'What was familiar becomes uncertain and then begins to reconstruct its familiarity into new possibilities' (Newling ibid. 39). He calls this disorientation 'a change in the relationship between time, place and person' (Newling ibid. 41). As in Lanyon's work, these artworks operate in the edges, in the gaps of spacing, the numerous spacings amongst things and individuals' lives and feelings.

Particularly distinctive in the kind of work that Newling engages is their invitation to encounter a site openly, gently challenged over variable durations; to re-orient dispositions to a site, remaking their relationality with particular sites. They do so through indirect openings of feeling and reflection, environmental directness that obliquely rather than in an attempt to direct narrative invites. He describes the state of disorientation as full of vitality and potentiality that can be bewildering and destructive. They can also deliver, as in the case of 'Chatham Vines', fluid growth of potentialities; refiguring of space through an engagement that emerges from challenge and change: belonging in disorientation. He turns his art into something that is temporarily lived by its participants. He takes artworking into the lives of individuals who find that they join in the potentialities, multiple immanent surfaces, to their own engagement and disorientation of belonging and memory.

There is a performative openness in the figurative, imaginative expression of flirting with spacetime in the Parish Maps of Balraj Kahnna, an Indian artist living in England, and of the English artist Lewty (Crouch and Matless 1996). Khana compiled 'scenes' of his years of walking in London's Westbourne Grove area into the form of a Lignum. When Lewty worked on his 'map', his expression, he found inner and outer feelings working together with the materiality of a nearby riverside known to him for years. '… drawing and writing became much like walking …; a discovery and reflection, as the sights and sounds and smells of the place touch off

points of memory and association ... the walk took on a shape in space and time which was not to be measured in years, or by a watch ... Never fully disclosed' (Lewty 1996: 71). Researching parish maps with David Matless I found a familiar but not pervasive contrast between artists' maps and those drawn together by local participants in the area of their lives that the maps sought to communicate. Some participants felt free to collide contrasts, express and alert local issues in a gentle politics; others found their expression in the tidy confinement of order and a version of heritage conservatism, their effort of identification merged in conformity and expressive of a dominant local politics (Crouch and Matless 1996).

O'Sullivan argues the pitfall of rule-bound representation: that often we may not actually think or feel at all because we fall prey to habit. Yet performative encounters can crack open our habitual ways of being and acting in the world to expose and affirm the new. He works a philosophy of affective aesthetics, working from how we can identify the 'excess' to which art can give rise. He finds, however, that poststructural approaches can often merely invert the familiar dualisms surrounding representation, subject and object, signifier and that signified 'merely entails the reversing of the binary, or the putting under erasure (the deferral) of the privileged term' (O'Sullivan 2004: 15) He argues instead for attending to art's rhythms and the lumps of sensation in its creativity as a 'meeting, or collision, between two fields of force, transitory but ultimately transformative'.

Rycroft considers the non-representational character of certain art practices in mid-century California (Rycroft 2007: 616). He relates them to the New Age spaces of dance practices. MacCormack has argued with regard to therapeutic dance that 'spaces emergent through the enactment of practices that explicitly attempt to facilitate a kind of transformation in awareness, thinking, feeling and relating' (McCormack 2003: 490-491). Explicit, self conscious hyper-attention to these kinds of openings were sought in a particular counter-culture, yet merely offered other means of trying out what artwork may in any case do.

Temporary disorientation can lead to temporary belonging, then disorientation, or stop at any point of trajectory. Resolution can be elusive, whichever 'way' or condition one may seek, desire, long for. In her fascinating de-centring work, though also working in everyday living, Emma Cocker explores 'irresolution', uncertainty, disorientation and the process of 'getting lost', that she regards as 'critical conditions of artistic practice' (Cocker 2007a). In her slant on flirting with space she considers liminal space, rather as John Newling. Cocker connects boredom, absurdity, aimless wandering, often working with conversations and co-presence of artists, as a further space open to the possibilities of ideas and negotiation (Cocker 2007b).

Newling's feelings of disorientation emerge in different ways in the working practice of another English artist Andrew Vass (Vass 1995-1996, Vass 2008). His work encounters and elides the social, cultural and environmental edges of a city where he lives in eastern England. I worked with Andrew in the mid-1990s and we had chance to share our thoughts and reflections on Lanyon and a wider number of artists' working and feeling about space. Vass works from site-specificity in his

drawings and paintings, at once chaotic looseness, coalescence and coagulations of lines that give deep texture and emotional resonance; unease, exploration and a feeling of disorientation. They also have a lightness, almost a luminescence. His recent work in Ipswich exemplifies this process: repeatedly sketching and making notes. His use of pencil, pen and brush is intense, almost scratchy, multitudes of sharp lines ill at ease with each other, momentarily and patchily achieving partial resolution, but constantly also alert and full of vitality. In his wandering he feels the tiredness and anxiety of exploring relationality.

Some of his drawn notes stay in their own right whilst others are worked into paint in the studio. His work offers the potentiality of individuals to draw into, even to make anxiety with the images. They are powerful images. His art works at that line of disorientation and disconnection from his feeling on the edge, even outside everyday matters. Yet ironically the locations and sites he dwells by are those much used in everyday life, in very different ways: roundabouts, stop lights, bus stops at the side of the road. He relates to everyday life at a tangent because these are sites familiarly used by large numbers of people, getting somewhere, waiting for something, taking care of children.

He does not seek to resolve but in his own way offers potential in the vibrating surface of his work obliquely with the site to which, in a general rather than specific sense it relates. In this he shares with Newling, Lanyon and other artists the interest to relate and to challenge, to explore with potentiality of discovery of what there is for anyone from their own life and encounter with the work. For Vass it is the flows of energy and the possibilities that such edgy work holds out rather than its being as object. Although he feels on the edge of everyday doing he conjoins with familiar, shares feelings of disorientation in the city and wondering why on earth we are somewhere. Thus his work connects, not with expectations of representational objects, but in these energy flows. In contrast Lanyon's early work was one of return, from several years away at the Second World War. He drew on myth and memory of the area where he grew up. He drew together a feeling of the return, of belonging through an expression of gathered artefacts of land. These expressive, felt memory works developed strongly and gauntly within a very few years to stark expressions of feelings of conflict and survival. They soon become more open with more disorientation and challenge but with a temporary resolution in presence.

Mixture, Mergings and Commingling

Bolt argues that 'it is not an easy matter to produce an intense series (of artwork) that is transformative; to do so is likely, to say the least, to rely on openness and becoming in performance; indeed much the same may apply to the practice of everyday life' (Bolt 2004: 184). Bolt emphasizes the performativity of creative practice. Taking the idea of performativity in and of artwork further, representations continue to participate in flows of poetic possibilities in their public availability. The

performative life or vitality of the artwork, even if two dimensional, is performed by the individual who encounters, participates. Two dimensional pictures may not be experienced only through the gaze, but with diverse dispositions of the body, memory recall, inter-subjectivity, emotion, fear and anxiety unlike the formal viewing mistakenly associated with art in the gallery (O'Sullivan 2004, Jones 1997). As Kandinsky sought, in its object-ness the painting remains performative. These perspectives open further and problematize the processes of artwork. Not merely considering the object, but as in the discussion of Lanyon's action at the easel, and taking it back, to a much wider involvements at the edges of things an feelings in the doing of the work. There emerges a curious combination of intense engagement and the self almost lost in a wider intensity of events and their emotion.

In his case for a creative shift in our thinking O'Sullivan considers art that positions between life's habitualities and something else as having potential if we think of what art can do to challenge and act performatively with our subjectivities: '... art practice can be positioned at that "seeping edge" between the existing state of affairs and a world "yet-to-come"'. Through this reasoning O'Sullivan assists a more open engagement with conceptual art that Deleuze and Guattari found difficult, through his insistence on its potentiality to create sensations (Deleuze and Guattari 1996). Discovering meaning performatively is not in referral to a pattern book but in this process and its encounter between forces, complexity in its vitality and inherent process of becoming. Expressivity is process, not in production of a fixed object: 'the expressed is not fundamentally a signified caught in an interplay of signifiers. It is a function involving a real transformation' (Massumi 1993: 18, O'Sullivan 2004: 21).

Art emerges not as a trace signature of the artist or the deconstructive his/her 'absent presence' but as

> Vibrating sensations – coupling sensation – opening or splitting, hollowing out sensation. These types are displayed almost in their pure state as sculpture, its sensations of stone, marble, or metal, which vibrate according to the order of strong or weak beats, projections or hollows, its powerful clinches that intertwine them, its development of large spaces between groups or within a single group where we no longer know whether it is the light or the air that scripts or is sculptured. (Deleuze and Guattari 1996: 168)

I include two of my paintings inside this book and one on the cover. The intention is to resonate, however awkwardly, my expression in writing and my expressive efforts in my artwork. I leave it to the reader/viewer to see if you find resonance between the modes of expression. These are: 'Walk' 2006, oil on canvas, 102 x 102 cms (cover); 'Land Waves' 2006, oil on canvas, 126 x 100 cms (Figure 3); 'Monastery I' 2003, watercolour on paper, 47 x 37 cms (Figure 4).

Extending the idea of going further and pointing the character of becoming in the artist's creativity O'Sullivan suggests that 'we might say that the artists is

simply he or she who has seen 'beyond' those already giving signifying formations and affective assemblages – and is able to offer new ones' (2004: 55). As Deleuze and Guattari remarked Van Gogh's sunflowers as becomings, O'Sullivan writes of how in encountering Van Gogh's sunflowers, 'we become sunflowers in the beholding … "We become" meaning to go through the sensations … becoming in this sense is capturing the sensations, a passing between things' (2004: 56).

The artist Steve Willatts' worked on a project in north west London. He problematized the ordinariness of space with its potential to be felt otherwise (Willatts 1980). In ways resembling Wentworth's metaphorical and material finding and handling of objects, Willatts worked with several young people who spent time in a piece of 'vacant ground', close to their home in poorly maintained high density flats nearby, but far enough away to give them a feeling of ownership and belonging. It was for them anything but vacant ground. He asked them to put together objects found in a patch of wasteland (sic) that they used that resonated with a feeling of this place as theirs; in their lives. Willatts photographed their assembled collections of scant, often recycled material as visual collages in an exercise of interactive representation; and a constitution and expression of their heritage, at least in its resistant production. Broken prams, pieces of discarded material, twigs and other objects that they had brought across from their flats. This event transformed the feeling and character of the space in an expression of their doing and feeling there, in a sense of belonging.

In another example that relates and commingles rather than blurs the vitality of art and life a group of performance artists worked with people who had plots on a community garden or allotment in Birmingham UK. The event, Bloom 98, was developed over a growing season and then performed and presented on one day (Crouch 2003b). More than one thousand people sought to celebrate; their performances intermingling. One was the growers' moulding of the cultivated areas that expressed their acts of cultivation in material artefacts. Their experience of cultivation was also expressed in written and spoken narratives; the whole area of the plots merged with artists' expressions of being there (Crouch 2003b, 2003c). On one plot, one hundred umbrellas that were lit from beneath were synchronized with recorded sounds of the crackling of roots growing in the earth. In another plot a decorated shed told a story of multi-ethnicity and green concerns. Participant-visitors were invited to have packets of free seeds, each hand picked from their plot by growers of different cultures: India, Jamaica, Britain and Poland. I involved myself, influencing the idea and talking stories as groups joined me on a journey between the plots. This event was a performance of quiet and explicit, gentle but celebratory politics of the feeling of being, becoming close to the ground (Heim 2003: 186). Both Bloom 98 and Willatts' presentations have a gentle politics whose expressive force works through flirting with space.

The reworking of something we may call 'heritage' is exemplified in allotments in another way. Their familiar popular heritage in the middle of the last century was of tired pieces of land and poor, inefficient, anachronistic people. A decade earlier, they had been a sparkle of national identity as they came to be reservoirs

for food production during the Second World War (Crouch and Parker 2003). More recently, they re-emerge as sites of multiple identities, often multi-ethnic, but sometimes refuge for refugee groups where their distinctive heritages of cultivation and the position of cultivation in everyday life is sustained, 'cultivated' today. These sites also have new cultural identities, too, across cultural capital, in, for example, the ecological movement. In this they become expressive in a Bloom-like articulation of their lives, spaces, doings, and what matters. One example of the latter in drawing upon an earlier version of its heritage is found in the reuse of the Second World War's allotment symbolism 'dig for victory', marked by a foot pushing a spade into the earth, widely distributed in posters and seen in cinemas at the time. During the 1990s, the poster was restyled as a banner against commercial development of these sites, sing the term 'dig in for victory' marked by an eco-warrior bent over, keeping on digging.

Spacing works in flows that engage and interplay across particular moments or events of varying intensities. Spacing can productively 'flatten out' traditional distinctions of representation, 'artistic' and other kinds of performativity. Whilst they each hold relative and relational distinctiveness, together they produce new spaces. Bolt asserts, art may be involved in making representations but it initiates and provokes rather than constrains, 'a performative not a representational practice' (2004: 83). Gabo identified a feeling of becoming amongst wind working with other materialities in his encounters with fjords and mountains in Norway. Malevich understood Constructivism as 'real'; set up as a palpable space for the audience, Gabo went further (Newman 1976: 10). For Gabo the Constructive principle 'embraces the whole complex of human relationships to (in) life; it is a mode of thinking, acting perceiving, *and living*' (Gabo 1944).

There is a prevailing idea that the gallery is uninviting and constraining for popular participation in art. I recall a show at London's Hayward Gallery some years ago; Matisse's superb, highly tactile nudes, from sketches to sculptures. Trying to express how I enjoy sculpture, as British sculptor Henry Moore encouraged, I showed our son how to caress them. After a moment a whistle was blown in the gallery. Yet there are other ways in which, for any kind of artwork, we engage more than an object; we (can) do more than look.

In our lives we construct, handle, make sense, cope with, respond to and anticipate amidst a complex collision of influences, unbidden occurrences and desires, only part-planned. Our way in life is 'continually altered and responds to the performance of others' (Hallam and Ingold 2007: 4). Creativity emerges through the experience or practice of doing. Walking amongst paintings, any more than 'watching' (sic) football, is not spectating; it is participating, in different registers. Temporally it is not collapsed into an instant or a series of instants but embodies and extends beyond 'itself', as object, duration, multiply enfolding and unfolding. Duchamp argued that '(in) the creative act, the artists goes from intention to realization through a chain of totally subjective reactions. His (sic) struggle towards the realization is a series of effort, points, satisfactions, refusals,

decisions, which also cannot be fully self-conscious, at least on the aesthetic plane' (Duchamp 1966).

Duchamp observes that 'in the chain of reactions accompanying the creative act, *a link is missing. This gap, representing the inability of the artist to express fully his* intention ...'. Recent rethinking on the experience, encounter, performativity in doing artwork, acknowledging its much greater durational complexities than merely with the immediate materials that may put together 'an object' (ibid.). The performance artist Hayley Newman's work for me is exemplified in a photograph of her at a 45 degree angle bouncing up from a trampoline naked, concerning the 'gap':

> A gap is an in-between – not just an abyss, a crack, a hole in the ground. It is a relation between two things ... A viewer and a work of art ... Newman's practice somehow *takes place* in this gap ... (the work) is to be found not so much in the physical material, in words or photographs, but the way that this material *does*.

This material 'does, not in representation or in mimesis, but in the moment's performative character' (Jarvling 2005).

In his notes on creativity Duchamp goes on to extend the duration of artwork and its infusion of the longer complexity of its process and experience: '... the creative act is not performed by the artist alone'; the spectator brings the work in contact with the 'external world ... thereby adding his contribution to the creative act'. For me, the spectator' is participant, thus widening the understanding of how we engage life; creativity emerges in acts and shifts in which we can engage with ease or awkwardly. Wilhelm de Kooning expressed: 'when I'm slipping I say, hey that's interesting! It's when I'm standing upright that bothers me: I'm not doing so good: I'm stiff. As a matter of fact, I'm really slipping most of the time, into that glimpse. I'm like a slipping glimpser' (de Kooning 1968).

Reflecting on the drawings and paintings of Bonnard relevance for the contemporary period, Phillipson and Fisher suggest that the drawings' attraction for us lies precisely 'in their effect upon 'today', upon what we take for granted in the way 'today' passes (our passing through 'today' as a passing by), upon the dailyness that inheres in what all of us 'know' of everyday life. They press upon us more vitally than ever when

> dailyness is suffocated by an excess of representation, a superfluity of images which pose no question about their emergence, or about what is to emerge into the light' to constitute living ... this ... obscurity poses a threat to anything that seeks to affirm the clarity, the unquestionable status of all the representing work that sets the parameters of our daily lives. (Phillipson and Fisher 1999: 128-9)

They offer a way to go further than the claim of the representational closure of a kind of art. '(T)he obscure threatens in the non-recognition of sovereignty of an

integral light. This integral light is what we are immersed in everyday lie; it is our element, that which causes us to breathe …' (Blanchot 1993: 239).

In her reflexive narrative of slow filming Kissel makes a remarkable echo of these observations:

> The practice of capturing a long take sometimes feels like an investigation or experiment – the possibility for deeper knowledge. It is a way to order the phenomena of the world: a means to enter into the structuring of chaos and complexity; a means to assimilate information, both visual and socio-political. Within the time of the frame, everyday things become visible and one is offered a moment to linger on a question rather than pursue a particular answer. The long take is the condition of possibility for drawing closer, in a sympathetic way, to that which is before the camera. (Kissel 2008: 351)

In her consideration of the slowness of her approach to film she refers to Bergson's duration, resembling Deleuze's enlightened thought on cinema (1989): 'Duration encourages attentiveness, a sensibility that is shared across production and reception, from the camera person and subject to the audience' (ibid. 355).

Casey, in his extensive discussion of land art and of paintings does not engage the kind of argument that Bolt uses around a kind of performativity but tends to develop an idea of more direct transferring of materiality from one site onto and across different material surface. Thus he refers to land art as earth mapping. He considers the painting of Diebenkorn and of de Kooning, each working around the time of American abstract expressionism, de Kooning in its centre and Diebenkorn, more west coast cool expressive abstraction. Casey does acknowledge the work of Deleuze and Guattari in becoming, possibility, using possibilities of immanent surfaces emerging from energies and so on, yet he does so curiously. He draws upon their critical consideration of fields in a rather too literal way.

Casey argues that the body is a smooth space, and that their over-concern for striated space was its power of vision. He also speaks of a break from the intended 'precision' of classical artists in their efforts to replicate 'in vivo' as it were 'what is/ was there'. We now understand that all sorts of distortion have long been deployed to deliver a sense of apparent mathematical rightness; a depiction that concurred with the impossibilities of even Euclidian transference of site, materiality, weather and affects to one dimensional surfaces. Negotiating rules, audience expectations and our own feeling is a complex matter. More worrying is a widespread opinion in art writing and amongst artists that art in our time can only engage the worrying of contemporary terror (Taylor 2007). In various times and spacetimes art has engaged the difficult, the pain and the fearful: Goya, el Greco and Hieronymous Bosch at least come to mind from ages when pain and fear were as present as today. Yet if art expresses living there is surely more than this.

Ongoing Observations

Rethinking the wider character of artmaking processes reveals much outside the focused act of wielding a particular set of materials. It reveals the spilling over far beyond its apparent edges into a more holistic, if fractured and tensioned living, doing and feeling. Some of its registers resonate, if awkwardly, with our living, its dissonance, delight, desire and registers. In this wider unravelling the dynamics of flirting with space, and the contingent flows of cultural and geographical knowledge and feeling begin to emerge.

Understood in a wider field of practice and performativity, the way artists flirting with space emerges with curious relationality with our everyday lives, rather than a separate world that produces representations. There is a shared resonance and dissonance in belonging and disorientation. Particular rules have not enforced closure on expressivity's representational presentation. These modes are mutually embroiled and implicated. Gesture resonates amongst art and living.

In the chapter that follows I take the discussion concerning flirting with space in art and in living more generally to the contested notion of landscape.

Chapter 6
Landscape and the Poetics of Flirting (with) Space

Introduction

Milan Kundera's observations on flirting, considered in the Prologue of this book, seem prescient to our efforts to grasp the tentative, explorative and emotional character of landscape. In recent years, in art theory, social anthropology and cultural geography, there has been a number of innovative contributions that auger fresh approaches to landscape thinking (Creswell 2004, Lorimer 2006, Matless 2004, Mitchell 2004, Merriman et al. 2008, Massey 2006, Rose 2006, Tilley 2006, Wylie 2006). Landscape has become exemplary of the critical debates between representational and so-called non-representational theories affecting debates in the humanities and social science, from art to cultural geographies. In this chapter I consider landscape as the expressivity and poetics of flirting (with) space; explored through journeys and creativities of the chapters so far.

When, over two decades ago, I began my work on allotments, 'landscape and culture', I was affected by an unease of the division occurring between two emerging critical geographies. One was a more humanistic geography of phenomenology; the other a very English and critically Marxist reading of the ideological power of landscape making (big gardens and nineteenth century painting in particular). The former offered a means to relate life and a materiality of landscape in practice (Seamon 1980). The latter worked between art history and historical landscape geographies with regard to the interpretation of power as expressed in the representation of ideas, in art and in the construction of large landed estates, especially in Renaissance to early nineteenth century European painting (Cosgrove and Daniels 1988, Daniels 1989). It is representation's capacity to frame and prefigure the world that is open to use in pursuit of particular ideologies of power (Matless 1999), focusing upon representations forged in the particular reading of artwork discussed in Chapter 5. Humanistic geography offered an alternative to the work of representations in the emphasis on landscape in experience, yet found limits in acknowledging too the work of representations, i.e. the broad cultural significances felt to affect experience (Seamon op cit.). The work on representations developed the more strongly. Alongside cultural studies, and continuing a long sociological perspective on material culture, Benjaminian philosophies of streets and shop windows, amongst others, these approaches broadened to a contemporary application to designs of products, streets and 'grand views' (Benjamin 1982, Pred 1995).

It is interesting to observe that much of the work on art/representation in discussions on landscape has concerned the deterministic meanings and significances of landscape in the form of values, relationships and influences including ideology, significantly examined in terms of the way place or space is experienced and consumed (Duncan and Ley 1993). Baudrillard's hyper-reality provided a postmodernism that disrupted deterministic imagery, at least detached it from rational moorings (Baudrillard 1988). Something as everyday and ordinary about community gardening, little plots and everyday life appealed as it threw together strong political histories, contexts, with everyday practice and its phenomenologies. A more contingent and flexible landscape became evident in the material patterning of the ground through working it, nature and diverse recycled and therefore unmediated materials aid of numerous materials and in further mutual affect with plants. Emerging through these was significant displacement of apparent consumer culture and passivity that is now acknowledged in material culture studies' critical understanding of consumption; and the insights of performativity, becoming; emotion, self and intersubjectivity, as considered in Chapter 4. Landscape flows. Similarly, through my encounters with Lanyon's art I became further engaged in the character of encounter, performativity and becoming in the presentation and presence of his work, his landscapes abstracted into what he called 'environments', in an effort to detach himself from the Renaissance constraints on a particular way of seeing. Alongside these very English summaries there were of course equally significant developments elsewhere, that interestingly have come to be much more engaged in these more recent developments, that are brought into this chapter's discussion.

With significant exceptions, conceptual debate on landscape has emphasized a relative stability, marked more recently by Ingold's articulation of dwelling, an articulation in which he refers both to habitual practices and their representation in Breugel's art (Ingold 2000). Important work on the ideology and power of particular landscapes in representation emphasize their persistent consumption and longevity (Cosgrove and Daniels 1988, op cit.). Whilst the intended political power of the use or doing of landscape is difficult to contest, the way it works is less clear yet no less important (Mitchell 2004). Familiarly presented in terms of powerful ideologies as sites of representation imposing of social relations even to the point of claiming national identity (Cosgrove and Daniels 1989, Matless 1999), or more recently in contested presences, or in Mitchell's unambiguous phrase 'a form of social regulation', landscape begins to bear more nuanced critical challenge (Mitchell 2004: 241). Olwig's more flexible treatment of landscape remains soundly of materiality with social, political, cultural, ethics and everyday practices and not confined to fields of vision. Any 'position' on landscape changes over the trajectories of these components (Olwig 1996).

Discussions concerning vitality, performativity, becoming, mobility and energy flows contest the familiar emphasis upon the only-habitual and situated character of landscape and its role in the work of representations. This chapter draws together, into relation, the growing awareness of a need to try and engage

these debates surrounding landscape across geographical, anthropological, cultural and art theory amongst others. In particular it considers different debates on landscape through the notion of spacing particularly in terms of how we understand artwork and representation, insistently in comparison with wider kinds of practice. Landscape is considered as the expressive-poetics of spacing in a way that makes possible a dynamic relationality between representations and practices both situated and mobile.

Landscape is a word that has considerable popular purchase. The 'stuff' that is often substituted for what is meant by landscape tends to be more in terms of countryside, but it can also include broadly the assemblage of landforms, concrete shapes, fields, gutters, designed spaces, and serendipitous collections of things. Implicitly included are our own bodies that are now enlivened into the 'landscape'. Cresswell persistently points to a problem with the (merely) commonsensical character of 'landscape', yet prefers the even more prevailingly popular word *place* as a relevant geographical category, as do Massey and Tuan (Cresswell 2001, Massey 2005, Tuan 2001). Moreover, reflecting on the tradition of understanding landscape, particularly in human geography, Creswell claims the tendency in the conceptual grounding of landscape into the early twenty-first century as an 'obliteration of practice' (2004, op cit.).

In the following passages I urge a debate upon these views as impeding a more open, flexible and expressive character of 'landscape' that brings the idea of landscape, as process, into the tactile character of belonging, performativity and becoming. Not least, landscape becomes a means to relate, moreover commingle, the complex self with, amongst the multiplicity of affects of and affects upon, to express the self in the relationalities of living in poesies. In doing so, landscape can express diverse emotions, of delight and loss (Wylie 2009). Articulating what landscape 'is' rather than how it emerges and happens feels very incomplete as Tolia-Kelly acknowledges from her work (2008).

If it is that we live space, not merely in relation to it, there would seem to be more going on in its occurrence than evocation of cultural resonance. At the core of this feeling of incompleteness is a sense that landscape and space might be conceptualized relationally. I suggest in this essay that understanding the performance of artwork both in the making and in its mutual articulation in life beyond its immediate material making may be considered relationally in an articulation of landscape in life, and space in relation to living. The following sections consider ways in which the process of spacing, with its openness to possibility, disruption, complexity, vibrancy and liveliness, may inform the making and liveliness of landscape in new ways. The chapter suggests a way of conceptualizing landscape as active, through notions of creativity, across journeys in living spacetimes, and flirting with space. Landscape is situated in the expression and poetics of spacing: apprehended as constituted in a flirtatious mode: contingent, sensual, anxious and awkward.

Thinking Landscape Relationally

Recent critical attention to space discussed in Chapter 1 directs attention to its relational, dynamic, contingent character. Space emerges from this as persistently 'in the making', through a complexity of forces, influences, practices. Massey's focus on space (itself) as relational to flows, energies and things renders space closer to the lived and human. She articulates the character of space as relational through the connectedness and dynamics of things (Massey 2005). Significant components of her thesis are that space is produced of inter-relationships in life, and that therefore space is always under construction, in flows of influence, in process. Ed Casey has written of more explicit connections of space to life, seeing them in fact as mutually constitutive (Casey 1993). The landscape geographer Yi-Fu Tuan has offered a framework that privileges the experience of the participant in place above all else. Tuan suggests that 'what can be known is a reality that is a construct of experience, a creation of feeling and thought' (Tuan 2001).

Habitually, landscape has been aligned with stability, long durations of practice, exemplified in Ingold's development of 'dwelling', and the imprint of power in the design of land. However there is also change. Growing unease with landscape identified only in rooted circumstances is well marked in conceptualizations of vitality, flows of energies and affects, that tends to emphasize the relatively multiply-located character of the ways in which individuals live. Further, there are developing ideas concerning increased tendencies towards rapidity, of movement and temporality, distance and its projected shallowness of encounters (Hannam et al. 2006). A key challenge is to be able to reason landscape in relation with the complexity, tension, adjustment and becoming in life.

However, there are also widespread everyday, outwardly mundane, habitual practices of profound significance that are relatively unchanged by such mobility, even though the relational iterations amongst diverse life modes is little evidenced (Merriman et al. 2008). How do these adjustments affect how landscape is felt, or the character of its expressivity in representation? J.B. Jackson argued the importance of mobility in understanding landscape, for conceptions of landscape as lived in and also moved amongst (1984). Amongst discussion of recent notions of 'mobilities' there is a rather isolated, and certainly untested, feeling that there is a contemporary shift from thinking of 'land' to 'landscape'. Borne on the idea that human sensory relations with the world are attenuated from a more nuanced and complex phenomenology there survives an idea of our detachment from a world that is otherwise framed and landscape is a shield of vision (Urry 2007: 106). However the possible similarities rather than distinctions between a possibly more 'mobile society' and the habitual are given attention in this chapter in consideration of how mobility and its arguably intensely multi-sited temporality may be related to more habitual practice in the constitution of landscape.

As Deleuzian geographer Bonta argues an awkward and pregnant vitality enables us to move beyond landscape as (fixed) text (Bonta 2005). Spacing emphasizes capacity and energies for change that is abrupt, non linear and non-

accumulative, and that includes influences that are other-than-human, as developed in Chapter 2, this volume. In an autobiographical narrative British geographer John Wylie wrote of the more familiar embodied thinking and the more-than-embodied practice suggested by Deleuze in accounting for landscape in his walk on the south west coast of Cornwall in England (Wylie 2005). Crucially he describes a landscape as geopoetics, as though it erupts in a clash of many impulses in his brief journey, and is definitely not (merely) pre-scripted. Landscape may not be a matter merely or even mainly of vision, not least for individuals with sight limitations. Yet Wylie suggest that 'to visualise is to set at a distance' (2007: 4). This is to misunderstand visual(ize). Of course sight as vision is part of what constitutes embodied experience and its phenomenology. As Wylie's (2003: 145-46) rejection of the visual gaze outright would be absurd; rather to connect with the diversity of what visual/sight comprise, rather than a particular, if often fetishized, controlling, dominating kind of vision. In contrast Nordic anthropologist Katrin Lund has called upon attention to the 'touching eye', of care, even love (2005: 29).

Landscapes become complex sites of encounters and performances, rather than presenting themselves to the researcher as a given set of views, vistas, or representations. What is expressed in Cezanne's 'landscapes', much considered by Merleau-Ponty (Merleau-Ponty 1962).

> ... the objective of an artist like Cezanne was not to create a landscape that anyone could instantly match with a patch of conventionally denoted geography as it is seen in a certain season, at a particular time of day, in specific weather conditions, and from a given standpoint. Such a painting would accept an assumption of ontological separation between viewer and viewed. In an alternative strategy that recognises the interdependence of viewer and landscape, the painter might try to paint the coherence in the movements of the perceiver's body that brings a specific scene into view, that accounts for the highlights and shadows of varying intensities of colour and shape ... asymmetries and so forth. (Katz 1999: 314)

As discussed in Chapter 5 Barbara Bolt argues that in its object-ness as landscape the painting continues in flow. Bolt's thesis offers a critical intervention in conceptualizing the working of landscape that moves forward the critical conceptualization of art as beyond representation. 'In rhyming the rhythms of the landscape and the body, meaning and reality are constituted in performance' (Bolt 2004: 171, et seq). Critical reflection on artmaking and everyday life further prompt engagement and relationality between modalities and realms of performativity in terms of landscape (Cant and Morris 2006).

The Expressive Performativity of Practices, Intensities and Becoming

Barbara Bolt's expressive argument for 'working hot' in the possibility of art resonates with the character across living:

> I am able to take pleasure in my walks and in my gardening and to accept the
> factual sort of existence of stones and things because I see them as my source. I
> find with this a bodily rhythm in digging and moving (the sort of rhythm I used
> to feel through the seat of a car when driving very fast), and I felt his produces a
> rhythm in my work. (Lanyon 1949)

There is a gentle politics in the negotiation of meaning and relationships that can
adjust world views. Allotment holders and caravanners express a poetic relation in
what they do and in its relationalities with soil, trees, sheds and others, relationally
patterning the spaces that emerge. Situated practice and performance builds,
reassures and agitates. Curious combination of intense engagement and the self
almost lost in a wider intensity of events through which landscape is detonated.
Lanyon articulated these as they were emergent in multiple reflections through
other streams of influence:

> Having experienced this long line say from the armpit down over the ribcage
> down to the pelvis, across the long thigh and down to the feet that line may
> take me out in the car to the landscape and I might experience this again. By
> having drawn the nude I experience it seriously, the sort of experience on would
> have by some sexual contact with the female. But in this case transformed to an
> understanding of the landscape. (Stephens 2000: 124)

Rather than reductively referring to this as merely a masculinist gaze I take
this to be a caring and slowness; intimacy across body and space through its
performativities. True, Lanyon was influenced in images such as Europa by the
Greek myth of sea, male; land, female. Yet Beach Girl is highly eroticized and
sensual paint is fleshily coloured; felt caressed, 'touch came to take its position
alongside vision in his approach to the body' (Stephens 2000: 124).

A particular version of grasping landscape in the way habitually it has been
positioned and manipulated in power, emerges from part of the feminist critique,
Observing the actualities of a style of doing and thinking landscape can be
interpreted as masculine, surveilling, controlling (Rose 1993). Yet Nash argues
that 'it is necessary to engage with them (women's bodies as terrain) to disrupt
their authority... this does not render this representation or vision as automatically
unacceptable' (Nash 1996: 149). She asks whether a female depiction of a male
body in the landscape merely replicates masculine vision (phallocentric etc): 'not
only other forms of feminine sexuality but other versions of masculine sexuality
as passive and desiring rather than active and desiring ... can it point to ways
of acknowledging the erotics, pleasure and power of landscape imagery while
relating to landscape in less oppressive ways?' (ibid. 153). As Vasseleu discusses
in relation to Irigary's work, it is not a matter of rejection of the visual, or even
its erotic component, but positioning it within a deeper grasp of human sensation,
feeling and becoming (Vasseleu 1996).

The British artist Larry Wakefield worked a sensuous aesthetics of desire and progressive ideals in two particular series of large paintings on canvas: 'Flag Women' and 'Women in the City', each exercises in a poetics of landscape (Crouch 1997). His earlier experience during the second world war of entering a severely damaged Netherlands and being able to paint naked models inspired a quest of contrast: ruined cities in the day and drawing and painting at night; on the way to rebirth. He later translated these expressions to the contrasts of decay he felt in cities' neglect, in the 'Women in the City' series his nudes express an awkward juxtaposition of intimate interiors, small rooms and a temporary, almost fragile security aside from the noise of an alien decay of an exterior world. The images fracture and re-form, of blobs and lines, articulating together in a series of tensions in a quest of temporary resolution in expression. 'The Flag Women' calms the contrast into simpler body forms and flat areas of divided colour, again articulating this expression in lines and blobs, as he called them (Crouch 1997).

A Gentle Politics of Landscape

Mitchell articulated an important political version of landscape (Mitchell 2004). He argues that landscape emerges in the social relations that go into its making, composed of practices of production, consumption and exchange that are phenomenal forms of social processes: they are constituted in striations, as Deleuze would observe, a gridded and rigid framework, in which individuals contributing their labour become forced participants. It is a 'stage on which capital circulates' (Mitchell 2004: 241); constructed as a 'given' through social regulation. 'It' materialises social relations that thereby become reified. Landscape emerges as a stage [pre-existing] experience except for its gridding, and a reality that is politically neutralised in its presentation to the world. It is an 'articulated moment in networks that stretch across space' (Schein 1997: 663, quoted in Mitchell 2004: 241), 'a form of social regulation; a structured phenomenon'.

For me this important contribution is too exclusive, too singular, largely resisting intimate feeling in the temporalities of human spacing, feeling and thinking. Of course, the feeling of power in his assessment undoubtedly is enormous in the strawberry fields of California, through which empirical discussion Mitchell builds this particular argument. Yet I argue for a much more diverse complexity in landscape; in the politics of landscape. My starting points are certainly not fully comparable to the working conditions of the individuals of Mitchell's case, and certainly offer no attempt to trivialize hardship; but open up the way in which we conceptualize landscape, and neither is exclusive. In my work on allotments, community gardening, for example there is a clear striated, rigid framework of plots that for many sites date over a century since they were laid out almost as charity for the poor, to keep people from the pub, especially in the UK. Yet there is a human engagement, inter-subjective, practices of relationality with the affects of plants and other materials; even, as discussed in Chapter 3; opportunity of

becoming. This leads to further reflections on the greater everyday complexity of landscape's politics.

Of course the power of expressing landscape is partly in the power of the text, whether written, photographed, filmed, digitalized or otherwise produced. Our performativities of landscape as developed in this chapter can be inflected by numerous prefigured cultural contexts and social tendencies. Landscape may be important in a number of everyday practices, related to ownership, access and determination of use. However, there is more than this to the power of landscape in communication and its particular expressive gesture. Landscape can occur in working with expressions of people's lives, identities and relationships. The values and significances that surround, or are contained in landscape, and which can be negotiated, contested and felt, in terms of access, ownership and determination of use may be informed by such action, thereby bringing to the fore more complex encounters that people make with, in and through landscape (Crouch and Malm 2003).

Indeed Dubow's interesting argument regarding colonial 'landscape making' is informative (Dubow 2001). Whilst she acknowledges the colonial 'mark' or striations inscribed on landscapes (as assemblages of materialities) she acknowledges too their topological character:

> ... as Merleau-Ponty understands it; of space as a matter of proximate envelopment; or as Deleuze and Guattari argue, of space given as a direct reflection of *where it is*; as a function of the *place it is in*. Thus to talk of (the Cape) as a landscape beaten out by the footfall of travellers inflecting the patterns of the land as they went ... Is to see it hold the palpable and the particular: to the intimate and the immediate. ... less a subject moving ahead than a body restoring itself to a world that it *topologically* works itself into. (Dubow 2004: 247)

Presentation and process combine Dyvia Tolia-Kelly's work with an artist in a constant engagement with individuals 'post migration'; interviewing, producing their painted imagery, responding, working with the artist to try and engender expressions of the complexities of their feeling of a particular site laden with peculiar 'English' cultural identities, the Lake District in north west England (2008a, b). These feelings mix fear and paradise in a revealing grasp of paradox and migrant culture: 'embodied, material and affectual' (Tolia-Kelly 2008a). Reflecting Williams' cultural theory of structure of feeling and culture as ordinary, Tilley positions landscape as 'often experienced as a structure of feeling through activities and performances which crystallize and express group identities to the outside world through passing through and identifying particular places and . histories', a politics of identity (Williams 1977, Tilley 2006: 18). Williams too had an enduring, conflicted unease in visiting the 'landscaped' large estates of the very wealthy in England (1979). We cannot rely on our poetic subjectivities to detach; things commingle.

Tolia-Kelly argues that 'we cannot see and feel separately ... aesthetics in representations are as much about emotion as they are about visual form' (Tolia-Kelly 2008b). One of the individuals she worked with 'feels fear of the open spaces, yet loves tree roots, the rocks, the mosses, the grubby, spotty spaces' (Tolia-Kelly 2008b: 346). It is a felt, emotional landscape that he expresses; not simply a received alienation of life on arrival in a new country. Attachment, disorientation and belonging collide in anybody's experience of spacing. There are competing 'ontological landscapes', each, Stephen Wright prefers 'landscape of *being*'... shifting rather than stable identities, their density variable' (Wright 2007: 509, 510). Working with Shotter's everyday, practical ontology, this fits. Landscape's ontology is grounded in performativity and becoming, but not escaped from such as ethnic and other affects, acknowledging which would ensure attention to the working of differential affective capacities; '... a multitude of planes, immanent or other; upon which varied capacities to experience, to know and to shape are acted out, formed and lived through' (Tolia-Kelly 2006: 216).

Vitality, Connections and Disorientation in the Flows of Landscape

Ingold observes that 'a way of believing *about* the world (is) ... a condition of being *in* it. This could be described as a condition of being alive to the world, characterised by a heightened sensitivity and responsiveness, in perception and action, to an environment that is always in flux, never the same from one moment to the next' (Ingold 2006: 10, original emphasis). Landscape 'is the world as it is known to those who dwell therein, who inhabit its places and journey along the paths connecting them' (Ingold 1993: 156).

> Imagine a film of the landscape, shot over years, centuries, even millennia. Slightly speeded up, plants appear to engage in very animal-like movements, trees flex their limbs without any prompting from the winds. Speeded up rather more, glaciers flow like rivers and even the earth begins to move. At yet greater speeds solid rock bends, buckles and flows like molten metal. The world itself begins to breathe. (Ingold 1993: 164)

I am uncertain regarding the filmic metaphor and the apparent only-out-thereness of landscape, passing by. As Deleuze notices, film is also slow, close up and dwelling on the everyday object detail: 'the shot turns towards objects and montage, the ... towards the whole ... giving time its real dimension. (It) selects ... significant moments ... making the present past, transforming our unstable and uncertain presents into a clear stable and desirable past ... other than a flowing representation of the synthesis of images: abrupt dwelling, selection, breaks in flow (Deleuze 1989: 33-35). There is a multiplicity of character in flows, even in mobilities. He writes of a 'mixture of rhythm, tonality and harmony; the past

appears as the present'. His way of thinking avoids our seduction into ever-rapid speeds and high intensities. Living is more complex, slow sensuousness.

Similarly whilst Wylie accurately acknowledges the ongoing unavoidable importance of visuality, his later contribution foregrounds, or privileges landscape as a process of gazing (Wylie 2003: 146, 2006). As Lund removes the unitary gaze of the visual to 'touching eye', Lanyon got to know his 'environments' through the tactility of his two feet, his wider body and emotion as much as his two eyes. Ness's narrative of climbing in Yosemite brings together a more whole body encounter, as discussed in Chapter 4. Cosgrove argues that 'the pictorial landscape' incorporates a more visceral and experiential' (2006: 51). Cosgrove's most powerful engagement with practised landscape is where he shifts dramatically from considerations of renaissance and other grand design to the character of walking in British hills and is brought to confront a very different landscape of encounter (Cosgrove 1984: 267-269).

Landscape, in, or as performance can be transformative and reassuring; awkward, uneven and risky. Several of the empirical cases foregrounded in these chapters, from artists to people in their play, refer to sites that were very familiar to him suddenly appearing very different, having been come across unawares. They express the potential of making landscape in the becomings of spacing. There is a possibility in artwork of an expression of tensions between a sense of what is 'out there – in us' of commingling tendencies as subjective; and the intensities of expression it carries and conveys. That vitality is distinct from the mere transference from one kind of materiality to another; the work is energetic, it bears energy through its life. Each includes contexts that are prefigured, sometimes in acute histories as discussed of Lanyon in Chapter 5.

Game's landscapes on the beach, Birkeland's Artic visit, gardeners' discoveries and caravanners out in the morning light (Chapter 4) were felt in an expressive poetics of spacing. That poetics can emerge between sites of performativity, be multiply situated, engaging different temporalities in memory and moments across their variously situated living. Such a poetics can become powerful, even if only gently performed as landscape. Momentary intensities in flows of sensuous feeling can emerge that, whether familiar or not, can create feelings of momentary belonging. The artist William de Kooning expressed this: 'There is a time when you just take a walk; and you just walk in your own landscape' (de Kooning 1960: 15).

The fleeting view from the car window has been familiarly offered as stereotypical of contemporary mobility, typically Revillious' painting 'From a train window' (Cosgrove 1984: 265). Seemingly detached from other kinds of practice it renders visual cues dominant, landscape passing by and emerging serially as in a movie. It is unclear why this kind of image has become so totemic. We habitually, daily, move and manoeuvre, in whatever capacity is available to us. Casey acknowledges a more spontaneous character of dwelling (1993). Life signified in the multiple sites of practice and performance; a multi-situatedness, has the potential of multiple dis-locatedness exemplified in being unsettled, 'out of place', even if in familiar ones, and detached from identities. Multi-site dwelling

and multiply 'situated locatedness' can each have a depth of feeling as Game and Wylie imply. Travel includes the complexities of 'being there'.

The landscape architect and landscape theorist J.B. Jackson argued that a pervasive shift was happening. He contrasted 'the values we stress (as) stability and permanence and the putting down of roots and holding on ...', and another strong, very different 'tradition of mobility and short-term occupancy'. He identified these apparent oppositions – 'roots' and 'routes' that merge, as James Clifford demonstrates globally (Clifford 1997). American cultural studies theorist Neil Campbell argues that Jackson asserts a mobile spacing and landscape constituted of practices that confront the essentialist tendencies of a rooted sense of place where 'land was the object men (sic) could best use in their search for identity' with an 'existential' perspective 'without absolutes, without prototypes, devoted to change and mobility', equally pregnant of expression and poetics (Groth and Bressi 1997, Campbell 2004).

Jackson subverted and undermined typical representations of the west as frontier through his different way of conceptualizing landscape as in process and provided an early intervention as to how people 'affect' as well as are affected by landscape in their living. The Finnish artist Anne Keskitalo traces the echoes between art and travel in a way that combines and expresses fragments that evoke the landscapes of W.G. Sebald's novel *Austerlitz* considered in Chapter 4 (Keskitalo 2006, 2004). There can be a momentary detachment from the self in a wider set of impulses, feeling and relations in reaching for landscape that resembles Lanyon and the dancer, feeling moving beyond oneself and the immediacy of materiality. From Chapter 5 in this book, it is evident that the Bloom 98 community gardening performances and performativities emerge as a multiplicity of landscapes, mingling across artists' and gardeners' work. One thousand visitors participated in these interlinking 'landscapes'. The young people who worked with Willatts' express their landscapes, both pained and poetic. Their performances and collages adumbrate a series of presentations and performativity in a multiple practical process, engaging and sharing an ideology of landscape. These varied examples speak to the potential experience in everyday life; the poetics of landscape in spacing.

John Newling noted the expressivity of landscape in his London Vines project (Chapter 5):

> The prior function of the church was self evident but the possibilities of that function had gone; it was a *landscape in transition* ... the vines also ... demanding the responsibility that we all have towards the living. Chatham Vines gave new knowledge through the simple action that brought context and intention together both physically and conceptually. (Newling 2006: 63-64, my italics)

Resembling Newling's landscape in transition might well consider a cathedral or mosque as a landscape, of histories and sensual encounters amidst the affects of timber's forests and stones' quarries amongst other materials. A painting *can be*

a landscape in and as its expressivity, constituted of flows and *an expression* of landscape; of and part of that complexity of encounter, its feeling, its collision and commingling of affects; its tensions of memory, emotion and loss.

Representations are familiarly considered as objects, objects of their own completeness that have reduced landscape to available contemplation (Bolt 2004). Artists are frequently understood as working in a situation of fixed location, if not in a studio, in European *plein air* of artists' colonies (Lubbren 2002). Representations are also momentary expressions of journeys, similar combinations of influences and affects erupt. Landscape emerges in moments of diverse temporality and different intensities. Like many other artworks, Lanyon's paintings and constructions not only demonstrate journeys through life over time in a more familiar, linear art-historical way; they also each perform moments of life possibly folding with others that they express in a fluid manner. Dissolving dualities of landscapes in art and life emerges in artwork and in everyday performativities.

Both the performance and performative examples of Bloom 98 and Willatts' collaborative-participatory work have a gentle politics whose expressive force works through space as landscape. Their collages adumbrate a series of representations and performativity in a multiple practical process, engaging and sharing an ideology of landscape. Two-dimensional art can have similar performative power. Bolt's interventions regarding representations adjust further the ways in which landscape is conceptualized. Spacing works in flows that engage and interplay across particular moments or events of varying intensities. Spacing can productively 'flatten out' traditional distinctions of representation, 'artistic' and other kinds of performativity. Whilst they each hold relative and relational distinctiveness, they both creatively produce 'new' landscapes. As Bolt asserts, art may be involved in making representations but it initiates and provokes rather than constrains, 'a performative not a representational practice' (Bolt 2004: 189-190). Such a position adjusts the reading of representations, and of landscape-as-representation.

Relating Dynamics of Landscape

Landscape would seem to emerge in the poetics and expressivity of engaging space in complex, uncertain and widely affected ways. The art theorist Griselda Pollock refers to paintings of landscape as the poetics of experience, 'a poetic means to imagine our place in the world' (Pollock 1997: 25). The register of landscape in this way would seem to extend well beyond artwork that provides a mutually vibrant 'surface', or depth, of mutual accessibility. A poetics of space, in and as landscape, emerges performatively in the making of representations and in life more generally. Adapting Deleuze, the world contains infinite possibilities, making an 'immanent surface' of possible poetics.

Through considering landscape beyond its earlier frameworks, representations emerge as part of a much wider relational field in which action and reflection

can be grasped in a broader process of making space in spacing. Spacing offers a way to rethink how and where landscape relates in life. This more explorative, uncertain and tentative way in which spacing can occur suggests a character of flirting: opening up, trying out, unexpected, multiply affected and embodied. Representations can be fluid and 'real' beyond their character as objects. Expressive poetics can emerge in spacing. Spacing offers a way of thinking through how space is given meaning and how landscape may relate in this process. In varying degrees of permanence and emotion and across different situatedness individuals negotiate life. The emergent landscape evoked in any one location may bear traces of other, earlier experiences there and elsewhere, merging the ways in which landscape happens, relationally.

Cultural resonance emerges as one way in which landscape is informed. Landscape erupts in this process as an expressive and poetic act of which artwork is unexceptional. Representations are borne of the performativity of living. The liveliness of performativity is available to individuals who encounter these representations. Thus in no sense are representations fixed or closed to change. They are open to further interpretation and feeling. Representations and their projected cultural significance remain open too, 'available' for further work. The certainty of representations can be disrupted in this complex/multiple process of spacing: available, open and flexible, with a permanent possibility of re-inscription and gentle politics as well as purposive resistance. They can underscore processes of identity (Tilley 2006, Edmonds 2006). Rather than hold on too closely to the familiar debates concerning institutional power, space and its ideologies of landscape, there is potential of diverse constitutions of identity through the performative emergence of landscape. Ideas of 'land' and feelings of identity through belonging and tensions relate with the contingent constitution of attitudes, values and meanings that become affective through practice and subjectivity.

My critique of the limitations of particular arguments for landscape captured in and as ways of seeing combines with an acknowledgement of the continuing contingency of romance in our landscapes as process (Edmonds 2006). Landscape is informed through combinations of different times and life durations, memory and rhythms, different registers and intensities of experience (Paterson 2001). Landscape emerges as continual process, emergent in the expressive and poetic character of spacing: creative, contingent, awkward and not blocked in representations. Landscape may be present or it may *present* itself in artwork variously on the ground (for example in landscape design), on canvas or in any other form. The continual insistence on the referral back to historical definitions in order to fix the meanings of landscape can be unhelpful in re-conceptualizing landscape, privileging continuity and fixity (Olwig 2005). Constant referral back in this way suggests a need to link landscape as contemporarily understood with its antecedent conceptualization in a linear fashion. For example, to consider landscape as only prefigured is now anachronistic. Instead landscape itself is vital.

The humanistic geographies of the 1970s and 80s variously pursued in North America, Scandinavia and North-West Europe are resonant in this approach, but

can become more dynamically engaged in cultural contexts and wider possibilities. An insistence on the only-representational statics of art-as-landscape becomes instead malleable, fluid, reflexively produced and experienced, not only as material productions within which were coded particular ideologies. In dwelling there is creativity, the possibility of unsettling rather than concreted stability. However in a similar way the new, fleeting and temporary moments of heightened intensity do not replace slowness, familiarity of rhythm and continuity, but awkwardly enfold with them.

This chapter has been concerned to open up possible ways in which landscape can be recognized as dynamic and processual through a consideration of representations relationally with the character of life and its practices, through each of which landscape arguably happens. These have been related to ways in which landscape can engage multiple interactions and a possible unsettling of cultural resonances through which new ones may emerge. Landscape is fleshy, felt, imagined, affected and affects. It is of presence, bodily, fleshy, and as Wylie elucidates, absence too, 'a fracture forbidding any phenomological fusion of self and world, entailing instead an *opening-to* and *distancing from*', anything more a constant dream (Wylie 2009). Returning to my parents' graves I feel a strange, agonising but love of presence in their absence; a performed engagement with the plants there, cultivating belonging, if in absence's disorientation.

The intensities of landscape, however mundane, soft, or powerful, borne in and through representations that are imagined, felt, and observed can circulate feelings of belonging but also of detachment. To 'feel' landscape in the expressive poetics of spacing is a way to imagine one's place in the world. The individual can feel so connected with space that s/he no longer is aware, momentarily, of being (merely) human; we may *become* the event, become landscape.

As Bolt urges 'we can set a work of art in motion to take us to a place other than where we usually are' (Bolt 2004: 190). Such a 'motion' is not linearly propelled through art. Berger and Bolt are not in conflict: we set our lives in moments where we can 'go' somewhere else. Landscape can collide with something else that resonates a sense of our own lives, and has the power to re-assemble it. Such intensities of significance, or merely calm moments of reassurance, happen across the range of performativities and their circulation in representations. Landscape resonates a capacity of belonging, disorientation and disruption. Landscape is not perspective and horizon, or lines, but felt smudges, smears, kaleidoscope, a multi-sensual expressive poetics of potentiality, becoming and poetics.

Whilst 'place' may continue in popular exchange, conceptually it seems superfluous in the face of spacing. The term *place* may have significant fluid connotations, but it is also archetypal in popular tourism literature: the synagogue or temple to be visited, the vibrant city, 'fixed'. It is difficult to relate place to process conceptually. Landscape as signified through spacing can have a gentle yet cumulative politics, profound in its feeling and ideas, as the community gardener expressed. Landscape as practice or *art* practice is forwarded into process, as dynamic rather than either 'outside' experience or only focused through the

physical character of encounters. In this article I have placed emphasis upon efforts to articulate the dynamic and complex character of landscape in process, working away from the particularly fixed character familiarly associated with landscape in and as representation. Landscape as the performative expressive-poetics of spacing is a way that makes possible an always emergent dynamic relationality between representations, practices and identities. By so doing, I hope to have rendered landscape's purported fixed and steady character as instead shuffling, unstable and lively. Visiting Henry Moore's Yorkshire Sculpture Park in Yorkshire again last year with my daughter, my encounters with Moore's sculptures elsewhere at other times merged with other memories of being with her; detonated amongst much shared laughter taking photographs of each of us, and them, in their temporary presence around us. And thanks Bryony for Bel and Sebastion.

Chapter 7
Some Conclusions

Introduction

One of the most powerful moments of feeling through my own research was after I had completed a presentation on community gardens as life and space, in an art gallery in the middle of England. A tall, thin Indian woman looking very tired came up to me on the edge of tears. As her eyes lit up she told me that for once she felt connected and proud of what she enjoyed in her life. This book has sought to unravel some of the ways in which thoughts and feelings (in both senses) of how we get through, negotiate, celebrate, suffer, cope with our lives, each other, and the manifold things, contests and contexts of interplay.

Through these engagements there emerge threads of gentle politics: tactics, tensions, negotiations, attitudes, values and relations. These connect with how we get along in our more immediate and more stretched out, intimate and other journeys, and how we may respond differently to contexts, producing our own trail of contexts as well as creativity around us. The various examples of people living that I have included offer a means to go further with understanding how these politics commingle with a more familiar institutional and organized politics and its feelings. I don't find these mutually isolated or polarized, but working in flows, jolts, events and partial frustrations commingling with other political formations.

Space has worked its way through these chapters; space as materiality, imagination and energy commingling. We find ourselves doing and feeling in relation to each of these and their nuanced and changing assemblage. I have drawn these threads in relation to the fleshiness of living as processes of flows rather than frameworks. Thereby it may become more accessible to progress groundwork from these threads through which we can understand the things through which we make our contribution to the world, ourselves and each other. How we, you and I, contribute to a reconstitution of the world, amongst other constituting flows. In part, how we all participate in its gentle politics. Change emerges in individuals, sometimes more gently too, not without affect. These multiples mingle, they do not sideline each other. Gentle politics is significant in the constitution of meaning and in the process of subjectification.

It continues to seem to me that our efforts to think and feel with sensitivity, responsiveness and generosity can only contribute to a progressive endeavour towards social justice; acting as and for human beings, and everything else. I recall my brief note on the vacuous character of much 'post-human' debate that simply seem to miss the point. Progress emerges through attention to the relationality,

in this character of Deleuze' rhizomes, with some rootlets, of still-much-around humanity (Bradiotti 2006).

Events, actions, encounters and feeling still happen overwhelmingly in an everyday, close-up manner, even in the so-called over-mobile at-a-distance 'western' world. Even when individuals are away from home, they familiarly do familiar things, relate to each other, act regarding things we can touch and feel, not merely gaze on in a detached manner, most evidently in the huge proportion of people visiting their friends and relatives elsewhere, engaging a complexity of identity, belonging and becoming (Brunner 2005, Smith 2006: 220). Miller has argued more recently the notion of timespace compression averts a connectedness or embedded character in living and creates a virtuality (connections-at-a-distance) that is very partial (Miller 2000). One example of this incompleteness is the subjugation of the emotional, the feeling and thinking of living, the multiple affects of small engagements and encounters; losses and memory that is not subjected to erasure in the global flows. These multiple energies and lives interact, and interact amongst global elements of time-space compression, and vice versa. In the chapters of this book I have sought to attend to the character of some of these intimacies and familiarities. To engage this complexity of human living is a means to open up the potential relationality of values, attitudes and meanings in the discussion of the working of gentle politics.

Such an approach to the gentle politics and human culture/geographical knowledge, rather than feminist or masculinist, is welcome in terms of understanding the power, rather than micro-*scopic* character of human living in politics. Much work has been done across disciplines in terms of so-called complexity at a global level of institutional power, international finance, investment, technology, networks and business (Urry 2002, Thrift 1999). Yet little comparative attention has been granted to the complexity and importance of subtle nuance in everyday living. I pursue this observation further in this final chapter, attending to the incompleteness of the notion of timespace compression and its presumption of overwhelming new power, not least in the ways individuals make sense of their world and negotiate their values, meanings and attitudes. Instead we observe a spacetime complexity, complexity resting not only in global mega-mobilities and connections, but in the nuanced, expressive and intimate lives of and between, amongst individuals, and non-human life and things; the merging of striating and smoothing (Crouch 2006). 'Foucault worked a philosophy, relation, rather than object to unravel complex relations that can be applied to the lifeworld with a different generosity' (Raffestin 2007: 130).

Moreover, my interest through these chapters to get closer to the emergence and working of 'gentle politics' sparks particular aspects of inquiry of how identity, meanings, values, relations occur, are negotiated and erupt through kinds of relations and the ways in which those relations happen. Rather than reduce human angst, or existence, to a trivial mundane feature, as often more urgent, anxious political geographies tend to do; here I want to offer a complementary,

rather than countervailing consideration of the constitution and performativity of feeling, relationships with individuals and things; and meaning.

In making an appeal to engage gentle politics in our debates I note Burkitt's observation:

> What we refer to as "institutions" associated with the state or the economy are attempts to fix social practice in time and space – to contain it in specific geographical sites and codify it in official discourses. The relations and practices more often associated with everyday life – such as friendship, love, comradeship and relations of communication – are more fluid, open and dispersed across time and space. However, the two should not be uncoupled in social analysis, as they are necessarily interrelated in processes of social and political change. (Burkitt 2004: 212)

It is the consideration of relationality that is central. As Divya Tolia-Kelly strongly argues, we do not share the same universal similarity and openness (Tolia-Kelly 2008b: 125). In considerations of the character of emotion and becoming it is crucial to attend to 'the intensities, striations and different properties of emotional experiences of 'love', 'fear', 'hate' and 'awe' for example' (Tolia-Kelly 2008b: 127). To go much further routing connections and values through everyday life and potentials for socially, culturally and environmentally progressive potentialities requires closer attention in our work to the working of threads, smudges, blobs; blocks of sensations and numerous kinds of assemblage, striations, smoothing and feeling. There are some pointers already.

Feeling Further

Hester Parr's considerations of emergence in performative multiplicities are an exemplary insight into the nuanced workings of the idea of gentle politics (Parr 2008). In her consideration of the experience of dislocation and of belonging amongst both individuals with mental health problems, particularly living in dispersed, small locations in parts of Scotland and those who may seek to work with them. She finds potential and becoming. Scenarios of well-considered ways of creatively engaging and building with the lived realities of mental health patients are presented so that fear, isolation, exclusion and stigma need not always dominate our frames of reference and our feeling of belonging. Here is a progressive programme for re-engagement, re-identification and belonging: an acutely progressive collation of practices of empowerment and integration that justifies Parr's shaping of her own 'hopeful epistemology' of mental health and its 'social spaces'. These are works of wellbeing. Wellbeing is less an escape to a site of temporary enhancement of wellness than potential becoming in performance and its performativities (Crouch 2009, Kearns and Andrews 2010).

There is a politics of relations, as Roger Lee has talked of economies of mutual regard (Lee 2000, Leyshon et al. 2003), through which values and meanings, however fluid, are positioned with regard to other humans and other things, living and not.

Andrew Metcalfe and Anne Game express the more-than-ordinariness of everyday life:

> The everyday is often seen as the time when nothing happens. This is a view that follows from a sense of chronological time, Euclidean space and Hegelian identity-play. The everyday can also be experienced as the time of eternity, the space of infinitude and the ontological condition of love. This epiphanic experience of the sacred is not of a release from the everyday but a return to it. The sacred is not the exception to the everyday, but the ground of our everyday belonging to the universe. (Metcalfe and Game 2008)

They have argued for the return of subjectivity in a new thinking of relationality; not as privileged but emerging in a new non-oppositional difference of wholeness (Metcalfe and Game 2008). In the case of community gardening, one character of practice and performativity that occurs is in the often-staged politics of contesting proposals to appropriate land and to build on plots. Such politics can involve the plotters in political organization, working out schemes of action in order to debate, protest, publicize their case. A more gentle politics is the more diffuse practice of negotiating with other gardeners on issues of what to do with communal areas on sites, over contested matters of how to grow plants and using the ground. Like numerous other things people do, what happens on these sites reflect the liveliness in the character of the everyday. Sometimes everyday negotiation can merge with feelings of a wider political spectrum. Individuals find that they develop a feeling and practice of mutual care and regard; and new relationships with natural things and the wider environment. Tension in attitudes to ways of working ground and cultural aesthetics emerge in cultural attitudes, othering of immigrant groups' manner of cultivation; the blowing of pesticide sprays across plots, or organically tended 'weeds' blowing onto neighbouring plots. There are numerous examples of what I have called 'play' in things people do, in fishing and car racing, for example (Moorhouse 1991, Hoggett and Bishop 1986). Similarly, the consumption of 'the global' in Coco Cola and for example rap music is hardly constrained by the evident internationalization of culture(s) (Wall 2000, Miller 1997). In a discussion on doing tourism, being and becoming as a tourist, however mundane and mingling with everyday mundane-ness, Luke Desforges and I argued that 'bodily cultures can inform our purchase on cultural and social changes in the formation of tourism …' (Crouch and Desforges 2003: 16).

There are the potentialities of everyday 'micro-politics' in practising alternative relations, human capacities and relationalities, geographies and democratically popular cultures (Domosh 1988). The complex and flexible notion of 'flirting with space' adheres to potentialities: how we 'know' and feel the world. Knowing

emerges from practice and its performativities, rather than global stories and their particular mediations; these together can become relational and engaged. Our actions together, with the non-human, materiality and others is under-considered in terms of everyday experiences: lying on the beach, walking around, breaking trees in the park, that are hardly engulfed by so-called 'new mobilities'. The social of class, gender, ethnicity, generation, disability acts contingently but is not erased. Time is spent talking face to face, slowly, interrupted. Individuals are aware of 'nature' not because of seeing what happens the other side of the world, but close-up: touched and felt. The 'left' rock singer Billy Bragg, who worked with me on my BBC community gardens film, recounted to me his earliest feeling for nature when his mum asked him to pick mint from the plant along the lane at the back of the house in closely built up east London (Bragg 1994, Crouch 1994). The mint was the only thing growing behind the house, just outside the back fence in the alleyway. The world may be 'on a plate' in its thought global representation/ presentation (Cook and Crang 1996). Yet on the plate, too, is food, things bought to feed a household, particular grades of health in eating, relating and engaging the household, gender relations and friendships in the practice of eating, and, for Bragg, an intimate feeling of belonging and nature (Valentine 1999). In its shopping the food can perform care for others (Miller 1987).

The importance of nuance in living and gentle politics emerges through considerations of flirting with space. The acknowledgement of the complexity of journeys and its critical celebration of their creativities is one of vitalism and affect.

Generosity and tolerance can be at the forefront in our thought, not merely being critical in polarization of our own thinking; not discarding our values of social fairness but to avoid our own isolationism, irrelevance often ironically unambiguously certain, of rightness. Not least there is the danger of a cliff-fall of thought leading to despair and nothingness; an exhaustion of hope, care and love in our work An insistence upon one set of positions, however progressively put may not be progressive in its affect: in danger of expiring in their own arrogance of 'knowing'. I am thinking of Bauman (2009), Baudrillard (2009), Virillio (2009) and Zizek (2010) amongst others. Much contemporary writing speaks of a retrospective regret and fear of hurtling through spacetimes like an (un)godly rapture of end of days.

Further, Baudrillard's high postmodern of the hyper-real where individuals are seduced unthinkingly that the postmodern unreal is more real than their lives was always most unhelpful in terms of social justice and progressive thinking for participation ... argued the importance of 'strategies of desire' (Baudrillard 1988: 85) through which individuals', consumers' needs are mobilized or provoked and their nascent interests captured in a process of consumption before consumption. In this strange assertion, he argued that signs as such no longer referred individuals to what they may have experienced. Power thus shifts from things, events, and objects themselves to their circulation in representations, their fuller consumption dominated by their sign-value and the value invested in anticipation. These

strategies, Baudrillard argued, consist of the signs on which the value of products are conveyed in the process of seduction.

Familiar arguments for art practice today being possible and useful only in working in relation with acts of the terrible, with an implied progressivity render no hope, only reaction (Taylor 2007). Joy, love, amusement and care happen. Of course such excellent work Anselm Kiefer's paintings of distressed environments and lives are vitally important, but not to the exclusion of the expression of other emotions (Schama 2007). My journey in this worked, through Colin Ward's sensitive pursuit of openness and tolerance in a position of social anarchy. This is not to claim a soggy pragmatism either, but tolerance of positions in an aim to engage and to persuade. Maffesoli rejects the temporality of modernism for living in the non-time tragedy of living in the present within a medium of communal images and practices (2004).

There is often an emptiness in 'critical' work that exists in being simply out of touch, disengaged with lives, that presumes pervasive circumstances of compliance, mere consumers, only oppression.

> Critical practices aimed at increasing potentials for freedom and for movement are inadequate, because in order to critique something in any kind of definitive way you have to pin it down ... separate something out, attribute set characteristics to it, ... a final judgement ... a moralising undertone (that) loses contact with other more moving dimensions of experience ... (one) more to with affective connection and abductive critique. (Massumi and Zoumazi 2002b)

How do individuals 'do' these lives, these ways of living, relating mattering and otherwise related to? I feel we need hope, a gentle hope, if we are to offer progressive thinking and feeling.

Brian Massumi approaches the hopes and potential for freedom amidst oppression and control, writing concerning the practice of everyday life, ethical practices, belief in the world that makes us care for our belonging as well as change, belonging in change (Massumi and Zoumazi 2002b). Abduction for Massumi is close to 'the passing awareness of being at a threshold ...; affect ... a movement of thought' (ibid. 2002b, Anderson 2007). 'Ordinary affects are the varied, surging capacities to affect and to be affected that give everyday life the quality of a continual motion of relations, scenes, contingencies and emergencies. They're the things that happen' (Stewart 2007: 1).

Frequently the writing of Deleuze and Guatttari on immanence, on 'energy' and 'forces' feels suggestive of a sense of spirituality, however vague or implicit, or absent. Yet there persists a feeling of resonance with what I can only call my 'grasp' on something like spirituality. Dewsbury and Cloke have considered the notion of 'spirituality' in terms of Deleuze and others (Dewsbury and Cloke 2009). Their perspective focuses explicitly on Christianity. My interest is unbound by tradition and any institutional prefiguring of spirituality (other than the fact that I am a very loose Quaker, part marked by Christianity in my 'roots' but less so

in its 'routes' taken). My thinking is inflected more by notion of 'enchantment' that Bennett considers, or sensation; feeling beyond the materially-constituted and beyond the socially-culturally constructed. Bennett's notion of enchantment is:

> to be struck and shaken by the extraordinary that lives amid the familiar and everyday ... enchantment entails a state of wonder ... a momentarily immobilising encounter; it is to be transfixed, spellbound. (Bennett 2001: 4)

Examining lives and their living it is evident that we live lives exceptionally well grounded in materiality, in stuff and feelings:

> The notion of a totalised system, of which everything is somehow already a part, (to say the least) in the effort to approach a weighted and reeling present. This is not to say that the forces these systems try to name are not real and literally pressing. On the contrary ... to bring into view as a scene of immanent force, rather than leave them looking like dead effects imposed on our innocent world. (Stewart 2008: 1)

Stewart's sensitive and responsive way of working opens up possibilities of hope through 'ordinary' individuals' lives:

> It tries to deflect attention away from the obsessive desire to characterise things once and for all long enough to register the myriad strands of shifting influence that remain uncaptured by representational thinking. It presumes "we" – the impacted subjects of a wild assemblage of influences – but it takes difference to be both far more fundamental and far more fluid than models of positioned subjects have been able to suggest ... it is drawn to the place where *meaning* per se collapses and we are left with acts and gestures and immanent possibilities ... it tracks the pulses of things as they cross each other, come together, fragment and recombine in some new surge. It tries to cull attention to the affects that arise in the course of the perfectly ordinary life as the promise, or threat, that something is happening – something capable of impact ... they take us to the surge of immanence itself. (Stewart 2005: 1029)

Flirting with space enables a breaking through continuing meta-thinking to attend to people's living in the world, partly as quiet or gentle politics; partly as profoundly significant influence and affect on the meaning and value of things and the way things happen. Across the several voices expressing feeling in flirting with space in these chapters there seems to be an element of these: in 'humble' (sic) caravanning and doing of community gardening ('my little bit kingdom'); in the moment of achieved tension in making artwork and in its circulation of participative encounter; in Owain Jones's feeling of belonging. Jones, like Lanyon, insists on atheism, that I find no contradiction with my loose notion of 'enchantment'. There are many

other voices in this book that for me express something similar. Moments, events and encounters can be felt deeply: so what may we mean by that?

Dewsbury and Cloke provide a formative way of thinking and feeling about spirituality, that they express 'the spiritual' as 'that part of the virtual in which faith forms a significant part of the move beyond rationality and of the possibility of other-worldly disposition' (Dewsbury and Cloke 2009: 696). 'Place' or space as sacralized does not rely upon institutional framing, figuring or permission (Kong 2001). They consider 'the spiritual as something constitutive of everyday life; cutting at that space between absence and presence, and manifesting itself at the immediate, and therefore non-metaphysical, level of the body' (Dewsbury and Cloke 2009: 697). They consider their reflections in relation to landscape. The notion of the poetic may not be equivalent to spirituality. The immanent surface, whilst trying to avoid immanence, and the 'unaccounted for' in their discussion come close in their readings to energies. John Newling found a similar character of the sacred space in disorientation (2007).

Ben Anderson rightly warns of the error of associating embodiment, performativity or becoming with hope, a riskily utopian leaning. He realistically asserts that hope, like performativity, becoming and creativity, is not a 'good' per se (Anderson 2007). Yet there is much room for balancing crisis-as-negative with hope through attention to the capacities and competence of love and hope in individuals. Jane Bennett goes beyond the limits of materiality as just inert, but rather as of 'liveness' (2001). It is too easy to ignore the feeling of many individuals globally in terms of something more, however loosely I would relate this experience, yet however channelled it may be felt through institutional power. There emerges a spiritual in Deleuze: 'the zone where forms become indiscernible and normal orientation is displaced as understanding comes to be arrested more upon sensible intuition' (Dewsbury and Cloke 2009: 705). Resembling the notion, energy, dynamic and character of flirting with space, they seek a spirituality that is an explicitly earthy, fleshily disposed thing. Deleuze asserted that 'this spirituality is the body without organs' (2003: 46-47).

Perhaps peculiar to materialists is Delueze's expression: 'Underneath the self which acts are little selves which contemplate and which tender possible both the action and the active subject. We speak of our "self" only in virtue of these thousands of little witnesses (itself a rather spiritual-religious term) which contemplate within us; it is always a third party which says it to me' (Deleuze 1994: 75 quoted in Dewsbury and Cloke 2009: 707, my parenthesis). In many of the threads of discussion across these chapters the notion of hope in becoming, whilst acknowledging its converse, emerges in flirting with space and in its creativities. To connect these with spirituality is to point, as Bennett argues, to its 'liveness'; possibilities and potentialities of social justice, through love and care, knowing the world through our sensitivities and awareness, in doing everyday things.

Deleuze and Guattari reason that affects are not feelings but can merge with and into the felt. They are overspill, excess of becomings. 'Like the beam of light that draws a hidden measure out of the shadow' (Deleuze and Guattari 1994: 66).

Deleuze' interest in art was its potentiality to work likewise; becoming, in and amongst art and living, is expressive. '(C)ommon notions' with 'other bodies in agreement' are produced when the individual is able to rise above the condition of experiencing effects and signs in order to inform agreements of joyful encounters with other bodies', that can engender a power through joy (Cocker 2009: 5). Cocker is particularly interested in the potential role of artists in this. She argues that 'stillness is pure disconnectedness, enabling nothing but the possibility of a community of experience to come into being' (Cocker 2009: 11). Yet, again, this coming is possible: 'affirmation though rupture … *a community still in waiting*' (Cocker 2009: 12).

> Without modes of enchantment, we might not have the energy and inspiration to enact ecological projects, or to contest ugly and unjust modes of commercialization, or to respond generously to humans and nonhumans that challenge our settled identities. (Bennett 2001: 174)

Metcalfe and Game sensitively point to this liveness:

> Of course, I could not see my children like this without seeing the world afresh. When my perspective was lowered by my fear of a tantrum, I had not noticed the glorious open blueness of the sky or the vital greenness of the street trees. This was the first sunny morning after days of rain, and the world was clean and full of promise. As Max and Leo and I walked to school, hand in hand, I could feel the world smiling at us, with us, through us. (Metcalfe and Game 2008: 21)

Artist John Newling brings together a sensitive and responsive feel of care, relationality and mutual affects with lived materiality, and ethics in his story of growing a lemon tree that is not shy of its politics:

> An ethical and aesthetic milieu coheres around the simple act of looking after the lemon tree, an ecology of values which in every sense can be considered local: the immediacy of the situation, the tactile and material encounter, the sustainability of the action, the micro-politics of gardening, the re-appropriation of time, the sanctity of place. The local disposition emphasizes qualities over quantities, and at the same time provides a welcome antidote to the greed and excess of the global market place and the parasitic nature of its protagonist. In stark contrast, *The Lemon Tree & Me* contains the seeds of a social ecology, a generative programme of "intensive care" based on the simplest of values, which are second nature to the gardener, and enriched by the cultural compost of the artist. The "strange ecology" of *The Lemon Tree & Me* is in fact only a cultural perception, based on the artificial separation of history from natural history, and our modern day experience of living in a reified economy of estrangement. When I observe the condition of the lemon tree's leaves, test its soil for moisture, check the Ph balance of the compost, adjust the light conditions, trim the foliage,

count the flowers, pick the lemons, legislate against the weather, experiment
with the growth cycle, I restore to art a sense of what is vital in practice, and in
turn reconnect the materiality of experience with an emerging history that is at
once natural, social and ecological in its composition. (Newling 2011)

It is through such sensitivities that connectedness with the so-called "'big matters"
about being progressive can emerge' (ibid.). Living mutually affectively with
'non-human', or, as Whatmore welcomingly prefers, 'more-than-human' works
also at intimate levels (Whatmore 2006).

In his consideration of navigating moments Massumi foregrounds different
notions of being and collective life. 'Belonging matters: "becoming other" that
acts relationally and collectively without the self-interest that can characterise
collectives' (Massumi 2002). In what is obviously an ethic quest Massumi
expresses that 'the practice of joy does imply some form of belief. It can't be
a total scepticism ... all mechanisms for holding oneself separate and being in
a position to judge or deride. (Rather), to believe in the world again ... really
experience our belonging in this world... our belonging to each other, and live
that so intensely that there is no room to doubt the reality of it ... self-affirming'
(Massumi 2002, my parenthesis).

It is not a matter of religion and its fixity of power as such:

> Since then I have given up the "religious" which is nothing but the exception,
> extraction, exaltation, ecstasy; or it has given me up. I possess nothing but the
> everyday out of which I am never taken ... I do not know much more. If that is
> religion then it is just everything, simply everything that is lived in its possibility
> of dialogue. (Buber 1966: 18, Metcalf and Game 2008: 351)

In his reflections on human relatedness Buber thoughtfully engaged the idea of
I-Thou, in a feeling of attitude and practice, care and affect, of mutual regard
reflective of Lee's evocation of intersubjectivity in everyday actions and relations
(Lee 2000). Spacetime and being can be considered in relational logic in love:

> The experience of eternal repetition is creative – original, originary – because it
> is accompanied by a sense of "newness": the original takes us back to origins by
> giving us the sense of "for the first time". This is the temporality of love at first
> sight. This is the original originary eternal love. (Metcalf and Game 2004: 354)

> There are aspects of everyday relations and practices more open to government,
> institutionalization, and official codification, while others are more resistant and
> provide the basis for opposition and social movements. Everyday life is a mixture
> of diverse and differentially produced and articulated forms, each combining
> time and space in a unique way. What we refer to as "institutions" associated
> with the state or the economy are attempts to fix social practice in time and space
> – to contain it in specific geographical sites and codify it in official discourses.

> The relations and practices more often associated with everyday life – such as friendship, love, comradeship and relations of communication – are more fluid, open and dispersed across time and space. However, the two should not be uncoupled in social analysis, as they are necessarily interrelated in processes of social and political change ... Space as well as time is now multiple and discontinuous. (Burkitt 2004: 211-227)

The problem is in thinking and feeling a globalized world; rather than one of multiply varied intimacies too. It is otherwise too easy to claim; insensitive to major tracts of our global population. Individuals anywhere also live their lives; an implication and application of some control, some affect.

Whilst our knowledge of technology, movement, speed, international networks and non-human energies, has taken centre stage it becomes necessary to 'catch up', to make comparable advances in understanding ourselves and our spacetimes. I am thinking, for example, of Thrift's reflection on affect, that places high the ways of scoring 'real' (sic) affect on politics only in a 'big' and urgent way (Thrift 2004). However much I admire Zizek's concern for social justice and anarchic edge (Zizek 2010), I defer to Massumi's concept of 'affect' as very human: the word for hope. Thus it becomes necessary to try and relate the often over-anxious 'push' to emphasize the importance of speed rapidity, and, it often seems, a hierarchy of what things matter, and how they matter, and the actuality of their mattering and how they relate.

Bissell discusses the tensions surrounding or in feeling and holding on too tightly to our comfort, between stasis and closing our creativity, and the beneficial character of feeling comfortable; in a reassurance of security and because it can feel pleasant. (Bissell 2007). Feeling comfortable is part of 'holding on', and can confine potentialities of going further, or work relationally together. As Miller explicates, comfort is important to the feeling of life and to its strength, and is not to be confused with fixity: it is contingent, negotiated, and exists in liveness (2008).

'(T)he coming together of the previous unrelated, a constellation of processes rather than a thing. This is place as open and internally multiple ... Not intrinsically coherent' (Massey 2005: 141). Yet there is need for more than this: to grasp, unravel, relate the more intimate character of process, how we understand its relationality with other politics; the mingling of smooth and striated space and spacing. And the world works through energies, some are in the mundane, some in self-conscious resistance (Thrift 1997). McCormack argues that the habitual economies of the everyday are not simply the matter upon which power works. They are powers in themselves (2003: 490). 'The habitual cannot be written out of a politics of propinquity yet tends to be undervalued in accounts of the everyday taken as the geographically proximate' (Amin 2004: 30). And a politics of the habitual needs consideration relationally with other kinds of politics. Recent debate concerning cosmopolitanism offers, not the familiar elements of mobility, distance, living virtually or timespace compressions, but of everyday life '... material analysis of

the way cosmopolitanism is performed in everyday life' (Kolz 2006). Kolz argues that debate concerning cosmopolitanism has familiarly held away from everyday life in order to privilege its 'critical' edge. Cosmopolitanism emerges in relation to the particularities, of culture, spacing, through which individuals move.

There is a strong case for 'a ground of action … a politics of acknowledgement that can better acknowledge the temporality of being, and the situated and provisional nature of subjectivity (Noble 2009: 875, 889). Gregg points to the potential mundane character of the small often inward circulation of angst ridden ideas amongst an academic class frustrated to be involved or to make a mark in international politics. She argues that culture works in, and is worked by and amongst, peoples everyday lives (Gregg 2004: 368). Massumi's challenge to cultural studies works at the same register, of moving away from abstract assumptions to do with an aspiring collectivity (the 'constituency' on which conventional political theories rely) towards the potential offered in writing 'singularity', that Massumi calls 'this-ness': 'an unreproducible being-only-itself' (2002a: 222). Morris asks for 'a historical analysis attuned both to socio-economic contexts and to the individuating local intensities' (Morris 2002: 4). She argues that these 'local intensities' come out when we attend to the mundane. 'Anecdotes figure a singular instance of how "this" happens *here*, which does not preclude other experiences, but acts as an example of how the world can be said to be working in this context. It is a voice that does not pretend to speak for others, conscious of its status as a simulated enunciative act' (Morris 2002: 4). In everyday life practices affective connections amongst individuals, families, the past and present emerge: spaces and their performance (Gregg 2004). Flirting can be productive; and destructive; it is, as Kundera provokes, no guarantee.

Individuals inhabit and part-constitute spaces and identities in terms of power relations. Crossley argued that through embodied ways of living the individual provides 'the necessary grounds through which to rethink' (1995: 59-60). Through practice we engage, discover, open and close, habitually practice and act performatively, express with bodily gesture; reassure, become and create. Happenings in living are negotiated and 'made sense' in complex time by feeling-thinking human beings. This process of negotiating leaves room for human beings to 'take it', to a degree, where s/he likes. As Taussig remarked, our everyday geographical and cultural knowledges and our sense of the everyday are 'not sense so much as sensuousness, an embodied and somewhat automatic 'knowledge' that functions like peripheral vision, not studied contemplation, a knowledge that is imageric and sensate rather than ideational' (Taussig 1992: 141).

The liveness of life needs re-integration in our thought. Sandywell goes as far as to say:

> … the ordinary has been systematically denigrated in the very act of being theorized as "everyday life". This dichotomous theorizing has helped sustain the myth of an ahistorical, unmediated everyday life … any attempt to go beyond the antinomies of contemporary theory must first abandon this mythology to

reveal the histor(icit)y and alterity of lifeworlds in their rich material, incarnate, political, and reflexive imbrications. (Sandywell 2004: 161)

Merleau-Ponty uses the term 'flesh of the world' to remind us that we are made of the same stuff as the world, and that this for phenomenologists is how we know: 'Immersed in the visible by his body ... the see-er does not appropriate what he sees ... he opens himself to the world ... (M)y body is caught in the fabric of the world' (1961: 62-163). We know the world with and through our bodies: 'Things arouse in me a carnal formula of their presence' (1964: 164). We are in the world, and the world is in us: relational logic reversibly entwines inside and outside:

> A "corporeal or postural schema" gives us at every moment a global, practical, and implicit notion of the relation between our body and things, of our hold on them ... For us the body is much more than an instrument or a means; it is our expression in the world, the visible form of our intentions. (Merleau-Ponty 1964: 5, Shotter 2004: 444)

Bachelard's character of feeling mingles in Bennett's observation. Enchantment is provoked by a surprise, by an encounter with something that one did not expect '... an energizing feeling of fullness or plenitude – a momentary return to childhood joie de vivre' (Bennett 2001: 4, 5). This is enchantment 'in the gaps', echoing Cocker's stillness and Newling's disorientation, enchantment can occur through modes of suspension of thought and discovery of transformation. Considering Lefebvre's considerations of rhythm Maffesoli finds a problem: 'Lefebvre's stance is characteristic of an intellectual attitude incapable of grasping what imbues the everyday with its poetry. This poetry is clearly not present as such, but is nonetheless at work in such things as the ironic stance toward any grandiloquent moral certainties, the humour suffusing run-of-the-mill conversations, and most of all in the body language expressing our passion for all things social' (Maffesoli 2004: 205). Moreover

> We are in the world, and the world is in us: relational logic reversibly entwines inside and outside: Since things and my body are made of the same stuff, vision must somehow take place in them ... "Nature is on the inside" says Cezanne. Quality, light, colour, depth, which are there before us, are there only because they awaken an echo in our body and because the body welcomes them. (Merleau-Ponty 1964: 164)

There is more than a hint of relationality of affect here.

Thinking in terms of flirting provides a means to understand the spatial encounters as unfolding, negotiation and contesting, rather than constantly finding the world always unstable and/or overwhelming (Levinas 1961). Yet it may also be useful to consider such an emotional negotiation in relation to the theme of holding on to who we feel we are and may want, in part, to be, in the contexts of

our living, a desire for feelings of belonging, even amongst uncertainty and change. The notion that such feelings are perpetually dislocated in the intensities, or in particular kinds of intensities of living would seem to be needing a relationality in our thinking; between holding on and going further; in a closer examination of how space or spacing is implicated, and implicates. Affect is diverse and multiple. In thinking through these threads with the help of diverse evidence something emerges of the character of creativity in relation with space, spacing, and the times and feelings of our journeys, that provokes further engagement.

Virginia Woolf's *The Waves* is constituted around a wave-like motion of becoming: 'The wave is a figure which suggests 'shifting and borderlines' between all the elements of the narrator; characters, ages, sexes' (Deleuze and Guattari 2004: 252). 'Perception will no longer ride on the relation between a subject and an object but rather in the movement, serving as the limit of their relation' (Deleuze and Guattari op cit. 282).

Bibliography

Ainley, D. 2004-2010. Personal conversations.

Ainley, D. 2010. Landscape: Prospect and process, in L. Ingham, *The Nature of Landscape: Visions and Distillations of Landscape and Place.* Grimsby, UK: Abbey Walk Gallery, 27-37.

Amin, A. 2004. Regions unbound: Towards a new politics of place. *Geografiska Annaller B* 86(1), 33-44.

Anderson, B. 2006. Becoming and being hopeful: Towards a theory of affect *Environment and Planning D: Society and Space* 24(5), 733-752.

Anderson, K. et al. eds. 2003. *Handbook of Cultural Geography.* London: Sage.

Andrews, H. 2004. Escape to Britain: The Case of Charter Tourists to Mallorca. Doctoral Thesis London Metropolitan University.

Andrews, H. 2009. Tourism as a moment of being. *Suomen Antropologi, Journal of the Finnish Anthropological Society* 34(2), 5-21.

Bachelard, G. 1994. *The Poetics of Space.* Boston, MA: Beacon Press.

Bachelard, G. 2000. *The Dialectics of Duration.* Manchester: Clinamen Press.

Badiou A. 2007. *The Century.* Cambridge: Polity Press.

Bakhtin, M. 1984. *Rabelais and his World.* Bloomington: Indiana University Press.

Bakhtin, M. 1990. *Art and Answerability: Early Philosophical Essays.* Austin: University of Texas.

Barnett, C. 1999. Deconstructing context: Exposing Derrida. *Transactions of the Institute of British Geographer.* New Series, 24, 277-294.

Batchelor, D. 1991. Abstraction, modernism, representation, in A. Benjamin and P. Osborne, eds. *Thinking Art: Beyond Traditional Aesthetics.* London: Institute of Contemporary Arts, 45-57.

Baudrillard, J. 1988. Simulacra and simulations, in M. Poster, ed. *Selected Writings.* Stanford, CA: Stanford University Press, 166-184.

Baudrillard, J. 2007. *Why Hasn't Everything Already Disappeared?* New York: Seagull Books, trans. C. Turner.

Bauman, Z. 2009. *Living on Borrowed Time.* Cambridge: Polity Press.

Bell, V. 1996. Performativity and belonging: An introduction, in V. Bell, ed. *Performativity and Belonging.* London: Sage, 1-10.

Benjamin, W. 1982. *Das Passagen-Werk.* R. Tiederman, ed. Frankfurt: Suhrkamp Verlag.

Bennett, J. 1991. *The Enchantment of Modern Life: Attachments, Crossing and Ethics.* Princetown, NJ: Princetown University Press.

Berger, J. 1972. *Ways of Seeing.* Harmondsworth: Penguin.

Berger, J. 1979. *About Looking.* London: Writers and Readers.

Bergson, H. 1912/2007. *Matter and Memory.* London: Allen and Unwin.

Binnie, J., Holloway, J., Millington, S. and Young, C. eds. 2007. Mundane geographies: Alienation, potentialities and practice. *Environment and Planning A* 39, 515-520.

Birkeland, I. 1999. *The Mytho-Poetic in Northern Travel*, in D. Crouch, ed. *Leisure/Tourism Geographies*. London: Routledge, 17-33.

Bissell, D. 2007. Comfortable bodies: Sedentary affects. *Environment and Planning A* 40, 1697-1712.

Bissell, D. and Fuller, G. 2009. The revenge of the still. *Journal of Material Culture* 12(1), 1-8.

Blanchot, M. 1993. The limit of experience, in *The Infinite Conversation.* Minneapolis: University of Minnesota, 123-142, quoted in Phillipson, M. and Fisher, C. 1999.

Bolt, B. 2004. *Art Beyond Representation.* London: I.B. Tauris.

Bonnett, A. 1992. Art, ideology and everyday space: Subversive tendencies from Dada to postmodernism. *Environment and Planning D: Society and Space* 10, 69-86.

Bonta, M. 2005. Becoming-forest, becoming local: Transformations of a protected area in Honduras. *Geoforum* 36(1), 95-112.

Bourdieu, P. 1984. *Distinction: A Social Critique of the Judgement of Taste.* London: Routledge.

Bradiotti, R. 2006. Posthuman, all too human. *Theory, Culture and Society* 23(7/8), 197-208.

Bragg, B. 1994. Personal conversation.

Bruner, E. 2005. *Culture on Tour.* Chicago, Ill: Chicago University Press.

Buber, M. 1966. *The Way of Response.* New York: Schocken Books, quoted in Metcalfe, A. and Game, A. 2004.

Buchannan, I. and Lambert, G. eds. 2005. *Deleuze and Space.* Edinburgh: Edinburgh University Press.

Budgeon, S. 2003. Identity is an embodied event. *Body and Society* 9(1), 35-55.

Burkitt, I. 1999. *Bodies of Thought: Embodiment, Identity and Modernity.* London: Sage.

Burkitt, I. 2004. The time and space of everyday life. *Cultural Studies* 18(2/3), 212-227.

Butler, J. 1997. *Excitable Speech: A Politics of Performance.* London: Routledge.

Caillois, R. 1961. *Man, Play and Games.* Chicago, Ill: University of Illinois Press.

Campbell, N. 2004. 'Much unseen is also here': John Brinckerhoff Jackson's new western roadscapes. *European Journal of American Studies* 23(3), 217-231.

Campbell, N. 2007. Critical regionalism, thirdspace, and John Brinckerhoff Jackson's western cultural landscapes, in S. Kollin, ed.

Cant, S. 2003. The tug of danger with the magnetism of mystery: Descents into 'the comprehensive, poetic-sensuous appeal of caves'. *Tourist Studies* 3(1), 67-81.

Cant, S. and Morris, M. 2006. Geographies of art and environment. *Social and Cultural Geographies* 7(6), 857-862.

Carlsen, M. 1996. *Performance: A Critical Introduction.* London: Routledge.

Cartwright, P. 2009a. Personal conversation.

Cartwright, P. 2009b. R. Clarke, *Exhibition Preview*, Peter Cartwright, Derby. *The Guardian*, 11 July.

Casey, E. 1993. *Getting Back into Place: Towards a Renewed Understanding of the Place-World.* Bloomington: Indiana University Press.

Casey, E. 2005. *Earth-Mapping: Artists Reshaping Landscape.* Wisconsin: University of Minnesota Press.

Castree, N. and Nash, C. 2004. Mapping posthumanism: An exchange. *Transactions of the Institute of British Geographers* 36, 1341-1363.

Clifford, J. 1997. *Routes: Travel and Translation in the Late Twentieth Century.* London: Routledge.

Cloke P. and Perkins H. 1998. Cracking the canyon with the awesome foursome. *Society and Space* 16, 185-208.

Cocker, E. 2007a. *Not Yet There: Writing and Research by Emma Cocker.* Available at: http://not-yetthere.blogspot.com/ (accessed 20/03/08).

Cocker, E. 2007b. Desiring to be led astray. *Papers in Surrealism* 6, 1-25.

Cocker, E. 2009. Stillness. *Journal Media-Culture* 12(1), 2-13.

Cohen, S. 2007. *Decline, Renewal and the City in Popular Music Culture: Beyond the Beatles.* Farnham: Ashgate.

Colebrook, C., Frenhsam R. and Threadgold, T. 2002. Deleuze: Ontologies of the virtual, in *Understanding Deleuze.* NSW, Australia: Allen and Unwin.

Conradson, D. and McKay, D. 2007. Translocal subjectivities: Mobility, connection, emotion. *Mobilities* 2(2), 167-174.

Cook, I. and Crang, P. 1996. The world on a plate: Culinary culture, displacement and geographical knowledges. *Journal of Material Culture* 1(2), 131-153.

Cosgrove, D. 1984. *Social Formation and the Symbolic Landscape.* Beckenham, Kent: Croom Helm, 254-271.

Cosgrove, D. and Daniels, S. eds. 1988. *The Iconography of Landscape: Essays on the Symbolic Representation, Design and Use of Past Environments.* Manchester: Manchester University Press.

Crang, M. 2001. Rhythms of the city: Temporalised space and motion, in *Time/Space: Geographies of Temporality.* J. May and N. Thrift, eds. London: Routledge, 187-207.

Cresswell, T. 1996. *In Place/Out of Place Geography, Ideology and Transgression.* Minneapolis: Minneapolis University Press.

Cresswell, T. 2004. Landscape and the obliteration of practice, in K. Anderson et al. eds, *Handbook of Cultural Geography.* London: Sage, 269-281.

Cross, T. 1984. *Painting the Warmth of the Sun: The St Ives Artists, 1939-1975.* Penzance: Alison Hodge.

Crossley, N. 1995. Merleau-Ponty, the elusory body and carnal Sociology. *Body and Society* 1(1), 43-61.

Crossley, N. 1996a. *Intersubjectivity: The Social Content of Becoming.* London: Sage.

Crossley, N. 1996b. Body–subject/body–power: Agency, inscription and control in Foucault and Merleau-Ponty. *Body and Society* 2, 107.

Crouch D. 1990. Personal conversation with *Guardian* newspaper travel editor.

Crouch, D. 1994. The Plot: A Documentary Film. BBC2.

Crouch, D. 1997. Environemnt, body, geography: Tensions and connections, in *Larry Wakefield*, Catalogue. Southampton: Millais Gallery, 13-18.

Crouch, D. ed. 1999. *Leisure/Tourism Geographies: Practice and Geographical Knowledge.* London: Routledge.

Crouch, D. 2001. Spatialities and the feeling of doing. *Social and Cultural Geographies* 2(1), 61-75.

Crouch, D. 2003a. Spacing, performance and becoming: The tangle of the mundane. *Environment and Planning A* 35, 1945-1960.

Crouch, D. 2003b. Performances and the constitution of natures: A consideration of the performance of lay geographies, in B. Szerzsinski and C. Waterton, eds. *Performing Nature.* Oxford: Blackwell, 17-30.

Crouch, D. 2003c. *The Art of Allotments: Culture and Cultivation.* Nottingham: Five Leaves Press.

Crouch, D. 2005. Flirting with space: Tourism geographies as sensuous/expressive practice, in C. Cartier and A. Lew, eds. *Seductions of Tourism.* London: Routledge.

Crouch, D. 2006. Embodiment and performance in the making of contemporary cultural economies, in T. Terkenli and A.-M. d'Hautessere, eds. *Landscapes of a New Cultural Economy.* Amsterdam: Springer, 19-38.

Crouch, D. 2007. The power of the tourist encounter, in A. Church and T. Coles, eds. *Tourism, Power and Space.* London: Routledge, 45-62.

Crouch, D. 2009. Gardens and gardening, in R. Kitchen and N. Thrift, eds, *International Encyclopaedia of Human Geography.* Oxford: Elsevier, 289-293.

Crouch D. 2009a. Constructing feelings of wellness, in R. Bushell and P. Sheldon, eds. *Wellness and Tourism: Mind, Body, Spirit.* New York: Cognizant, 114-124.

Crouch, D. 2010a. Flirting with space: Thinking landscape relationally. *Cultural Geographies* 17(1), 5-18.

Crouch, D. 2010b. The perpetual performance and emergence of heritage, in E. Waterton and S. Watson, eds. *Culture, Heritage and Representation: Perspectives on Visuality and the Past,* 57-74.

Crouch, D. and Desforges, L. 2003. The sensuous in the tourist encounter: Introduction: The power of the body in tourist studies. *Tourist Studies* 3(1), 5-22.

Crouch, D., Jackson R. and Thompson F. eds. 2005. *The Media and the Tourist Imagination.* London: Routledge.

Crouch, D. and Lubbren, N. eds. 2003. *Visual Culture and Tourism.* Oxford: Berg.

Crouch, D. and Matless D. 1996. Refiguring geography: The parish maps of common ground. *Transactions of the Institute of British Geographers* 21, 236-255.

Crouch, D. and Parker, G. 1993. Digging-up utopia: Space, place and land use heritage. *Geoforum* 34(3), 395-408.

Crouch, D. and Toogood, M. 1999. Everyday abstraction: Geographical knowledge in the art of Peter Lanyon. *Ecumene* 6(1), 72-89.

Crouch, D. and Ward, C. 1997. *The Allotment: Its Landscape and Culture.* Nottingham: Five Leaves, fifth edn., first pub. Faber and Faber 1988.

Csordas, T. 1990. Embodiment as a paradigm for anthropology. *Ethos* 18, 5-47.

Csordas, T. 1994. *Embodiment and Experience. The Existential Ground of Culture and Self.* Cambridge: Cambridge University Press.

Cummings, L. 2009. *A Face to the World: On Self-Portraits.* London: Harper.

Daniels, S. 1989. Marxism, culture and the duplicity of landscape, in N. Thrift and R. Peet, eds. *New Models in Geography II.* London: Unwin Hyman, 196-220.

Daniels, S. 1993 *Fields of Vision: Landscape Imagery and National Identity in England and the United States.* Cambridge: Polity Press.

Davidson, J. et al. eds. 2004. *Emotional Geographies.* Farnham: Ashgate.

Davidson, J. and Milligan, C. 2004. Embodying emotion, sensing space: Introducing emotional geographies. *Cultural Geographies* 5(4), 523-532.

De Bello, P. and Koureas, G. 2010. *Art, History and the Senses.* Farnham: Ashgate, 1, 17.

De Botton, A. 2001. *The Art of Travel.* London: Hamish Hamilton; Harmondsworth: Penguin, 2002.

de Certeau, M. 1984. *The Practice of Everyday Life.* Berkeley: University of California Press, trans. S. Rendell.

de Kooning, W. 1960. *Sketchbook No. 1: Three Americans.* New York, *Time*, 15, see Casey, *Earth Mapping*, 148.

de Kooning, W. 1968. *Collected Writings.* New York: Hanuman Books.

De Landa, M. 1999. Deleuze, diagrams and the open-ended becoming of the world, in E. Grosz, ed. *Becomings: Explorations in Time, Memory and Futures.* Ithaca: Cornell University Press, 29-41.

De Landa, M. 2005. Space: Extensive and intensive, actual and virtual, in I. Buchanan and G. Lambert, eds. *Deleuze and Space.* Edinburgh: Edinburgh University Press, 80-88.

Deacon, B. 1993. And shall Trelawny die? The Cornish identity, in P. Payton, ed. *Cornwall Since the War: The Contemporary History of a European Region.* Redruth: Institute of Cornish Studies, University of Exeter and Dyllansow Truran, 200-223.

Deleuze, G. 1989. *Cinema 2.* London: Athlone Press, trans. R. Hurley.

Deleuze, G. 1991. *Bergsonism.* New York: Zone Books, quoted on p. 411 in M. Hodges 2008.

Deleuze, G. 1994. *Difference and Repetition.* London: Athlone Press.

Deleuze, G. and Guattari, F. 1988. *A Thousand Plateaus.* London: Athlone Press.

Deleuze, G. and Guattari, F. 1996. *What is Philosophy?* Berkeley: University Press California.

Deleuze, G. and Guattari, F. 2004. *A Thousand Plateaus.* London: Continuum.

Dewsbury, J.-D. 2000. Performativity and the event: Enacting a philosophy of difference. *Environment and Planning D: Society and Space* 18, 473-496.

Dewsbury, J.-D. 2002. Introduction: Enacting geographies. *Geoforum* 33, 337-440.

Dewsbury, J.-D., Harrison, P., Rose, M. and Wylie, J. 2002. Enacting geographies. *Geoforum* 33, 437-440.

Dewsbury, J.-D. and Thrift, N. 2005. 'Genesis Eternal': After Paul Klee, in Buchanan I. and Lambert, G. eds. *Deleuze and Space.* Edinburgh: Edinburgh University Press, 89-108.

Dezeuze, A. 2006. Everyday life, 'relational aesthetics' and the 'transfiguration of the commonplace'. *Journal of Visual Art Practice* 5(3), 143-151.

Diebenkorn, R. 1990. *Richard Diebenkorn Whitechapel Gallery Catalogue.* London: Whitechapel Art Gallery.

Diebenkorn, R. 1998. *The Art of Richard Diebenkorn.* Los Angeles: Whitney Museum of Modern Art.

Doel, M. 1999. *Postsructuralist Geographies: The Diabolical Art of Spatial Science.* Edinburgh: Edinburgh University Press.

Domosh, M. 1998. 'Those gorgeous incongruities': Polite politics and public space on the streets of nineteenth-century New York. *Annals of the Association of American Geographers* 88, 209-226.

Dubow, J. 2001. Rites of passage, in Bender B. and Winer M. eds. *Contested Landsdcapes: Movement, Exile and Place.* Oxford: Berg, 241-257.

Dubow, J. 2004. The mobility of thought: Reflections on Blanchot and Benjamin. *The International Journal of Postcolonial Studies* 6(2), 216-228.

Duchamp, M. 1966. Lecture at the MOMA, New York, 1961. Published in *Art and Artists* 1, 4.

Duncan, J. and Ley, D. eds. 1993. *Place/Culture/Representation.* London: Routledge.

Edensor, T. 1996. Mundane mobilities and performances and the spaces of tourism. *Social and Cultural Geographies* 8(2), 199-215.

Edensor, T. 2001. Walking in the British countryside. *Body and Society* 6(3-4), 81-106.

Edensor, T. and Holloway, J. 2008. Rhythmanalysing the coach tour: The Ring of Kerry, Ireland. *Transactions of the Institute of British Geographers* 33(4), 83-501.

Edmonds, M. 2006. Who said romance was dead? *Journal of Material Culture* 11(1/2), 167-188.

Finnegan, R. 1989. *The Hidden Musicians: Music Making in an English Town.* Buckingham: Open University Press.

Fortier, A.-M. 1999. Re-membering places and the performance of belonging. *Theory, Culture and Society* 16(2), 41-64.

Foucault, M. 1980. *Power/Knowledge: Selected Interviews and Other Writings*. C. Gordon, ed. London: Harvester Press.

Francis, D., Kellaher, L. and Neophytou, G. 2005. *The Secret Cemetery*. Oxford: Berg.

Frello, B. 2008. Towards a discursive analytics of movement: On the making and unmaking of movement as an object of knowledge. *Mobilities* 3(1), 25-50.

Gabo, N. 1920. *The Realistic Manifesto*, quoted in Tate Gallery, 1976. *Naum Gabo: The Constructive Process*. London: Tate Gallery.

Gabo, N. 1944. An exchange of letters between Naum Gabo and Herbert Read. *Horizon*, July, quoted in Newman, T. 1967. *Naum Gabo: The Constructive Process*. London: Tate Gallery.

Gade, A. and Jeslev, A. eds. 2005. *Performative Realism*. Copenhagen: University of Copenhagen, Museum Tusculanum Press.

Game, A. 1991. *Undoing the Social: Towards a Deconstructive Sociology*. Buckingham: Open University Press.

Game, A. 2001. Belonging: Experience in sacred time and space, in J. May and N. Thrift, eds. *Timespace: Geographies of Temporality*. London: Routledge, 226-239.

Game, A. 2009. Riding: Embodying the centaur. *Body and Society* 7(4), 1-12.

Gandy, M. 1997. Contradictory modernities: Conceptions of nature in the art of Joseph Beuys and Gerhard Richter. *Annals of the American Association of Geographers* 87, 636-659.

Gardiner, M. 1999. Bakhtin and the metaphorics of perception, in I. Heywood and B. Sandywell, eds. *Interpreting Visual Culture: Exploring the Hermeneutics of the Visual*. London: Routledge.

Garlake, M. 1992. *Peter Lanyon: Air, Land, Sea*. London: South Bank Centre.

Geertz, C. 1986. Epilogue: Making experiences, authoring selves, in V. Turner, W. and E. Bruner, eds. *The Anthropology of Experience*. Urbana, Ill: University of Illinois Press, 373-380.

Goffman, E. 1959/1990. *The Presentation of Self in Everyday Life*. Harmondsworth: Penguin.

Goodman, M., Goodman, D. and Redclift, M. 2009. *Consumption, Space and Place*. Farnham: Ashgate.

Grande, J. 2006. The logoising of land art: Re-sighting ourselves in it all. *Ecologues: Art and Environment*. Conference, University of Falmouth, 25-33.

Gregg, M. 2004. A mundane voice. *Cultural Studies* 18(2/3), 363-383.

Gregson, N. and Crewe, L. 1997. The bargain, the knowledge and the spectacle: Making sense of the of the car boot sale. *Environment and Planning D: Society and Space* 15.1, 87-112.

Grossberg, L. 2000. (Re)con-figuring space: Defining a project. *Space and Culture* 4/5, 13-22.

Grosz, E. 1994. *Volatile Bodies: Toward a Corporeal Feminism*. Bloomington: Indiana University Press.

Grosz, E. 1995. *Space, Time and Perversion: Essays on the Politics of Bodies.* London: Routledge.

Grosz, E. 1999. Thinking the new: Of futures yet unthought, in E. Grosz, ed. *Becomings: Explorations in Time, Memory and Futures.* Ithaca, NY: Cornel University Press, 5-28.

Groth, P. and Bressi, T. eds. 1997. *Understanding Ordinary Landscapes.* New Haven: Yale University Press.

Hallam, E. and Ingold T. 2007. Creativity and cultural improvisation: An introduction, in E. Hallam and T. ingold, eds. *Creativity and Cultural Improvisation.* Oxford: Berg, 1-24.

Hannam, K., Sheller, M. and Urry, J. 2006. Mobilities, immobilities and moorings. *Mobilities* 1(1), 1-22.

Harre, R. 1993. *The Discursive Mind.* Cambridge: Polity Books.

Harrison, P. 2000. Making sense: Embodiment and the sensibilities of the everyday. *Environment and Planning D: Society and Space* 18, 497-517.

Harvey, D. 1989. *The Condition of Modernity.* Oxford: Blackwell.

Harvey, D. 1996. *Justice, Nature and the Geography of Difference.* Oxford: Blackwell.

Hebdige, D. 1979. *Subculture: The Meaning of Style.* London: Methuen.

Heim, W. 2003. Slow activism: Home, love and the ligthbulb, in B. Szerzsinski and C. Waterton, eds. *Performing Nature.* Oxford: Blackwell, 183-202.

Highmore, B. 2002. *Everyday Life and Cultural Theory: An Introduction.* London: Routledge.

Hinchcliffe, S. and Whatmore, S. 2006. Living cities: Towards a politics of conviviality, Technonatures special issue, *Science as Culture* 15(3), 123-138.

Hitchings, R. 2005. At home with someone non-human. *Home Cultures* 1, 169-186.

Hodges, M. 2008. Rethinking time's arrow: Bergson, Deleuze and the anthropology of time. *Anthropological Theory* 8(4), 399-429.

Holloway, J. 2003. Make-believe, spiritual practice, embodiment and sacred space. *Environment and Planning A* 1961-1974.

Ingold, T. 1993. The temporality of landscape. *World Archaeology* 25, 152-174.

Ingold, T. 1995. Building, dwelling, living: How animals and people make themselves at home in the world, in M. Strathearn, ed. *Shifting Contexts: Transformations in Anthropological Knowledge.* London: Routledge, 57-80.

Ingold, T. 2000. *The Perception of the Environment: Essays on Livelihood, Dwelling and Skill.* London: Routledge.

Ingold, T. 2007. *Lines: A Brief History.* London: Routledge.

Ingold, T. 2008. Bindings against boundaries: Entanglements of life in an open world. *Environment and Planning A* 40(8), 1796-1810.

Jackson, J.B. 1984. *Discovering the Vernacular Landscape.* New Haven: Yale University Press.

Jackson, M. 2005. *Existential Anthropology. Events, Exigencies and Effects.* Oxford: Berghahn.

Jarvling, C. 2005. Inventing reality: Of truth and lies in the work of Hayley Newman, in R. Gade and A. Jerslev, eds. *Performative Realism: Interdisciplinary Studies in Art and Media.* Copenhagen: Museum Tusculanum Press, 145-180.

Jay, M. 1993. *Downcast Eyes: The Denigration of Vision in Twentieth Century French Thought.* Berkeley: University of California Press.

Jones, N. 1997. The Perception of Character in the Phenomenology of Paintings, in Context and Value: Art History and Aesthetic Judgements. Unpublished Masters Thesis, University of Warwick, 152-169.

Jones, O. 2004. An emotional ecology of memory, self and landscape, in J. Davidson et al. eds. *Emotional Geographies.* Farnham: Ashgate, 205-218.

Kaprow, A. 1993. *Essays in the Blurring of Art and Life.* Berkeley: University of California Press.

Katz, J. 1999. *How Emotions Work.* Chicago: University of Chicago Press.

Kearns, R. and Andrews, G. 2010. Geographies of wellbeing, in S. Smith et al. eds. *The Sage Handbook of Social Geographies.* London: Sage, 309-328.

Keskitalo, A. 2004. Shelters – travelling beyond places: Kaiuru's site-specific art framework, *Finnish Art Review* 1, 46, 47.

Keskitalo, A. 2006. *On the Road and in Camp: From the Experience of Travelling to a Work of Art.* Rovaniemi: Lapland University Press.

Kissel, L. 2008. The terrain of the long take. *Journal of Visual Culture* 7(3), 349-361.

Klee, P. 1920/1961. Creative credo 1920, in *Notebooks, Vol 1. The Thinking Eye.* J. Spiller, ed. London: Lund Humphries.

Kollin, S. ed. 2007. *Postwestern Cultures:Literature, Theory, Space.* Nebraska: University of Nebraska Press.

Kundera, M. 1984. *The Unbearable Lightness of Being.* London: Faber and Faber.

Lanyon, A. 1993a. *Peter Lanyon.* Newlyn: Andrew Lanyon.

Lanyon, A. 1993b. *Portreath.* Newlyn: Andrew Lanyon.

Lanyon, A. 1994. Interview.

Lanyon, A. 1995. *Peter Lanyon: Works and Words.* Newlyn: Andrew Lanyon.

Lanyon, P. 1949. Letter to Naum Gabo, in M. Garlake 1995. Peter Lanyon's letters to Naum Gabo. *Burlington Magazine* April, 233.

Lanyon, P. c.1952. Untitled note, in Lanyon, A. 1993a: 288.

Lanyon, P. 1956/1985. Letter to the St Ives Times, 6 July 1956, in *St Ives 1939-1964.* St Ives: Tate Gallery, 108.

Lanyon, P. 1956/1993. Letter to Roland Bowden, 15 November 1956, in R. Bowden, *Peter Lanyon and the third abstraction Modern Painters*, Autumn, 92.

Lanyon, P. 1962. A sense of place, *Painter and Sculptor*, Autumn.

Lanyon, P. 1963a. Recorded talk on Cloudbase, in Lanyon, A. 1993a: 229.

Lanyon, P. 1963b. Recorded talk, in Lanyon, A. 1993a: 231.

Larson, J. and Haldrup, M. 2010. *Tourism, Performance and the Everyday.* Farnham: Ashgate.

Lash, S. and Urry, J. 1994. *Economies of Signs and Space.* London: Sage.

Law, B. 2000. *Bob Law: Drawings, Sculpture and Painting.* Cambridge: Kettles Yard, 1999.

Law, J. 2004. *After Method: Mess in Social Sciences.* London: Routledge.

Lee, R. 2000. Shelter from the storm: Geographies of regard in the worlds of horticultural consumption and production. *Geoforum* 31(2), 137-157.

Lee, R. 2010. Economy and society/social geographies, in S. Smith, R. Pain, S. Marston, J.P. Jones eds. *Sage Handbook of Social Geography.* London: Sage, 205-221.

Lefebvre, H. 1947/1991. *The Critique of Everyday Life.* London: Verso, trans. J. Moore.

Lefebvre, H. 1974. *The Archaeology of Knowledge.* London: Tavistock.

Lefebvre, H. 1991. *The Production of Space.* Oxford: Blackwell.

Lefebvre, H. 2004. *Rhythmanalysis: Space, Time and Everyday Life.* London: Continuum.

Lewis, A. 1982. Peter Lanyon: Offshore in progress. *Artscribe* 34, March, 58-61.

Lewty, S. 1996. Old Milverton 1986: Some notes in retrospect, in S. Clifford and A. Knight, eds. *From Place to Place.* London: Common Ground.

Lippard, L. 1996. *Thinking about Art: Conversations with Lucy Lippard.* Manchester: Manchester University Press, 205-232.

Lloyd, M. 1996. Performativity, parody and politics, in V. Bell, ed. *Performativity and Belonging.* London: Sage, 195-214.

Lomax, Y. 2000. *Writing the Image: An Adventure with Art and Theory.* London: I.B. Tauris.

Longhurst, R. 2007. Plots, plants and paradoxes: Contemporary domestic gardens in Aotearoa/New Zealand. *Social and Cultural Geography* 7(4), 581-593.

Lorimer, H. 2006. Herding memories of humans and animals. *Environment and Planning D: Society and Space* 24, 497-518.

Louis, B. St. 2009. On the necessity and 'impossibility' of identities: The politics and ethics of 'new ethnicities'. *Cultural Studies* 23(4), 559-582.

Lubbren, N. 2001. *Rural Artists' Colonies in Europe: 1870-1910.* Manchester: Manchester University Press.

Lund, K. 2005. Seeing in motion and the touching eye walking over Scotland's mountains. *Etnofor* 18(1), 27-42.

Maffesoli, M. 2004. Everyday tragedy and creation. *Cultural Studies* 18(2/3), 201-210, trans. K.I. Ocaña.

Malbon, B. 1999. *Dancing, Ecstasy and Vitality.* London: Routledge.

Malpas, J. 2008. New media, cultural heritage and the sense of place: Cultural Heritage in the age of new media: Mapping the conceptual ground. *Journal of International Heritage Studies* 14(3), 197-209.

Manning-Sanders, R. 1949. *The West Country.* London: Batsford.

Martin, S. 2007. Critique of relational aesthetics. *Third Text* 21(4), 369-386.

Massey, D. 1993. Power-geometry and a progressive sense of place, in J. Bird, B. Curtis, T. Putnam, G. Robertson and L. Tickner, eds. *Mapping the Futures: Local Cultures, Global Change.* London: Routledge.

Massey, D. 1994. *Space, Place and Gender.* Minneapolis: University of Minnesota Press.

Massey, D. 2005. *For Space.* London: Sage.

Massey, D. 2006. Landscape as a provocation: Reflections on moving mountains. *Journal of Material Culture* 11(1/2), 33-48.

Massumi, B. 1993. *A User's Guide to Capitalism and Schizophrenia: Deviations from Deleuze and Guattari.* Cambridge: MIT Press.

Massumi, B. 2002. *Parables for the Virtual: Movement, Affect, Sensation.* Durham, NC: Duke University Press.

Massumi, B. and Zournazi, M. 2002. *Navigating Moments.* Available at: www.21cmagazine.com; and www.brianmassumi.com/english/interviews.html.

Matless, D. 1992. An occasion for geography: Landscape, representation and Foucault's corpus. *Environment and Planning D: Society and Space* 10(1-21), 41-56.

Matless, D. 1999. *Landscape and Englishness.* London: Reaktion Books.

Matless, D. 2004. The properties of landscape, in K. Anderson, M. Domosh, S. Pile and N. Thrift, eds. *Handbook of Cultural Geography.* London: Sage, 227-232.

Matless, D. and Revill, G. 1995. A solo ecology: The erratic art of Anthony Goldsworthy. *Ecumene* 2(3), 423-447.

McCannel, D. 1976/1999. *The Tourist: A New Theory of the Leisure Class.* Berkeley: University of California Press.

McCormack, D. 2003. An event of geographical ethics in spaces of geographical affects. *Transations of the Institute of British Geographers* 28(4), 488-507.

McRobbie, A. 1984. Dance and social fantasy, in A. McRobbie and M. Nava, *Gender and Generation.* London: Macmillan, 130-161.

Merleau-Ponty, M. 1961. *Eye and Mind.* Evanston: Northwestern University Press.

Merleau-Ponty, M. 1962. *The Phenomenology of Perception.* London: Routledge, trans. C. Smith.

Merleau-Ponty, M. 1964. *Signs.* Evanston, Ill: Northwestern University Press, trans. R.M. McCleary.

Merriman, P., Revill, G., Cresswell, T., Lorimer, H., Matless, D., Rose, G. and Wylie, J. 2008. Landscape, mobility, practice. *Social and Cultural Geography.* 9(2), 191-212.

Metcalf, A. and Game, A. 2004. Everyday presences. *Cultural Studies* 18(2/3), 350-362.

Metcalfe, A. and Game, A. 2008a. Potential space and love. *Emotion, Space and Society* 1(1), 18-21.

Metcalfe, A. and Game, A. 2008b. From the de-centred subject to relationality. *Subjectivity* 23, 188-205.

Miller, D. 1995. *Cultures of Consumption.* London: Routledge.

Miller, D. 1997. Coco-Cola: A black sweet drink from Trinidad, in V. Buchlli, ed. *The Material Culture Reader.* Oxford: Blackwell, 254-261.

Miller, D. 1998. *Material Culture: Why Some Things Matter.* London: Routledge.

Miller, D. 2000. Virtuaism – the culture of political economy, in I. Cook, D. Crouch, S. Naylor and J. Ryan, eds. *Cultural Turns/Geographical Turns.* London: Longmans, 196-213.

Miller D. 2007. Consumption and its consequences, in G. Mackay, ed. *Consumption and Everyday Life.* London: Sage, 13-64.

Miller, D. 2008. *The Comfort of Things.* London: Routledge.

Mitchell, D. 2005. Dead labour and the political economy of landscape – California living, California dying practice, in Anderson, K. et al. eds. 2003: 233-248.

Moorhouse, H. 1991 *Driving Ambitions: An Analysis of the American Hotrod Enthusiasm.* Manchester: Manchester University Press.

Morley, D. 2001. Belongings: Place, Space and Identity in a Mediated World. *European Journal of Cultural Studies* 4(4), 425-448.

Morris, B. 2004. What we talk about when we talk about 'walking the city'. *Cultural Studies* 18(5), 675-697.

Nash, C. 1996. Reclaiming vision: Looking at landscape and the body. *Gender, Place and Culture* 3, 149-69.

Nash, C. 2000. Performativity in practice: Some recent work in cultural geography. *Progress in Human Geography* 24, 653-664.

Ness, S. 2007. Choreographies of tourism in the Yosemite Valley: Rethinking 'place' in terms of motility. *Performance Research* 12(2), 79-84.

Ness, S. and Noland, C. 2008. *The Migration of Gesture: Film, Art, Dance, Writing.* Wisconsin: University of Minnesota Press.

Newling, J. 2005. *An Essential Disorientation.* Poland: SIRP.

Newling, J. 2006. *Chatham Vines.* London: Artoffice.

Newling, J. 2008. *The Preston Market Mystery Projec*t. Harris Museaum and Art Gallery, Preston.

Newling, J. Forthcoming. *The Lemon Tree and Me.*

Newman, M. 1991. Richard Deacon and the end of nature, in S. Bann and W. Allen, eds, *Interpreting Contemporary Art.* London: Reaktion, 177-204.

Newman, T. 1967. *Naum Gabo: The Constructive Process.* London: Tate Gallery.

Noble, G. 2009. Countless acts of recognition: Young men, ethnicity and the messiness of identities in everyday life. *Social and Cultural Geography* 10(8), 875-891.

Obrador-Pons, P. 2007. A haptic geography of the beach: Naked bodies, vision and touch. *Social and Cultural Geography* 8(1), 123-141.

Olwig, K. 2005. Representation and alienation in the political landscape. *Cultural Geographies* 21, 19-40.

Parker, A. and Sedgewick, E. 1995. *Performativity and Performance.* Routledge: London.

Parker, A. and Sedgewick, E. 1995. Introduction: Performativity and performance, in A. Parker and E. Sedgewick, eds. 1995: I-18.

Paterson, M. 2001. On Bachelard and Bergson and the complexity of memory. *Philosophy in Review* 21(3), 159-62.

Paterson, M. 2006. Feel the presence: Technologies of touch and distance. *Environment and Planning A* 24, 691-708.

Patton, C. 1999. Performativity and spatial distinction: The end of AIDS epidemiology, in A. Parker and E. Sedgewick, eds. 1995: 173-196.

Pearce, L. 2000. Driving north/driving south: Reflections upon the spatial/temporal co-ordinates of 'home', in L. Pearce, ed. *Devolving Identities: Feminist Readings in Home and Belonging.* Aldershot: Ashgate.

Phillipson, M. and Fisher, C. 1999. Seeing, becoming drawing, in I. Heywood and B. Sandywell, eds. *Interpreting Visual Culture: Explorations in the Hermeneutics of the Visual.* London: Routledge, 123-142.

Pinder, D. 1996. Subverting cartography: The situationists and maps of the city, *Environment and Planning A* 28, 405-27.

Pinder, D. 2005. Arts of urban exploration. *Cultural Geographies* 12(4), 383-411.

Pink, S. ed. 2010. Walking: Special issue, *Journal of Visual Culture* 25, 1.

Pollock, G. 2004. The homeland of pictures, reflections on Van Gogh's place memories, in J. Tucker and I. Biggs, eds. *LAN2D: Beyond Landscape.* Bristol: Royal West of England Academy, 52-65.

Powell, R. 2009. Learning from spaces of play: Recording emotional practices in High Arctic Environmental Science, in N. Smith, J. Davidson, L. Cameron and L. Bondi, eds. *Emotion, Place and Culture.* Farnham: Ashgate, 116-132.

Pred, A. 1995. *Recognizing European Moderniites: A Montage of the Present.* London: Routledge.

Radley, A. 1990. Artefacts, memory and a sense of the past, in D. Middleton and D. Edwards, eds. *Collective Remembering.* London: Sage, 46-59.

Radley, A. 1995. The elusory body and social constructionist thinking. *Theory Body and Society* 1(2), 3-23.

Raffestin, C. 2007. Could Foucault have revolutionised geography? in S. Crampton and S. Elden, eds. *Space, Knowledge and Power: Foucault and Geography* Farnham: Ashgate, trans. G. Moore, 129-152.

Read, H. 1967. *Art and Alienation: The Role of the Artist in Society.* London: Thames & Hudson.

Roach, J. 1995. Culture and performance in the cirum-Atlantic world, in A. Parker and E. Sedgewick, eds. *Performativity and Performance.* London: Routledge, 45-63.

Rojek, C. 1993. *Ways of Escape.* London: Routledge.

Rose, G. 1993. *Feminism and Geography: The Limits of Geographical Knowledge.* Wisconsin: University of Minnesota Press.

Rose, G. 2001. *Visual Methodolgies.* London: Routledge.

Rose, M. 2006. Gathering 'dreams of presence': A project for cultural geography. *Environment and Planning D: Society and Space* 24, 537-54.

Rycroft, S. 2005 The nature of Op Art: Bridget Riley and the art of non-representation. *Environment and Planning D: Society and Space.*

Rycroft, S. 2007. Towards an historical geography of non-representation: Making the counter-cultural subject in the 1960s. *Social and Cultural Geography* 8(4), 615-633.

Sandywell, B. 2004. The myth of everyday life: Toward a heterology of the ordinary. *Cultural Studies* 18(2/3), 160-180.

Schama, S. 2007. Trouble in Paradise. *Guardian Weekend Review* 20.01, 12-13.

Schieffelin, E.L. 1998. Problematising performance, in F. Hughes-Freeland ed. *Ritual, Performance, Media*. London: Routledge, 194-212.

Schneckloth, S. 2008. Marking time, figuring space: Gesture and the embodied moment. *Journal of Visual Culture* 7(3), 277-292.

Seamon, D. 1980. Body-subject, time-space routines and space ballets, in A. Buttimer and D. Seamon, eds. *The Human Experience of Space and Place*. London: Croom Helm.

Sebald, W.G. 2001. *Austerlitz*. London: Hamish Hamilton.

Shotter, J, 1993. *The Politics of Everyday Life*. Cambridge: Polity Press.

Shotter, J. 2004. Responsive expression in living bodies: The power of invisible 'real presences' within our everyday lives together. *Cultural Studies* 18(2/3), 443-60.

Simonsen, K. 2005. Bodies, sensations, space and time: The contribution of Lefebvre. *Geografiska Annaler B* 87(1), 1-14.

Skinner, J. 2010. Forthcoming. Displeasure on Pleasure Island: Tourist expectation and desire on and off the Cuban dance floor, in J. Skinner and D. Theodossopoulos, eds. *Great Expectations: Imagination, Anticipation, and Enchantment in Tourism*. Oxford: Berghahn.

Smith, N., Davidson, J., Cameron, L. and Bondi, L. eds. *Emotion, Place and Culture*. Farnham: Ashgate.

Stephens, C. 2000. *Peter Lanyon: At the Edge of the Landscape*. London: Twenty-First Century Publishing, 124.

Stewart, K. 2005. Cultural poesis: The generativity of emergent things, in N. Denzin and Y. Lincoln, eds. *The Sage Handbook of Qualitative Research*. London: Sage, 1015-1030.

Stewart, K. 2007. *Ordinary Affects*. Durham, NC: Duke University Press.

Stuckenberger, A. 2005. *Community at Play*. Amsterdam: Rozenberg, 213, in Powell, R. 2009. Learning from spaces of play: Recording emotional practices in High Arctic Environments, in N. Smith, J. Davidson, L. Cameron and L. Bondi, eds. *Emotion, Place and Culture*. Farnham: Ashgate, 116-132.

Swenson, I. et al. 2002. *Landing: Eight Collaborative Projects between Artists and Geographers*. London: Royal Holloway College University of London.

Szerszynski, B., Heim, W. and Waterton, C. 2003, *Introduction, Nature Performed: Environment and Culture*. Sociological Review Monographs. Oxford: Blackwell, 1-14.

Taussig, M. 1991. Tactility and distraction. *Cultural Anthropology* 6, 2.

Taussig, M. 1992. *The Nervous System*. London: Routledge.

Taylor, B. 2006. Kandinsky and contemporary painting. *Tate Papers Online* 6, Autumn.

Thrift, N. 1994. Inhuman geographies: Landscapes of speed, light and power, in P. Cloke et al. *Writing the Rural*. London: Paul Chapman, 191-248.

Thrift, N. 1996. *Spatial Transformations*. London: Sage.

Thrift, N. 1997. The still point: Resistance, expressive embodiment and dance, in S. Pile and M. Keith, eds. *Geographies of Resistance*. London: Routledge, 124-154.

Thrift, N. 1999. The place of complexity. *Theory, Culture and Society* 16(3), 31-69.

Thrift, N. 2004. Intensities of feeling: Towards a geography of affect. *Geografiska Annaler B* 86(1), 57-78.

Thrift, N. 2007. Overcome by space: Reworking Foucault, in J. Crampton and Elden, eds. *Space, Knowledge and Power: Foucault and Geography*. Farnham: Ashgate, 53-58.

Thrift, N. 2008. *Non-Representational Theory: Space, Politics, Affect*. London: Routledge.

Thrift, N. and Dewsbury, J.-D. 2000. Dead geographies and how to make them live. *Environment and Planning D: Society and Space* 18, 411-432.

Tilley, C. 2006. Introduction: Identity, place, landscape and heritage. *Journal of Material Culture* 11(1/2), 7-32.

Tolia-Kelly, D. 2006. Affect: An ethnocentric encounter? *Area*, 38(2), 213-217.

Tolia-Kelly, D. 2008a. Motion/emotion: Picturing translocal landscapes in the nurturing ecologies research project. *Mobilities* 3(1), 117-140.

Tolia-Kelly, D. 2008b. Fear in Paradise: The affective registers of the English Lake District landscape re-visited. *Senses and Society* 2(3), 329-351.

Trampoline/Radiator Festival. 2009. *The Wireless City*. Nottingham, UK/Berlin, Germany.

Tuan, Y-fu. 1975. *Topophilia*. New York: Prentice-Hall.

Tuan, Y-fu. 2001. *Space and Place: The Perspective of Experience*. Minnesota University Press, 2nd ed.

Tulloch, J. 2000. *Performing Culture*. London: Sage.

Urry, J. 1995. *Consuming Places*. London: Routledge.

Urry, J. 2000. *Sociology Beyond Societies*. London: Routledge.

Urry, J. 2002. *Global Complexity*. Cambridge: Polity Press.

Urry, J. 2003/1999. *The Tourist Gaze*. London: Sage.

Valentine, G. 1999. Consuming pleasures: Food, leisure and the negotiation of sexual relations, in D. Crouch, ed. *Leisure/Tourism Geographies: Practice and Geographical Knowledge*. London: Routledge, 164-180.

Vasseleu, C. 1996. Illuminating passions: Irigaray's transfiguration of the night, in T. Brennan and M. Jay, eds. *Vision in Context: Historical and Contemporary Perspectives on Sight*. London: Routledge, 127-137.

Vergunst, J.L. 2008. Taking a trip and taking care in everyday life, in T, Ingold and J. Vergunst, eds. *Ways of Walking: Ethnography and Practice on Foot.* Farnham: Ashgate, 105-122.

Verstraete, G. and Cresswell, T. eds. 2001. *Mobilising Place, Placing Mobility.* Amsterdam: Rodolpi.

Victoria Art Gallery. 2009. *Porthmoer: A Peter Lanyon Mural Rediscovered.* Bath: Victoria Art Gallery.

Virilio, 2009. *The University of Disaster.* Cambridge: Polity Press, trans. J. Page.

Wall, M. 2000. The popular and geography, in I. Cook, D. Crouch, S. Naylor and J. Ryan, eds. *Cultural Turns/Geographical Turns.* London: Longmans, 75-87.

Whatmore, S. 2006. Materilaist returns: Practising cultural geography in and for a more-than-human world. *Cultural Geographies* 13, 600-609.

White, T.-A. 2004. Theodore and Brina: An exploration of the myths and secrets of family life, 1851-1998. *Journal of Historical Geography* 30, 520-530.

Wiley, S. 2005. Spatial materialism: Grossberg's Deleuzean cultural studies. *Cultural Studies* 19(1), 63-99.

Willatts, S. 1980. *Ways of Escape.* Belfast: Orchard Gallery.

Williams R. 1977. Structures of feeling, in Williams, R. *Marxism and Literature.* Oxford: Oxford University Press.

Williams, R. 1979. *Politics and Letters: Interviews with New Left Review.* London: Verso, 303-323.

Wise, J.M. 2004. Home: Territory and identity. *Cultural Studies* 18(2/3), 363-383.

Woolf, V. 1931. *The Waves.* Hogarth Press, 1998. Oxford: Oxford World's Classics, edited with introduction by G. Beer.

Wylie, J. 2002. An essay on ascending Glastonbury Tor. *Geoforum* 32(4), 441-455.

Wylie, J. 2005. A single day's walking: Narrating self and landscape on the South West coast path. *Transactions of the Institute of British Geographers* 30, 234-237.

Wylie, J. 2006. Depths and folds: On landscape and the gazing subject. *Environment and Planning D: Society and Space* 29, 519-535.

Wylie, J. 2007. *Landscape.* London: Routledge.

Wylie, J. 2008. Landscape, absence and the geographies of love. *Transactions of the Institute of British Geographers* 34(3), 275-289.

Young, I.M. 1991. *Throwing Like a Girl and Other Essays in Feminist Philosophy and Social Theory.* Indiana: Indiana University Press.

Zizek, S. 2010. *Living in the End of Times.* London: Verso.

Zukin, S. 1995. *The Culture of Cities.* London: Sage.

Index